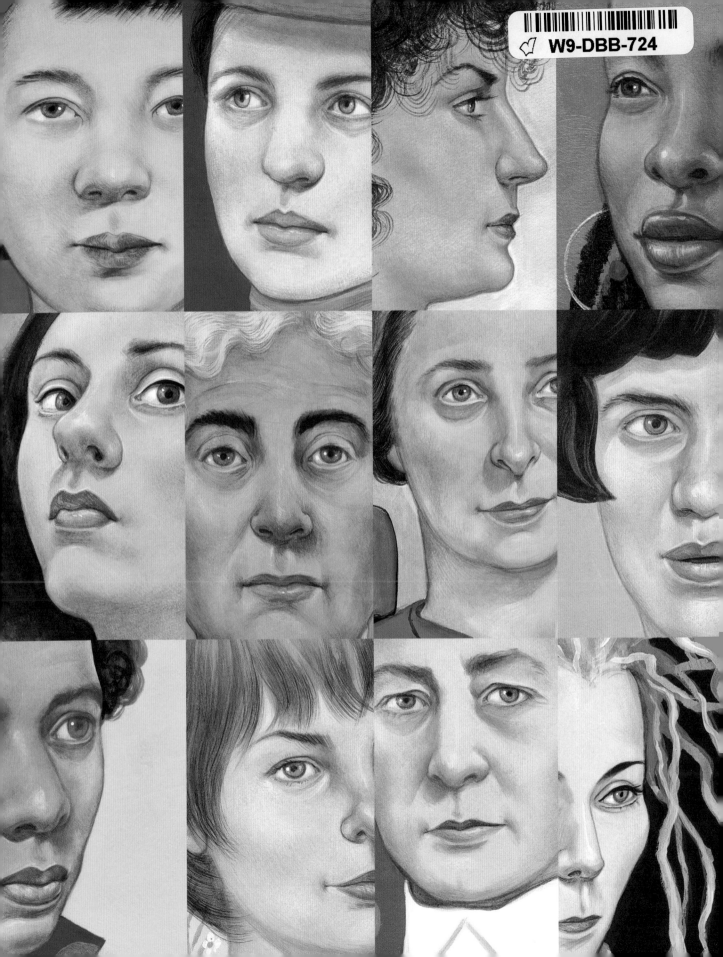

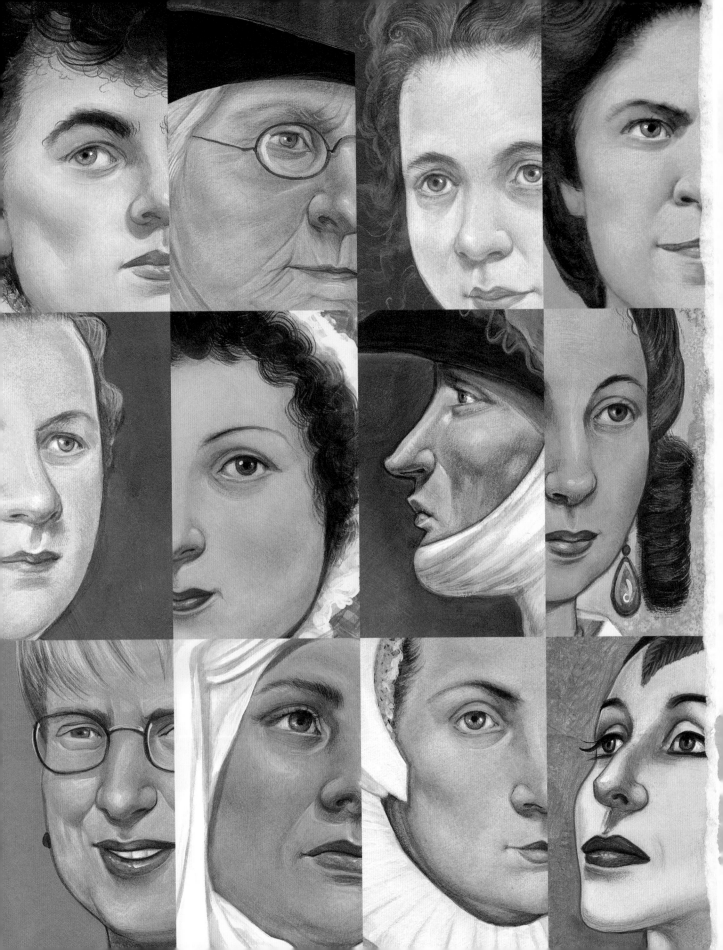

ORIGINAL
SISTERS

PORTRAITS OF
TENACITY AND COURAGE

ORIGINAL

PORTRAITS OF

PANTHEON
BOOKS

NEW YORK
2021

SISTERS

TENACITY AND COURAGE

ANITA KUNZ

FOREWORD BY
ROXANE GAY

Library of Congress Cataloging-in-Publication Data
Names: Kunz, Anita, [date] author. Gay, Roxane, writer of foreword.
Title: Original sisters : portraits of tenacity and courage / Anita Kunz ; foreword by Roxane Gay.
Description: First edition. New York : Pantheon Books, 2021
Identifiers: LCCN 2020052307 (print). LCCN 2020052308 (ebook). ISBN 9780593316146 (hardcover). ISBN 9780593316153 (ebook).
Subjects: LCSH: Women—Biography. Women—Portraits.
Classification: LCC CT3202 .K869 2021 (print) | LCC CT3202 (ebook) | DDC 920.72—dc23
LC record available at lccn.loc.gov/2020052307
LC ebook record available at lccn.loc.gov/2020052308

www.pantheonbooks.com

Jacket design by Chip Kidd
Jacket illustration by Anita Kunz

Printed in China

First Edition
9 8 7 6 5 4 3 2 1

Dedicated to Chelsey and Shelby,
in the hope of a better world for girls and women.

CONTENTS

RECLAIMING ORIGINAL SISTERS

As you read the biographies of the women of *Original Sisters: Portraits of Tenacity and Courage*, you will notice an unsettling connective tissue. These women are all accomplished and fascinating, but many of their stories were lost to history, or their greatness was not appreciated until now, or men tried and often did take credit for their bold, brilliant work. So much of women's history has to be excavated or rediscovered because for far too long, women's contributions have gone unrecognized, disrespected, underestimated.

Original Sisters is a powerful act of feminist reclamation. It is a necessary corrective. From one entry to the next, I delighted in how much women have contributed to the world we live in and how we live in that world. I was surprised by how much I didn't know, by how much has been ignored, and to what end? The word *empowering* is overused, and it is often diluted to the point of having no meaning at all when people suggest that a woman doing anything reasonably sentient is empowering. And yet. There is something incredibly empowering about reading *Original Sisters*, about learning the breadth of what women have made possible. This book, as a whole, offers the reader possibility and promise.

These original sisters span the prehistoric era to the present day. Some of the names in these pages will be familiar, but you will be introduced to many of these women for the first time, because history is rarely kind to women until it is forced to be. You will learn about artists and activists, rulers and rebels. There is a portrait of Ching Shih, a Chinese pirate who commanded seventy thousand men and a massive fleet of ships. Peggy Jo Tallas was a notorious bank robber who committed acts of well-mannered thievery. We have Irna Phillips to thank for soap operas and serial storytelling. Gladys West's calculations were key to the development of GPS, which allows us to travel without the anxiety of getting lost.

As interesting as the biographies are, the portraits are visually arresting, beautifully rendered. They demand our attention, and Anita Kunz reminds us that women's history is the world's history. She reminds us that so much of the culture we take for granted exists by the grace of women's ingenuity. *Original Sisters* makes way for us to do the ongoing work of excavating as much of women's history as we can. This is also a book that demands that we continue to interrogate why women and their historical contributions are, all too often, overlooked. Why are their contributions dismissed? How do we ensure that the women who make history from this moment forward don't suffer the same fate as too many of the women in these pages?

In 2021, Kamala Devi Harris became the first woman vice president of the United States, the first Black woman, the first South Asian American woman. With her inauguration, she joined the incredible women Anita Kunz brings to life in these pages. She shattered the glass ceiling of the American presidency and vice presidency that had been impenetrable for 231 years, despite formidable women like Shirley Chisholm, Geraldine Ferraro, and Hillary Clinton doing their absolute best to join the executive branch of our government. With the 2020 election, Vice President Harris has joined the pantheon of these original sisters. From the women who drew on cave walls of the prehistoric era to those who shattered the highest of glass ceilings, these original sisters illuminate the path for the rest of us to follow.

—Roxane Gay, January 2021

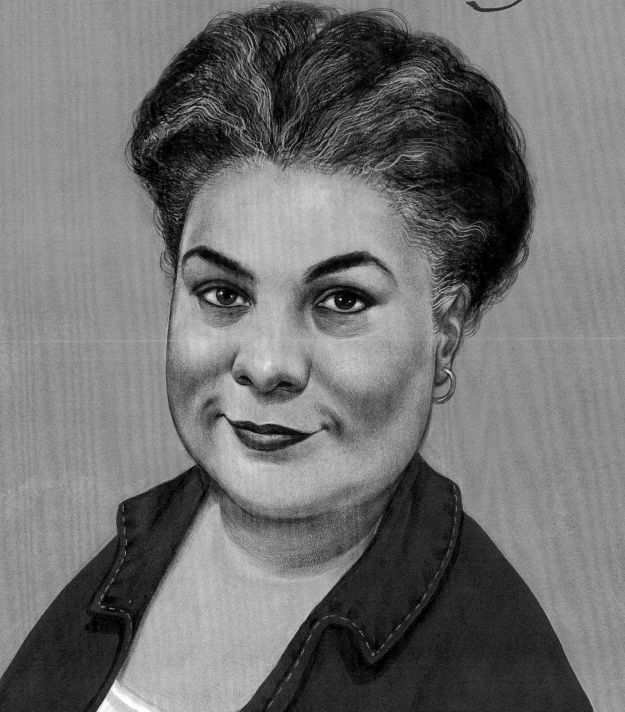

Roxane Gay

INTRODUCTION

Women have been responsible for remarkable achievements in all areas of life and have made major contributions throughout the ages. Yet for a number of reasons they are not known or remembered in the way they should be. Many have fallen through the cracks, or have been forgotten, or have simply not been taken as seriously as their male counterparts.

Women have always been here. Women make up half the world's population and have had a significant presence in all areas of the arts, sciences, sports, and more. Some of the women portrayed in this book are well known, but many others have been marginalized. But these are women whose names we all should know.

I got the idea for this project a few years ago. I began to hear amazing stories about remarkable, tenacious women and wondered why I had never heard of them before. I had the idea to paint their portraits, but I was busy and distracted with other projects. When the lockdown began, I thought it was the perfect time to finally get to work on the series.

I began my research by asking friends in different fields if they knew of any women who had contributed greatly but been overlooked. I searched sources such as Wikipedia, Britannica Online, and the National Geographic website (NatGeo.com). Locating visual references was often more difficult. Sometimes I found only one grainy black-and-white picture of a subject, so I had to try and improve the image by filling in details and imagining the color. Often, particularly with subjects from long ago, there was simply no photograph or other source material to be had, so I took artistic license and painted what she might have looked like. I created the portraits quickly. I felt time was of the essence to celebrate these women, especially in a political climate that is often quite toxic to women and minorities. I tried to paint one portrait every day. Immersing myself in the lives of these women helped my state of mind during the pandemic. Researching so many women who had gone through so much, I began to take a larger view of our place in the world.

And yet this list is only a beginning. I could very easily have painted hundreds more women. How many other unsung heroines are there from all walks of life who have faded from memory?

This is a book that celebrates extraordinary women. It is a tribute to those upon whose shoulders I stand with gratitude, respect, and love.

—Anita Kunz, November 2021

ORIGINAL
SISTERS

PORTRAITS OF
TENACITY AND COURAGE

ANONYMOUS

(CIRCA 40,000 BCE)

The first artists of our species were likely female. Landmark findings resulting from handprint analysis now strongly suggest that most of the oldest known cave art paintings were made by Paleolithic women. The cave paintings analyzed in the study are located in France and Spain. Anthropologists and scholars had made unwarranted assumptions about who was responsible for these works due to the usual male bias in scientific literature, so these findings overturn decades of dogma.

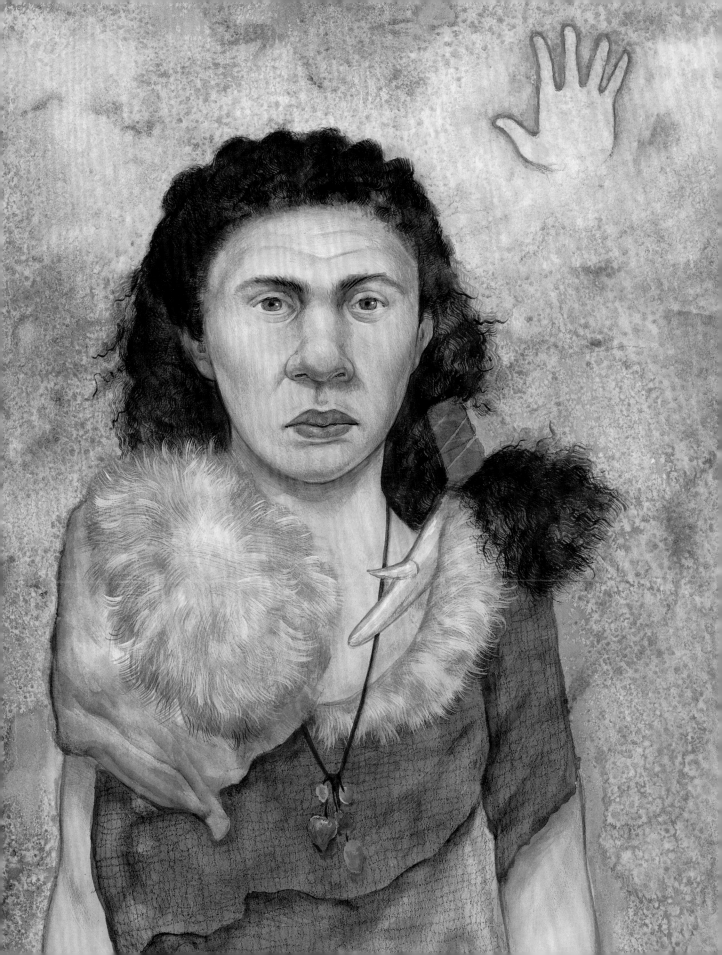

SAINT ÆBBE THE YOUNGER

(DIED 870)

was a martyr who, according to legend, mutilated herself by cutting off her nose to avoid rape by Viking marauders, and instructed her fellow nuns to do the same. She was head of the Benedictine abbey at Coldingham, Scotland, and thought that if the nuns' appearance was disgusting, they could avoid the horrific fate of sexual assault. When the Vikings finally broke into the convent, they were repelled and did not rape the nuns, but instead set fire to the abbey and burned all of them to death. The common expression "cut off one's nose to spite one's face" may have been inspired by their actions.

St.
ÆbbE

ANNA AKHMATOVA

(1 8 8 9 − 1 9 6 6)

born Anna Andreyevna Gorenko, was one of the most significant and revered Russian poets of the twentieth century. She also wrote memoirs and literary criticism and translated poetry from several languages. Some of Akhmatova's work dealt with the suffering of the Russian people, particularly women, under Soviet state terror and repression. Although Akhmatova never won the Nobel Prize, she was shortlisted for the award in 1965 and received three nominations the following year. Akhmatova wasn't fully recognized in her native Russia until after the Soviet regime ended, when all her banned works finally became accessible to the general public.

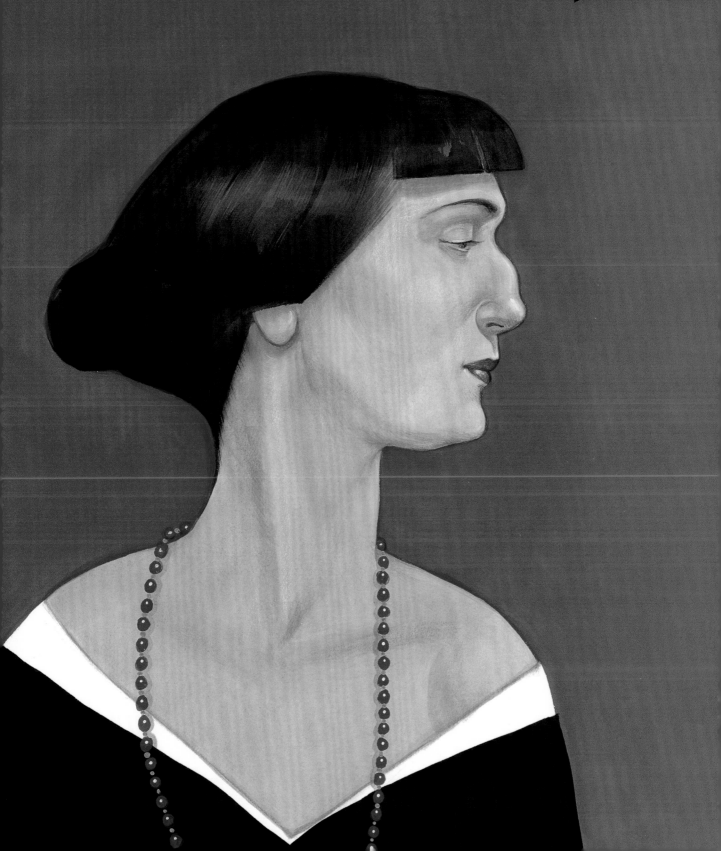

FATIMA AL-FIHRI

(CIRCA 800–CIRCA 880)

was an Arab woman who has been credited with founding what many consider to be the oldest existing and continually operating, and the first degree-granting, university in the world. Legend has it that her father, a successful merchant, left her and her sister his considerable estate on his death. Al-Fihri used her inheritance to construct the mosque in Fez, Morocco, that eventually evolved into the educational institution known as the University of al-Qarawiyyin. The library there is reputedly the world's oldest.

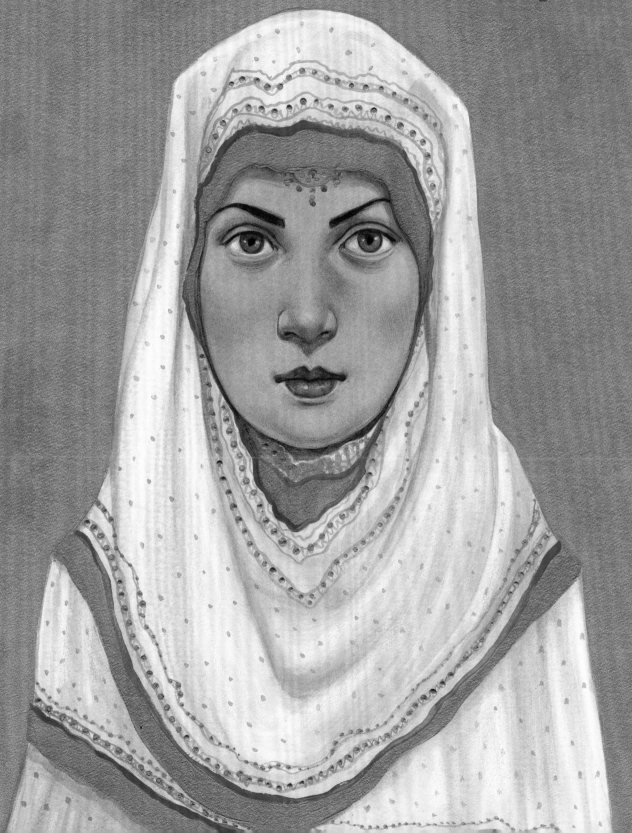

fatima al·fihri

PRINCESS ALICE
OF BATTENBERG

(1 8 8 5 – 1 9 6 9)

was the mother of Prince Philip of England. Born deaf, she married Prince Andrew of Greece and Denmark in 1903 and had five children. In her early forties, the princess was diagnosed with schizophrenia and spent time in a sanatorium. At one point Sigmund Freud consulted on her case; he recommended her ovaries be treated with X-rays to kill her libido. After her release, Princess Alice helped shelter a Jewish family from the Nazis. For this, she was honored as one of the Righteous Among the Nations: non-Jews who took risks to save Jews during the Holocaust. The princess also established an order of nuns dedicated to caring for the sick.

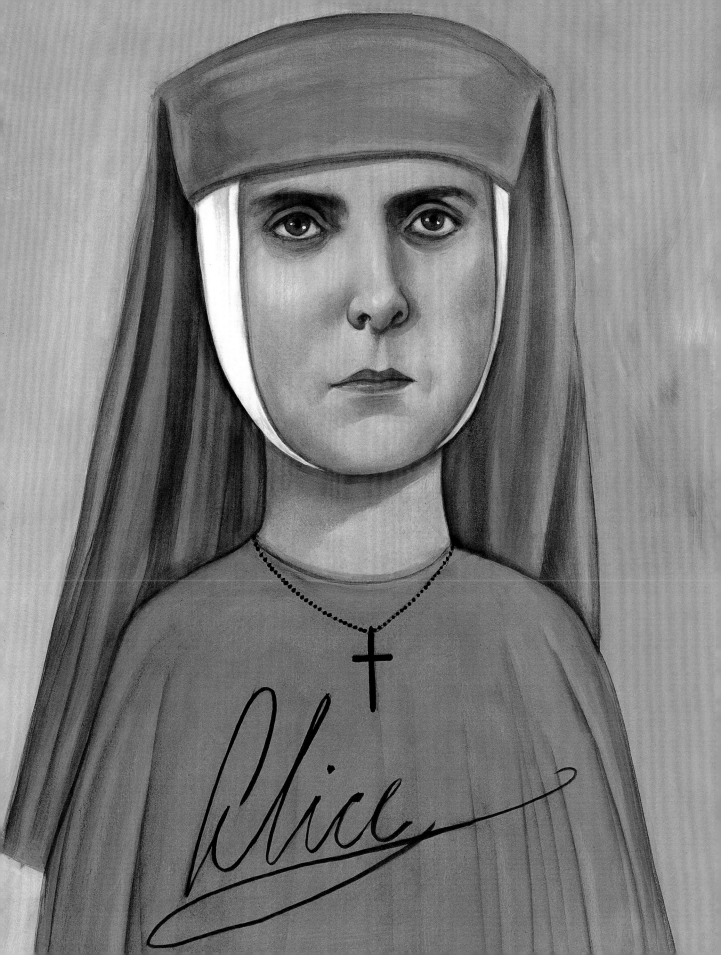

AMANIRENAS

(DIED CIRCA 10 BCE)

was the brave African warrior queen of the kingdom of Kush (in what is now Sudan) who defeated Augustus Caesar. Blind in one eye, she fiercely fought back the army of the Roman Empire so that it was unable to move south past Egypt. Her army decapitated a statue of Augustus and brought the head back to Kush as an insult and a symbol of their power. The head was buried under a temple so that people could regularly trample on it. It is thought that during the five-year war she employed terrifying tactics including feeding her captives to her pet lion, possibly illustrated in ancient carvings. Unfortunately, the language of the Kush remains poorly understood, so the full story of the battles is still unknown. The kingdom of Kush faded as a power by the first or second century CE, leaving only ruins and mystery.

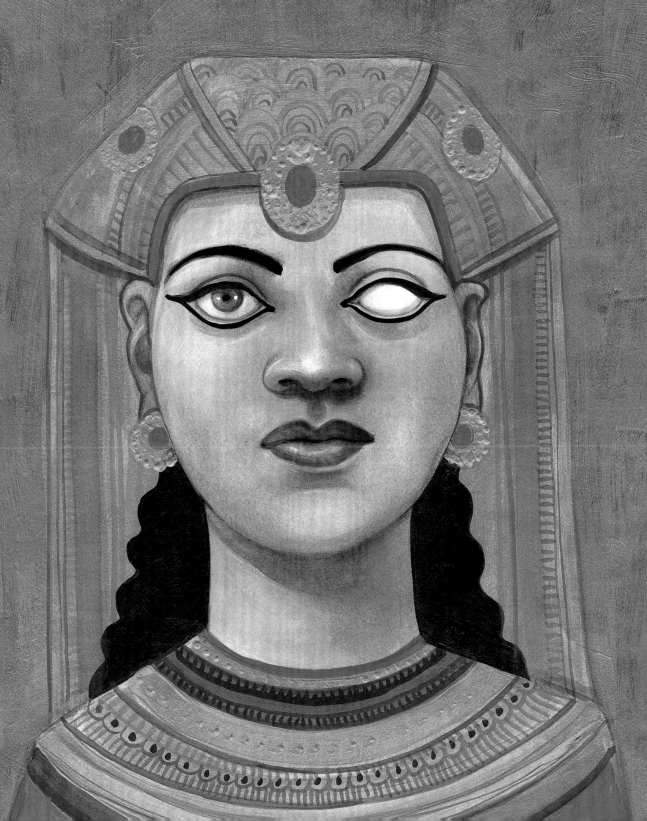

MARY ANNING

(1799–1847)

was an English fossil collector whose numerous finds were essential to the development of the young science of paleontology. She explored the cliffs near her home in southwest England, which contained Jurassic marine fossil beds. Anning's groundbreaking discoveries contributed to a new understanding of the history of the planet and of prehistoric life. However, as a woman, she was ineligible to join the Geological Society of London, and she rarely received full credit for her finds. The tongue twister "She sells seashells by the seashore" may have been inspired by Anning.

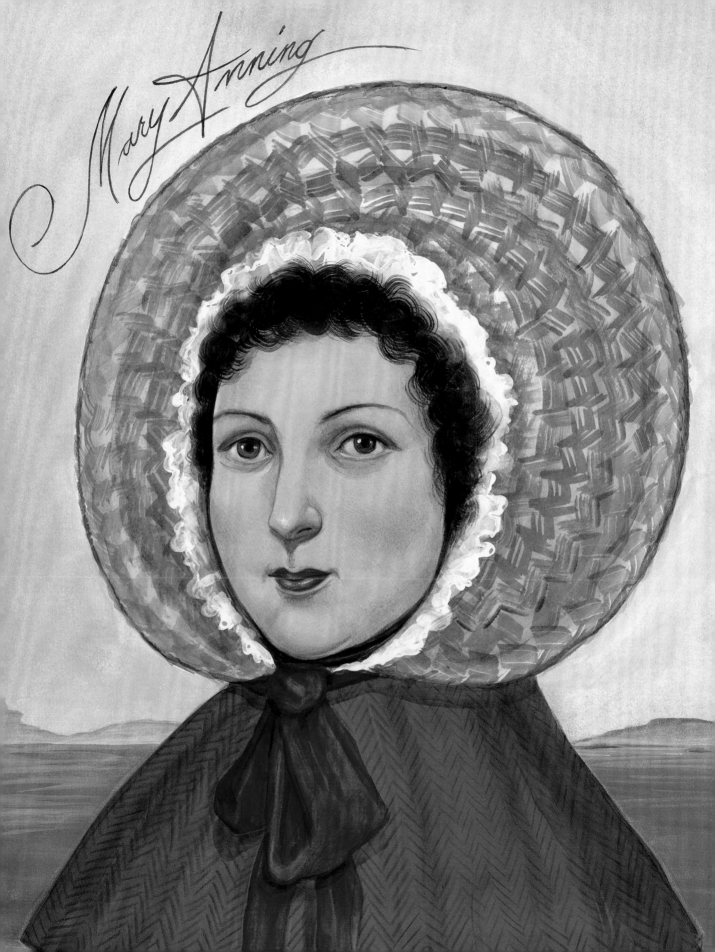

Mary Anning

ANNA MAE AQUASH

(1945–1975?)

was a Mi'kmaq activist from Nova Scotia, Canada. A follower of the American Indian Movement (AIM), she was part of the resistance at Wounded Knee in 1973. Aquash participated in many protests over the years, advocating for equal rights for Canadian and American Indigenous peoples. She disappeared in 1975; her body was found the following year, when authorities first said she had died of exposure. Aquash's death was eventually ruled a homicide, but—as is often the case for the many Indigenous women who die violent deaths—questions still remain about her murder.

anna mae aquash

HANNAH ARENDT

(1906–1975)

was a humanist thinker and one of the most influential philosophers and political theorists of the twentieth century. Born in Germany, she fled Nazi Europe for the United States in 1941. In the 1940s Arendt wrote essays on anti-Semitism and refugees, and in the 1950s she published her masterworks *The Origins of Totalitarianism* and *The Human Condition*. Arendt's insights about the reasons behind the rise of totalitarianism were often controversial. Her use of the phrase "the banality of evil" in relation to Adolf Eichmann is still much debated and, some believe, widely misunderstood.

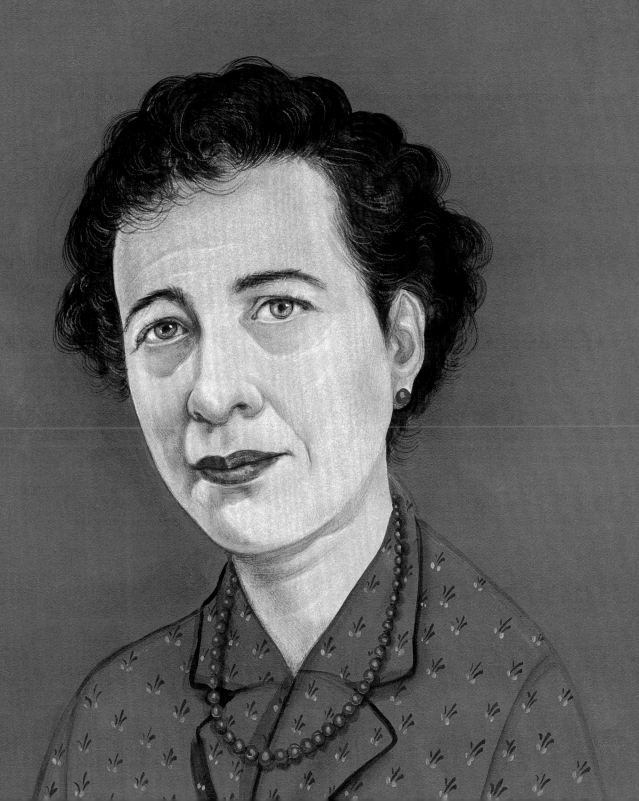

JOSEPHINE BAKER

(1 9 0 6 – 1 9 7 5)

was an iconic dancer and singer. Although she had danced professionally in the United States, her career took off when she moved to France, becoming one of that country's most popular performers. Among her famous routines was the "banana dance," for which she wore only a skirt of artificial bananas and a necklace. Baker worked for the French Resistance during World War II, then returned to the United States, where she spent much of the 1950s and '60s fighting segregation and racism. She also adopted twelve children from around the world, whom she referred to as the "rainbow tribe." Baker was the first American woman to be buried in France with full military honors.

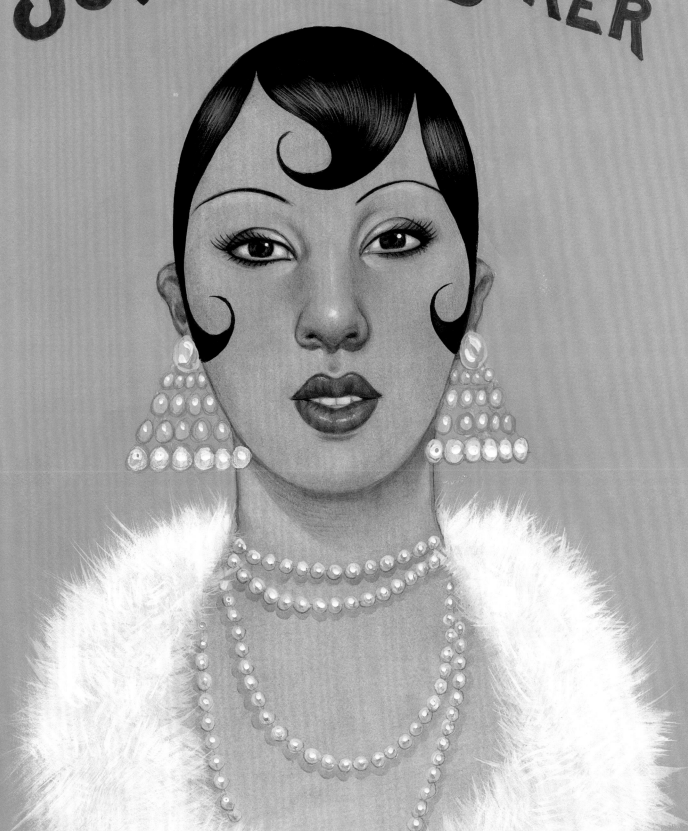

JOSEPHINE BAKER

ALICE BALL

(1892–1916)

was a brilliant chemist who developed the first effective treatment for leprosy. Overcoming the racial and gender barriers of the time, she was the first African American and the first woman to graduate with a master's degree from the University of Hawaii. She died suddenly, at the age of twenty-four, probably after inhaling chlorine gas during a lab accident, and before she was able to publish her research on her leprosy treatment. It was initially called the Dean Method, named not after her but after the president of the university, who stole her research and took full credit for it. Ball had been nearly forgotten until the twenty-first century, when she finally received long-overdue credit for her important place in medical history. The treatment is now known as the Ball Method.

ALICE BALL

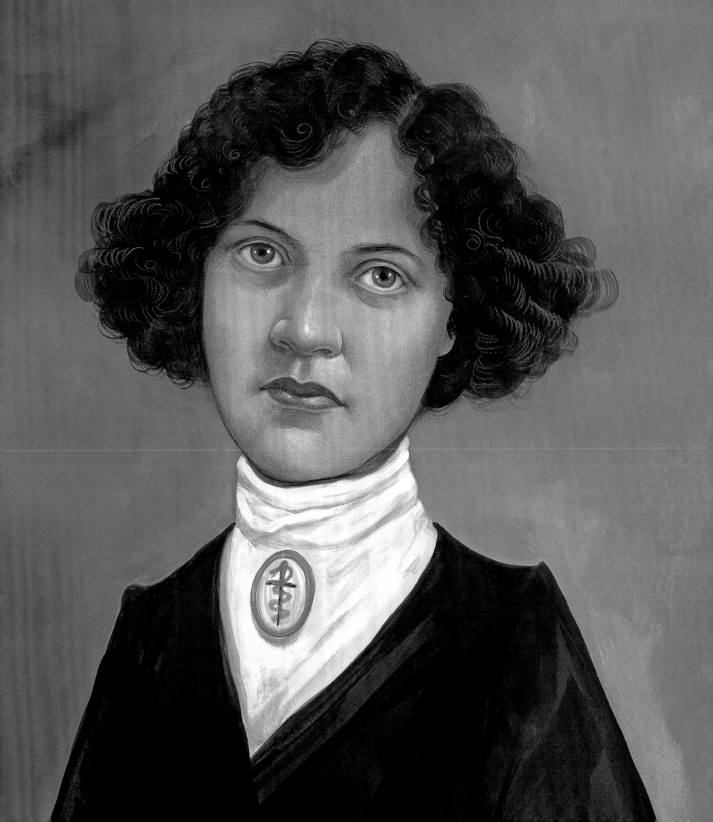

PATRICIA BATH

(1942−2019)

invented a medical device to remove cataracts that has improved the sight of people around the world. The first African American female ophthalmologist, Bath was also a humanitarian, an academic, and an inventor who held five patents. She founded the American Institute for the Prevention of Blindness and earned numerous honors and awards over her distinguished career. Bath overcame sexism, racism, and poverty on the path to becoming the first female member of the Jules Stein Eye Institute, the first woman to lead a postgraduate training program in ophthalmology, and the first woman elected to the honorary staff of UCLA Medical Center, where she was the first Black woman to serve on staff as a surgeon.

Patricia Bath

AMALIE AUGUSTE MELITTA BENTZ

(1873 – 1950)

was a German entrepreneur who invented the coffee filter. Frustrated with the choice between difficult cleanup and mediocre flavor offered by the usual coffeemaking methods, Melitta Bentz began to experiment. Success came when she placed ground coffee in paper from one of her son's schoolbooks, put this in a pot she'd punctured with a nail, and poured hot water over it. The result was a delicious brew with less mess. Bentz decided to go into business, obtaining a patent and registering her company. In 2019 the Melitta Group, which is still family owned, was valued at more than $2 billion.

Melitta Bentz

ALICE GUY BLACHÉ

(1873–1968)

was a French cinema pioneer; until 1906, she was probably the only female filmmaker in the world. She made her first film in Paris in 1896 and went on to direct and produce almost six hundred silent films. Blaché also worked on almost 150 synchronized-sound films. After moving to the United States she became the first woman to run her own studio, the Solax Company, the largest pre-Hollywood cinema studio in America. She directed her last film in 1919. Although she directed more than a thousand films, only 150 survive. Her contributions to cinema were largely overlooked until recently.

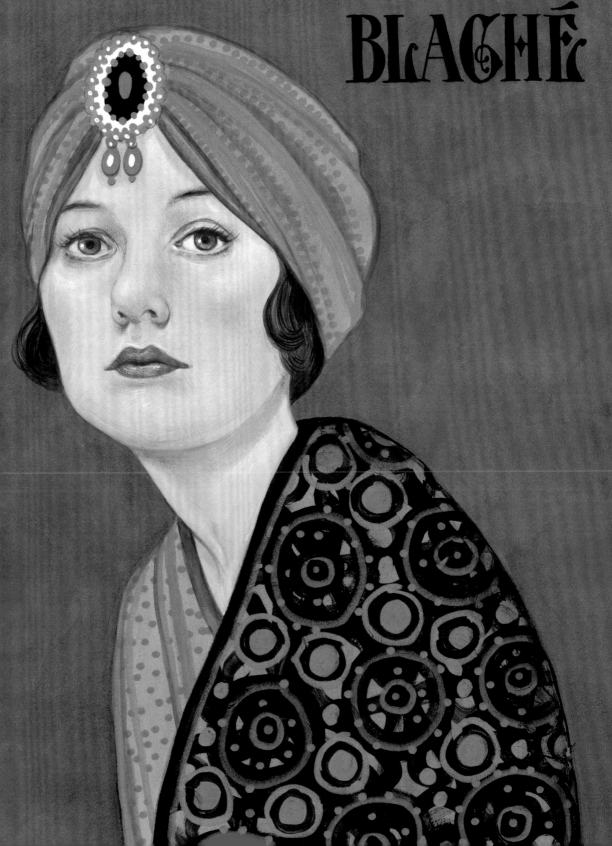

ALICE GUY BLACHÉ

ADA
BLACKJACK

(1898–1983)

was an unlikely hero of the Arctic. A poor, young Iñupiat woman, Blackjack joined a dangerous expedition to a frozen island north of Siberia in 1921 because she wanted to earn enough money to bring home her ill son, whom she had placed in an orphanage because she was financially unable to care for him. She wanted to pay for treatment of his tuberculosis. The team of five intended to claim the land for Canada. However, all the men on the team died, and Blackjack was the only one left alive. She survived on the island for nearly two brutally cold years, about three months of that time on her own, before she was rescued. She was finally able to afford medical treatment for her son and they were reunited.

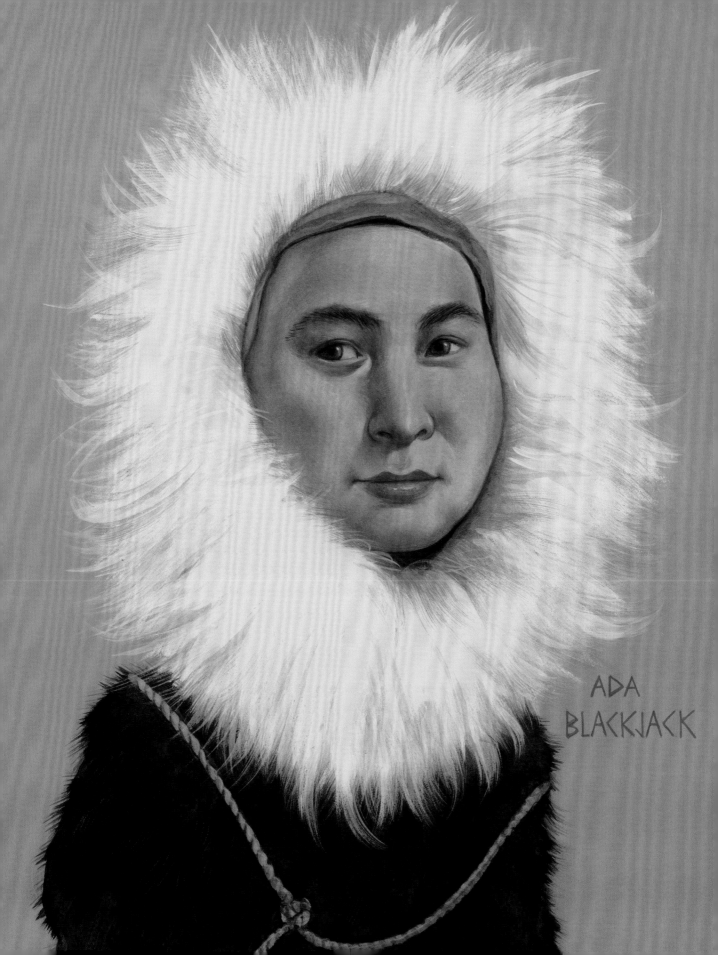

ADA
BLACKJACK

LORENA BORJAS

(1960–2020)

was a Mexican American transgender woman and community activist in Queens, New York. A victim of human trafficking, Borjas spent the rest of her life rescuing other trans women from the horrors of that crime and has been called the mother of the transgender Latinx community. She patrolled the streets, providing food and condoms to people in need, and offered help with legal and immigration concerns. Borjas set up syringe exchanges to protect transgender people undergoing hormone therapy and allowed transitioning people to stay with her. She died of complications from COVID-19.

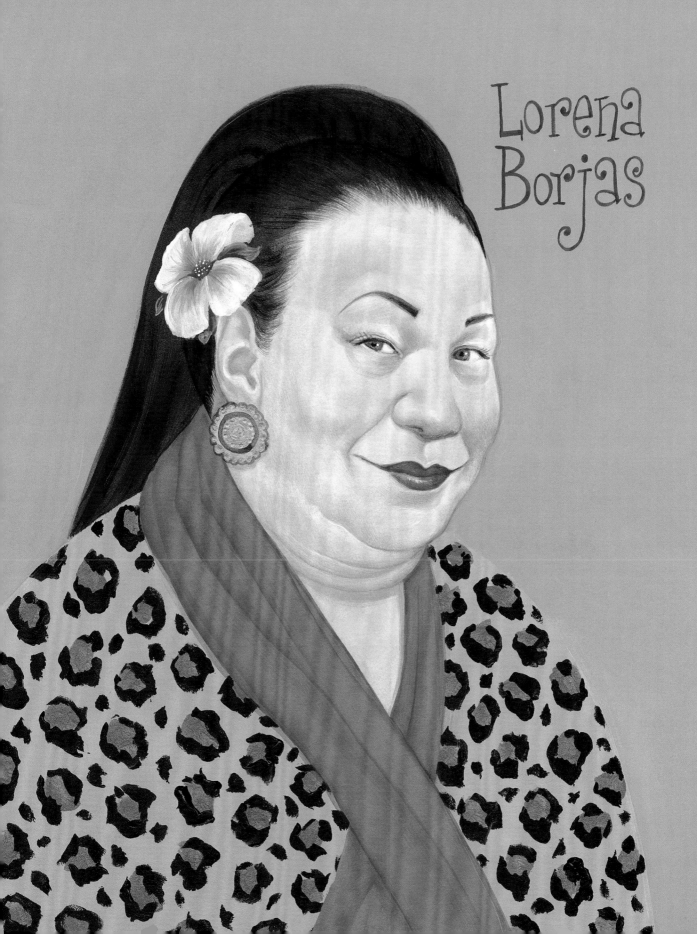

Lorena Borjas

BOUDICCA

(CIRCA 30 CE–CIRCA 60 CE)

was a fierce Celtic warrior queen and leader of the Iceni people who led a revolt against the invading Roman army in what is now East Anglia, Britain. Her husband, Prasutagus, was king of the Iceni tribe and died with no male heir, leaving his kingdom to their two daughters and to Emperor Nero. The Romans, ignoring his will, annexed the kingdom and confiscated his property. Boudicca took up arms and bravely fought the invaders. Although she and her army massacred seventy thousand Romans, her rebellion ultimately failed. The reason for her death is unclear, but it is thought that she either took poison or died of illness or shock. Today she is celebrated as a national heroine.

BOUDICCA

BREFFU

(DIED 1734)

was an enslaved woman from what is now Ghana who led one of the earliest slave rebellions in the New World. On St. John (then known as St. Jan), a small island in the Danish West Indies, she and one other enslaved person killed a plantation owner and his family and began the resistance in 1733. Rather than allow herself to be captured, she took her own life in a ritual suicide along with twenty-three other rebels. Little else is known about her life.

RUBY
BRIDGES

(1 9 5 4 –)

was six years old when she became the first African American child to integrate an all-white public elementary school in the South. On November 14, 1960, she was escorted to class by her mother and U.S. Marshals due to the violent mobs of white people yelling racist slurs. Bridges's first few weeks at William Frantz Elementary School were not easy. Several times she was confronted with blatant racism in full view of her federal escorts. On her second day at school, a woman threatened to poison her. On another day, she was greeted by a woman displaying a Black doll in a wooden coffin. Bridges's bravery was a milestone in the civil rights movement.

DOROTHY BROOKE

(1883–1955)

was a British aristocrat, socialite, and animal lover who dedicated her life to saving thousands of abandoned, neglected, and mistreated horses that had served in World War I. Raised in Scotland and the English countryside, she later lived in India and traveled annually to Cairo, where she helped to heal sick and injured working horses, and educated their owners about proper equine care. The organization she founded as a hospital for ex-warhorses has evolved into an animal charity, Brooke, that aids working horses, donkeys, and mules and their owners in the developing world.

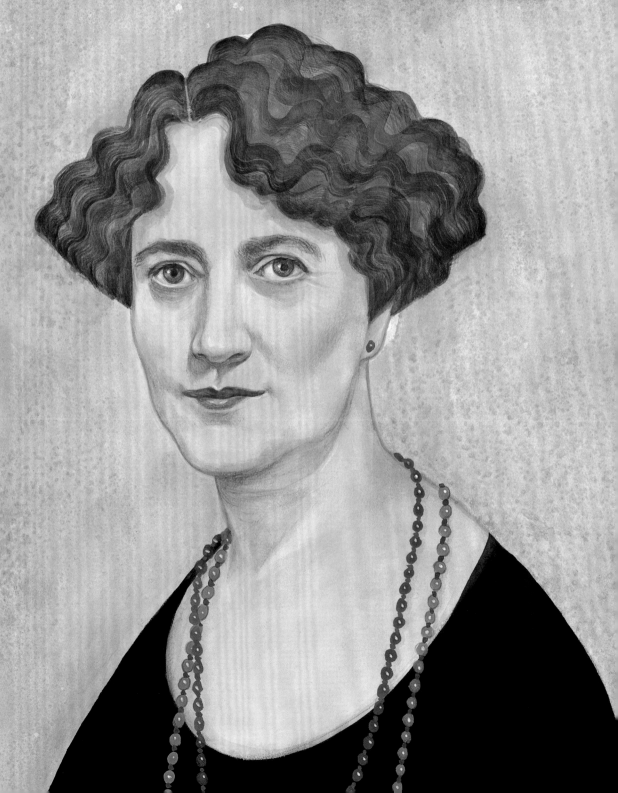

DOROTHY BROOKE

BUFFALO CALF ROAD WOMAN

(CIRCA 1850 — 1879)

was a Northern Cheyenne warrior who has become known as Custer's final foe. Her reputation for exceptional bravery and battle skills was cemented at the Battle of the Rosebud in 1876, where she dodged enemy fire to save her wounded brother, Chief Comes in Sight. Inspired by her actions, the Cheyenne warriors rallied to win the battle. New information about Buffalo Calf Road Woman's role in the Battle of the Little Bighorn came to light in 2005, when members of the Northern Cheyenne broke their vow of silence regarding the confrontation. According to their oral history, she knocked Custer off his horse and delivered the final killing blow.

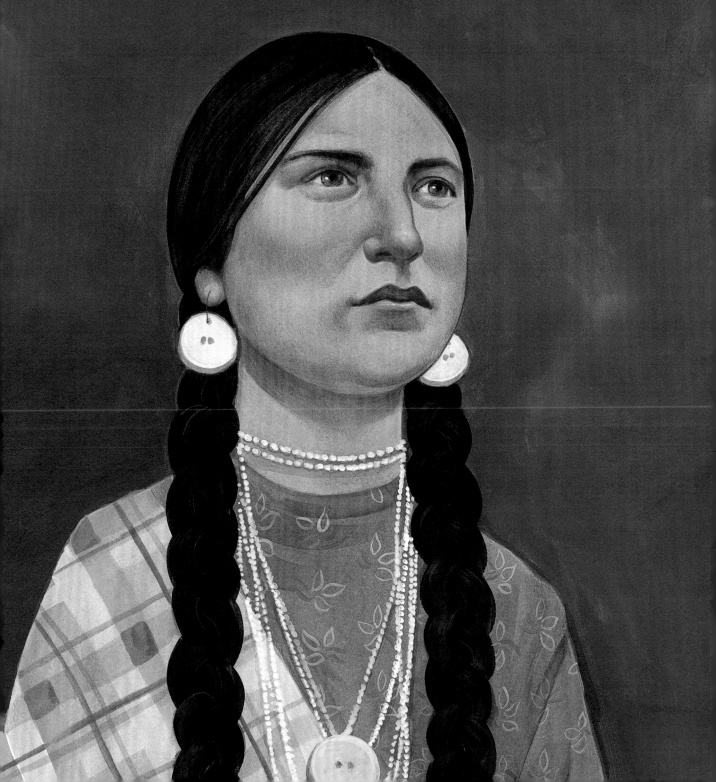

TARANA BURKE

(1973–)

is a community organizer and civil rights activist who founded the Me Too movement in 2006. Her initiative has turned into a world-wide campaign to raise awareness about sexual harassment and abuse. Burke's personal experience of abuse inspired her lifelong passion to help girls and women, particularly in marginalized communities. Although she began the movement, her role as founder was frequently overlooked until recently. As part of a group *Time* dubbed "the silence breakers," Burke was named one of its 2017 Persons of the Year.

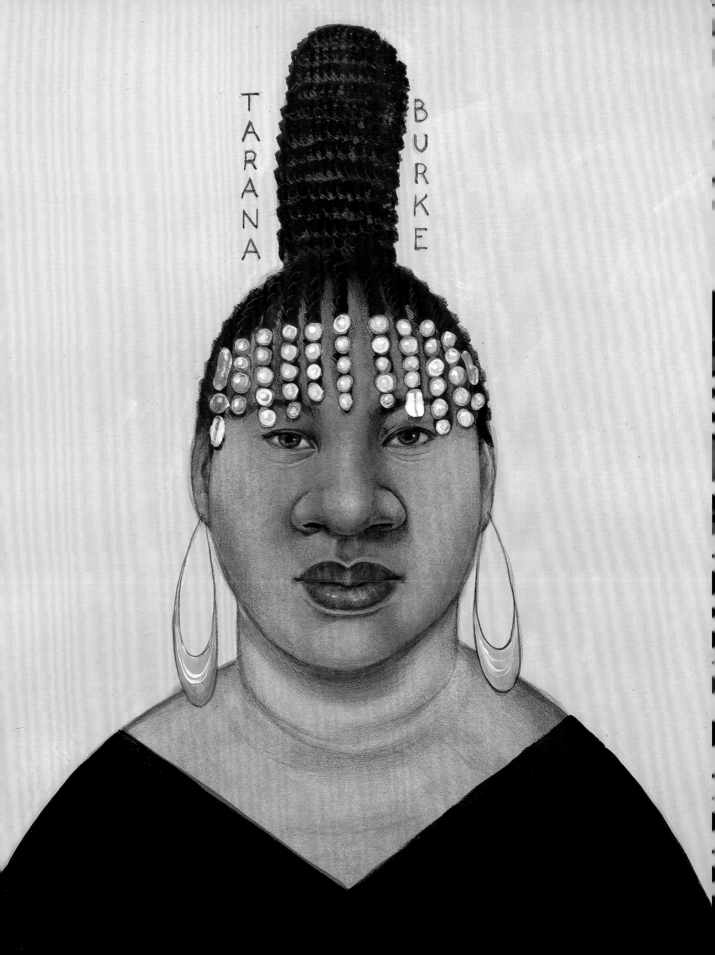
TARANA BURKE

RUTH
COKER BURKS

$(1959-)$

served as a caregiver and confidante for people with AIDS during the early years of the crisis. In the 1980s and '90s, she assisted those who had been abandoned by their families and communities and were neglected in hospitals. Burks ministered to patients, holding their hands and sitting with them for hours until their death. When she was unable to find clergy to perform graveyard services due to the stigma attached to AIDS, Burks performed her own rites and buried the ashes of about forty people in her family's cemetery plots. In total she cared for more than a thousand dying people and became known as the Cemetery Angel.

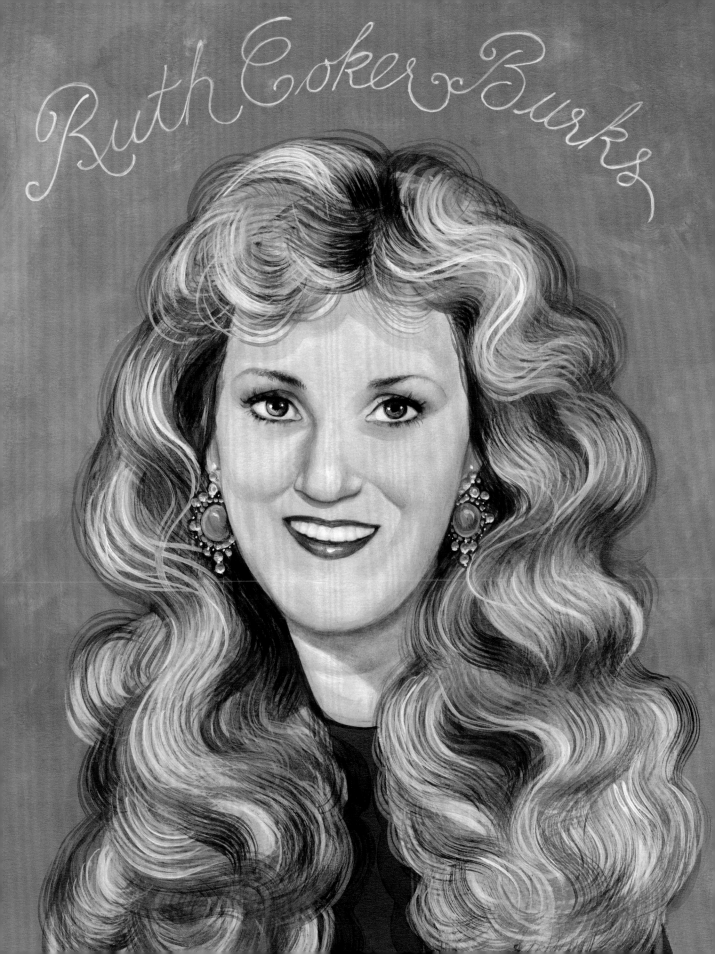
Ruth Coker Burks

MARIA CALLAS

(1923–1977)

was one of the most beloved and influential sopranos of the twentieth century. Born in the United States to Greek parents, she studied music and began singing professionally in Greece. After World War II, Callas moved to Italy, where she established herself as a soprano of the first rank. Unfortunately, as her fame grew, the press was often more fascinated with her fluctuating weight, supposedly tempestuous behavior, and love life than with her musical accomplishments. Revered for her interpretive skills, versatility, and distinctly expressive voice, Callas remains one of classical music's best-selling vocalists.

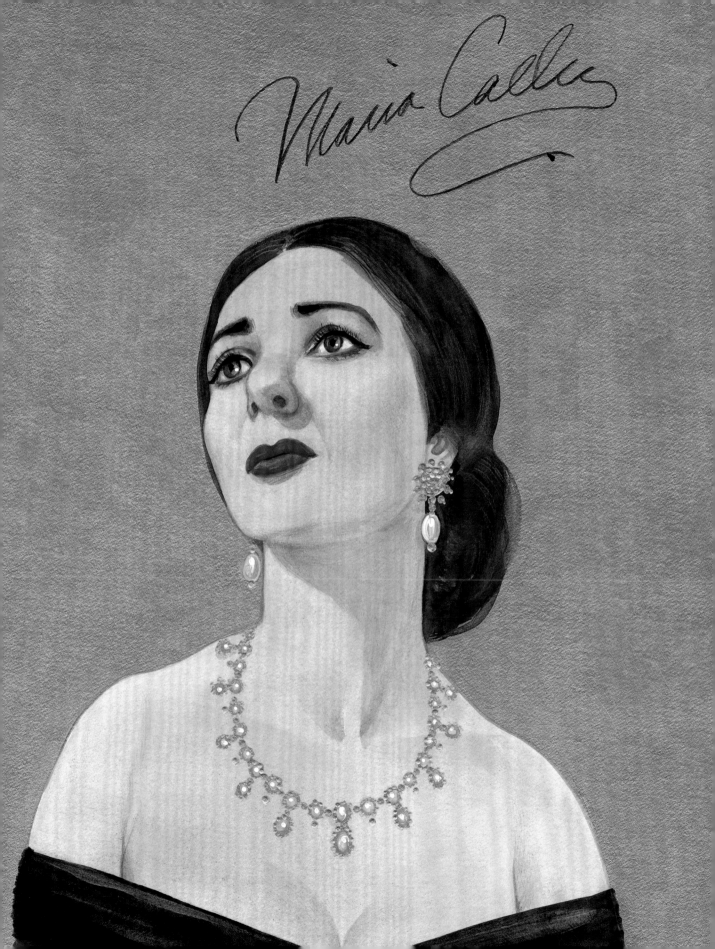

RACHEL CARSON

(1 9 0 7 – 1 9 6 4)

was an American marine biologist and author who became one of the most important figures in the modern environmental movement. Her writings, especially the book *Silent Spring*, were deeply influential in the early years of that movement and warned of the dangers to natural systems from the use of chemical pesticides. Her work inspired the movement that eventually led to the formation of the Environmental Protection Agency.

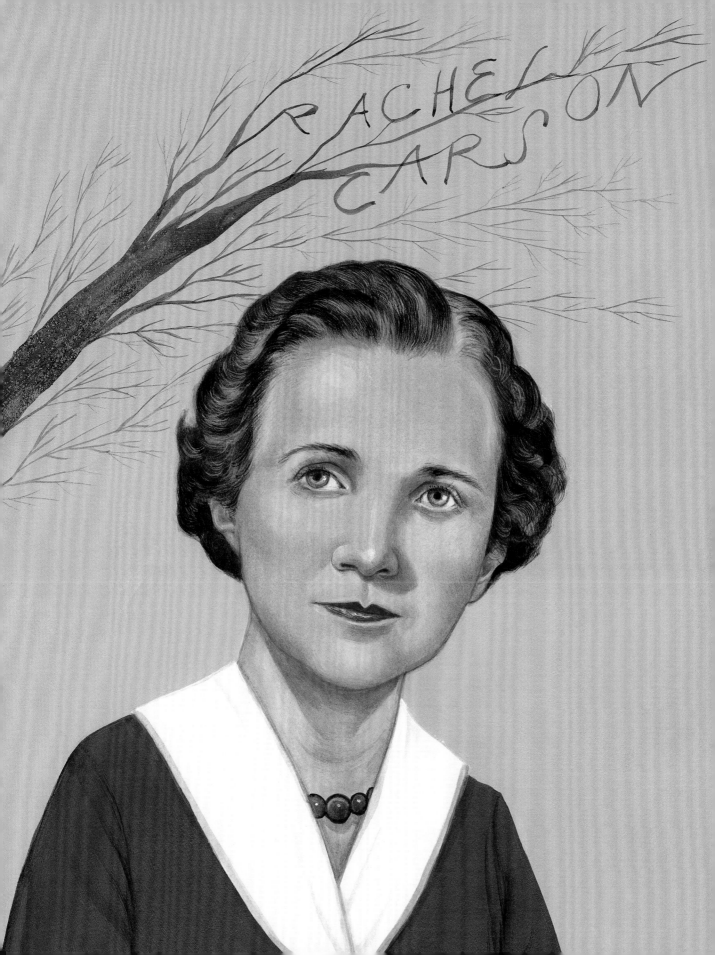

QUEEN CHARLOTTE

(1744−1818)

was England's first Black queen, through a branch of Portuguese royalty. The wife of "mad" King George III and the great-great-great-grandmother of the current queen, Elizabeth II, Charlotte bore fifteen children, thirteen of whom survived to adulthood. She was an amateur botanist and a great admirer of German composers; Mozart dedicated one of his compositions to her. Several portraits of the queen suggest African facial features, although they depict her with fair skin, as was the fashion of the time (achieved through lead paint makeup).

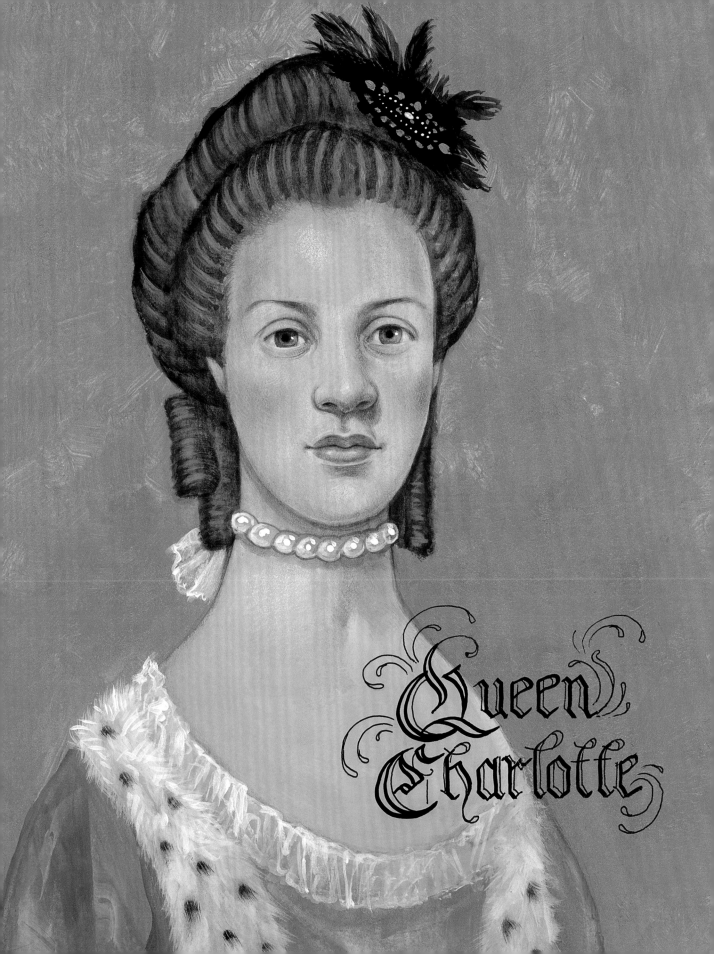

Queen Charlotte

CHING SHIH

(1775–1844)

was a pirate who terrorized the South China coast as leader of the largest pirate confederation in history. At the height of her power she commanded about seventy thousand men and twelve hundred ships. Born into poverty, Ching Shih was a sex worker who married the commander of a powerful pirate fleet. After his death, she took control of that fleet and spent the next years pillaging, looting, and generally causing mayhem. When the Chinese emperor offered amnesty to the pirates working in his territory, Ching Shih took him up on the pardon. One of her conditions was that she could walk away with her illegally gained fortune, and it was granted.

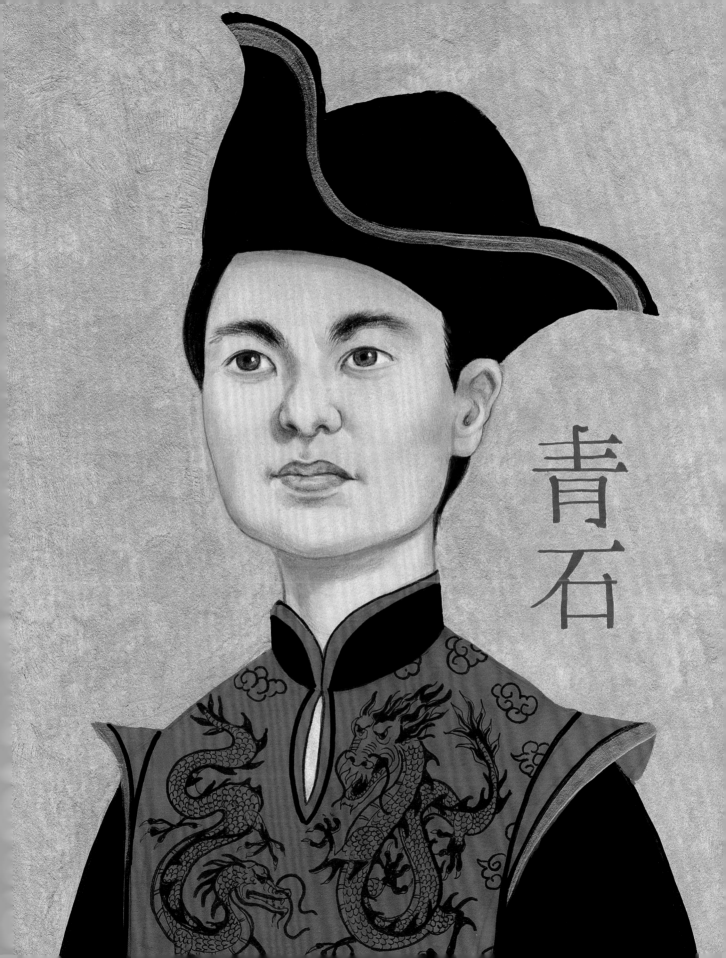

青石

SHIRLEY CHISHOLM

(1924–2005)

was an educator, politician, and author. She became the first Black woman to seek a major party's nomination for president of the United States, enduring racism, misogyny, and death threats in the process. As the first African American woman to be elected to Congress, Chisholm represented New York's Twelfth Congressional District for seven terms. When she decided to run for president, Chisholm was blocked from participating in televised primary debates. After taking legal action, she was permitted to make only one speech. President Barack Obama awarded Chisholm a posthumous Medal of Freedom in 2015.

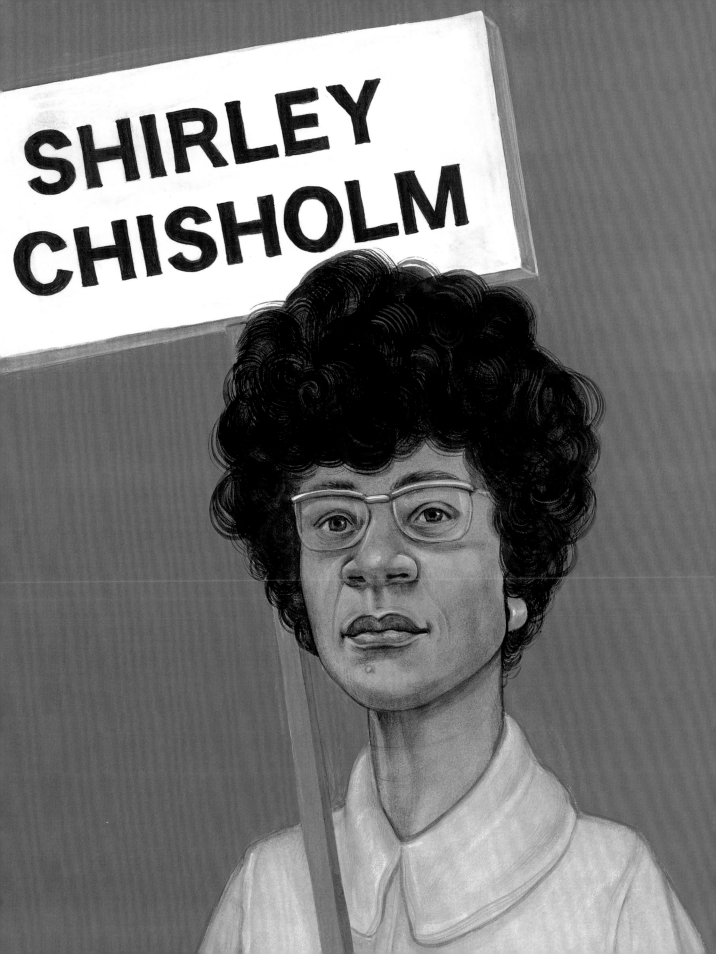

CHRISTINE DE PIZAN

(1364–CIRCA 1430)

was the first professional woman of letters in France and one of the earliest feminist authors. A prolific writer, she produced a variety of works in verse and prose, including biography and literary criticism. Much of her output, such as *The Book of the City of Ladies*, concerned the status of women. Christine critiqued the misogyny of one of the most famous books of her day in *The Tale of the Rose*, and her writing emphasized the importance of education for women. She also argued for the equality of men and women, challenging conventional thinking.

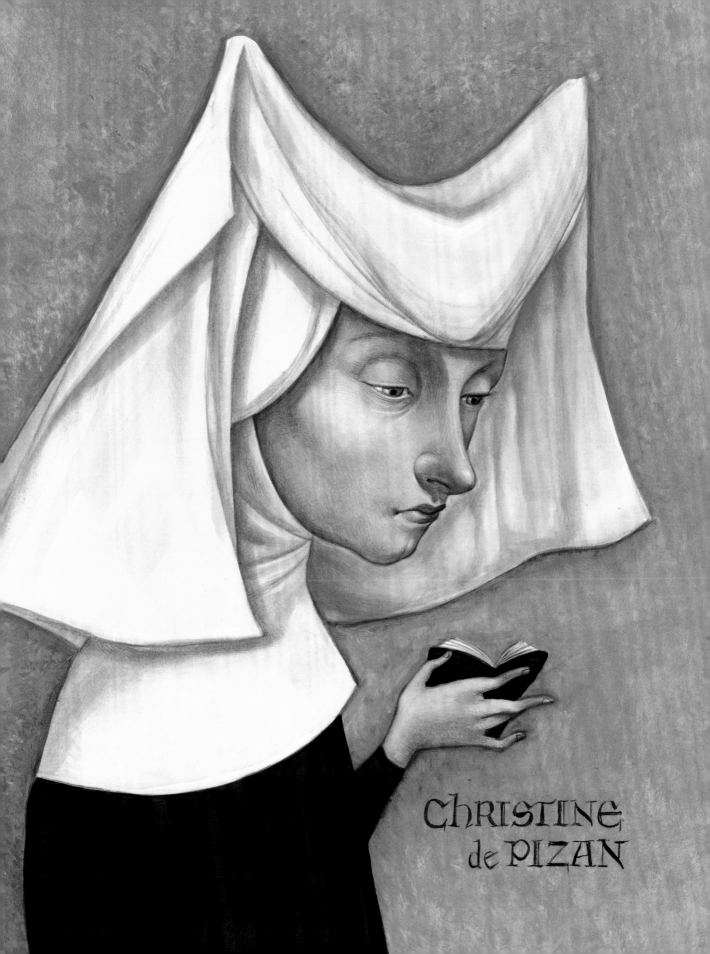

CHRISTINE
de PIZAN

CAMILLE CLAUDEL

(1 8 6 4 – 1 9 4 3)

was a brilliant French sculptor who is now recognized for her originality in depicting the human form yet died in obscurity. Her sculptures were censored for being overly sensual, and her reputation as an artist was overshadowed by her personal relationship with fellow sculptor Auguste Rodin. Critics were often cruel to her, which may have contributed to her declining mental state; after age forty, she began to show signs of mental illness. Forcibly institutionalized in 1913, Claudel remained in an asylum for thirty years, until her death.

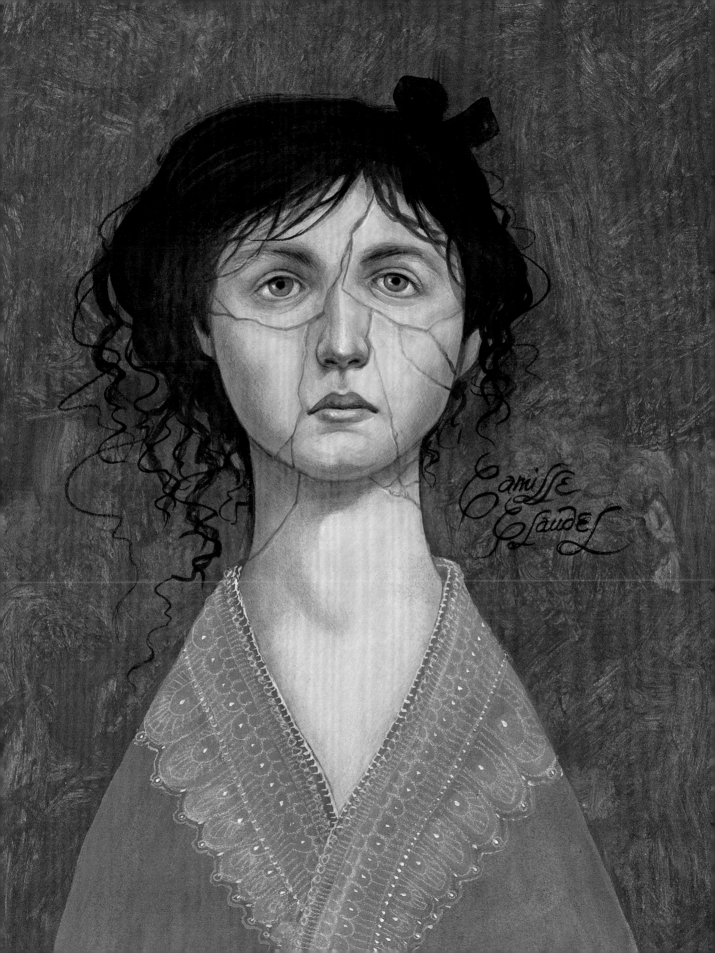

JEANNE DE CLISSON

(1300–1359)

known as the Lioness of Brittany, was a noblewoman and aristocrat who became a ruthless pirate. She swore revenge upon the French for the murder of her third husband, who was executed by order of the French king Philip VI after being accused—falsely, she believed—of treason. De Clisson raised a small army of troops and began attacking castles and villages. Her three warships, painted black with red sails, were known as the Black Fleet. She sailed the English Channel for thirteen years and targeted French ships, slaughtering crew members and leaving few alive to tell the tale.

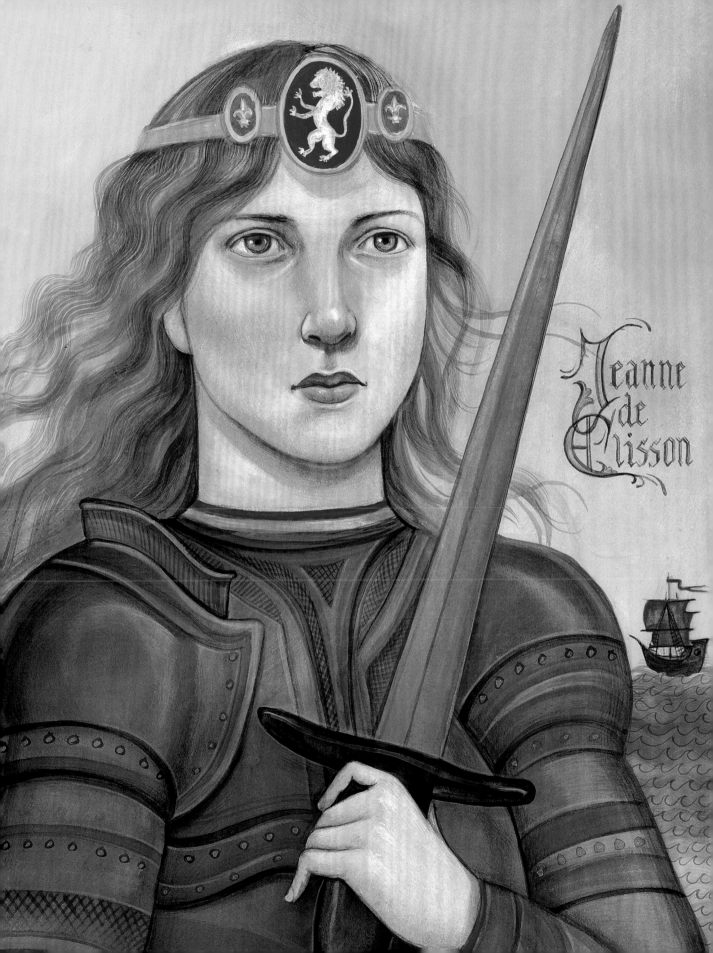

Jeanne de Clisson

NADIA COMANECI

(1 9 6 1 –)

became the first gymnast ever to score a perfect 10, at age fourteen, in the 1976 Olympic Games in Montreal. At the time, perfect scores were considered unachievable. The Romanian athlete received seven 10s in total, winning gold medals for the uneven bars, the balance beam, and the individual all-around competition. At the 1980 Olympic Games in Moscow, she won two gold and two silver medals. Comaneci retired from the sport in 1984 and defected to the United States in 1989.

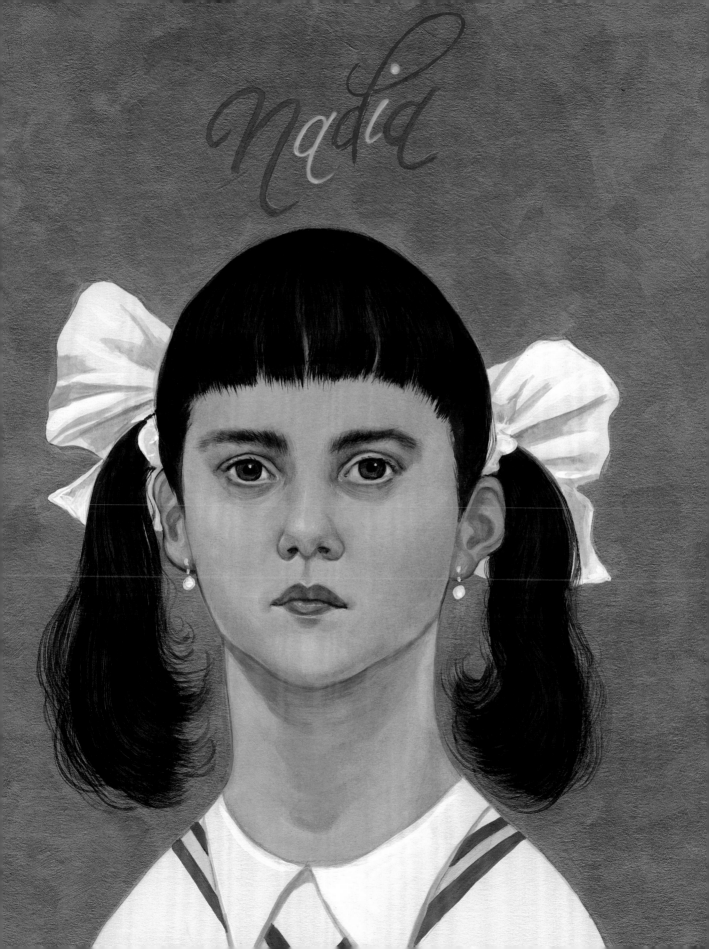

MISTY
COPELAND

(1 9 8 2 –)

is a renowned American ballerina. In 2015 she became the first African American woman to be promoted to principal dancer by the American Ballet Theatre in the company's seventy-five-year history. Considered a prodigy, Copeland has earned a number of prestigious awards. In 2014, President Barack Obama appointed her to the President's Council on Fitness, Sports and Nutrition. Copeland is also a best-selling author. *Time* magazine named Copeland to its 100 Most Influential People list in 2015.

misty copeland

DOROTHY COTTON

(1930–2018)

was one of the most important unsung heroes of the American civil rights movement. A close aide to Dr. Martin Luther King Jr., she was an activist and served for twelve years as the education director of the Southern Christian Leadership Conference. Her greatest achievement was her work with the Citizenship Education Program, which helped African Americans register to vote at a time when most southern states made that difficult through a variety of tactics, including literacy tests that were designed to disqualify them. A confidante of Dr. King's, she typed his "I Have a Dream" speech and accompanied him to Oslo to receive his 1964 Nobel Peace Prize. While acknowledging some progress toward racial justice in a 2009 interview, Cotton added, "That still does not mean we have reached the Promised Land."

MARIE SKŁODOWSKA CURIE

(1867–1934)

was a pioneering physicist and chemist. Unable to obtain a higher education in her native Poland due to her gender, she moved to Paris to study at the Sorbonne. She initially worked in partnership with her husband, Pierre Curie, and after his death, she continued her research on her own. She was the first woman to win two Nobel Prizes: one in physics, together with her husband for developing the theory of radioactivity, and a second in chemistry for her discovery of polonium and radium. She advanced not only science but also women's place in the scientific community. Her death by aplastic anemia is believed to have been caused by prolonged exposure to radiation.

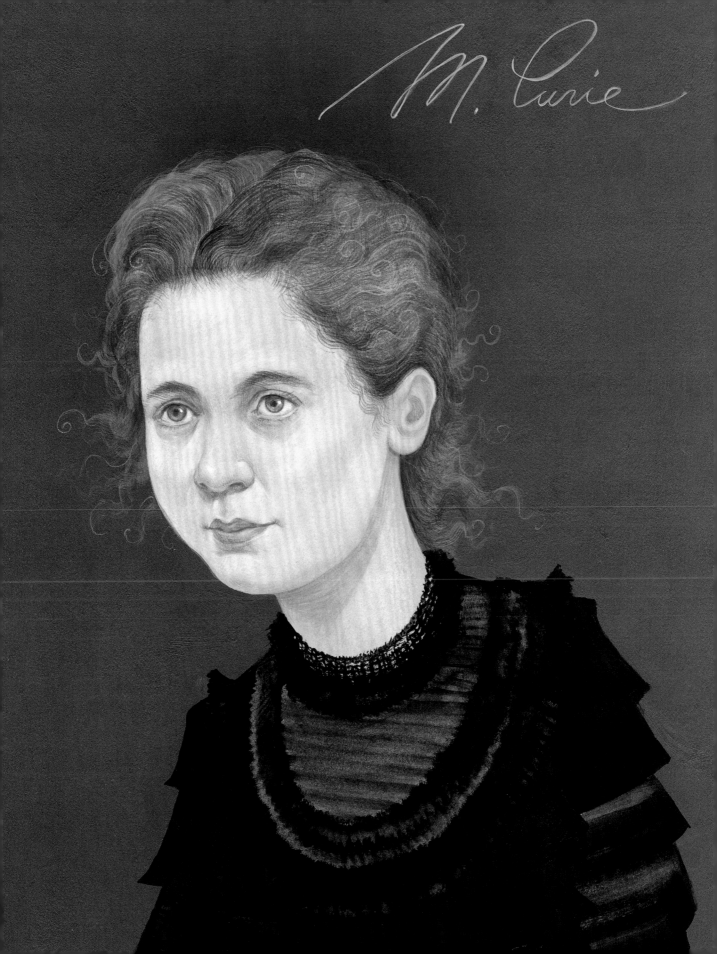

M. Curie

ANGELA DAVIS

(1 9 4 4 –)

is an American political activist, philosopher, academic, and author.
Davis was a member of the Communist Party and a supporter of
the Los Angeles chapter of the Black Panther Party. She has had a
long academic career and has published books on class, feminism,
race, and prison reform. In 2019 she was inducted into the National
Women's Hall of Fame, and in 2020 she was included in *Time* maga-
zine's 100 Women of the Year list of the most influential women of
the past century, for the year 1971.

ANGELA DAVIS

STORMÉ DeLARVERIE

(1 9 2 0 – 2 0 1 4)

was an American drag performer and civil rights activist. Some claim she threw the first punch that started the Stonewall uprising in New York City. A biracial entertainer, she performed at venues in Europe and the United States and became a style icon for wearing her elegant, dandyish suits. For years she patrolled the streets of Greenwich Village as a self-appointed guardian of her fellow lesbians. DeLarverie also organized and performed at benefits for battered women and children. An MC, bouncer, singer, and volunteer, she is remembered as the Rosa Parks of the gay community.

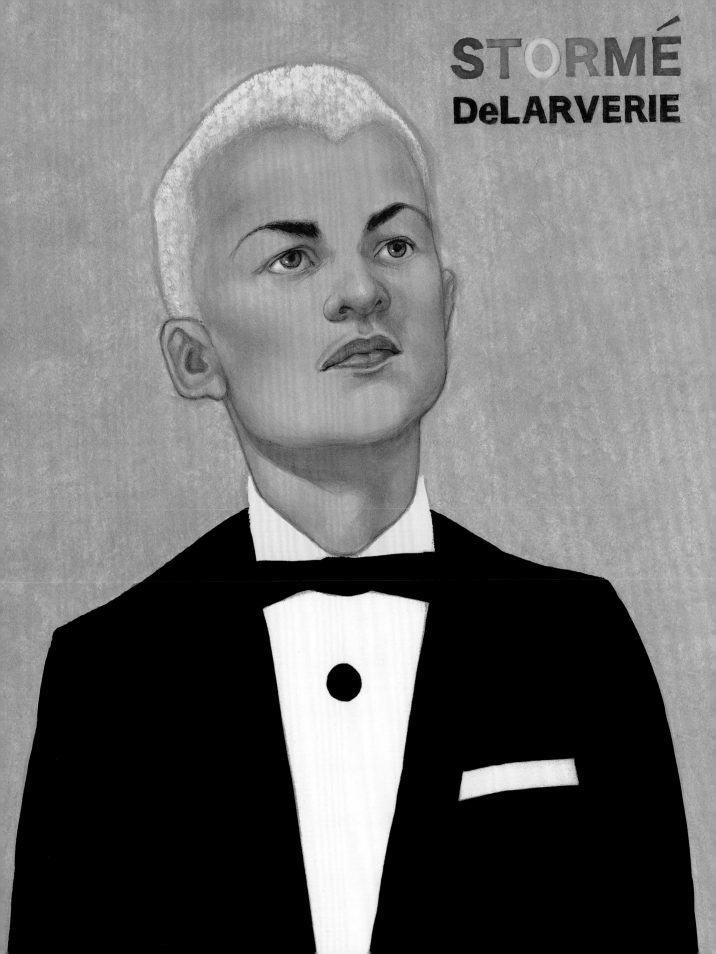

STORMÉ
DeLARVERIE

ISADORA DUNCAN

(1877 OR 1878–1927)

was an innovative American dancer who paved the way for modern expressive dance. She rejected the rigid, structured form of ballet of the time for a more free-form and instinctive style of movement. She often danced in a simple white tunic and performed barefoot. She was unconventional in her personal life as well, eschewing marriage and defying social taboos. She toured internationally from her early twenties until her tragic accidental death at age fifty in a car accident.

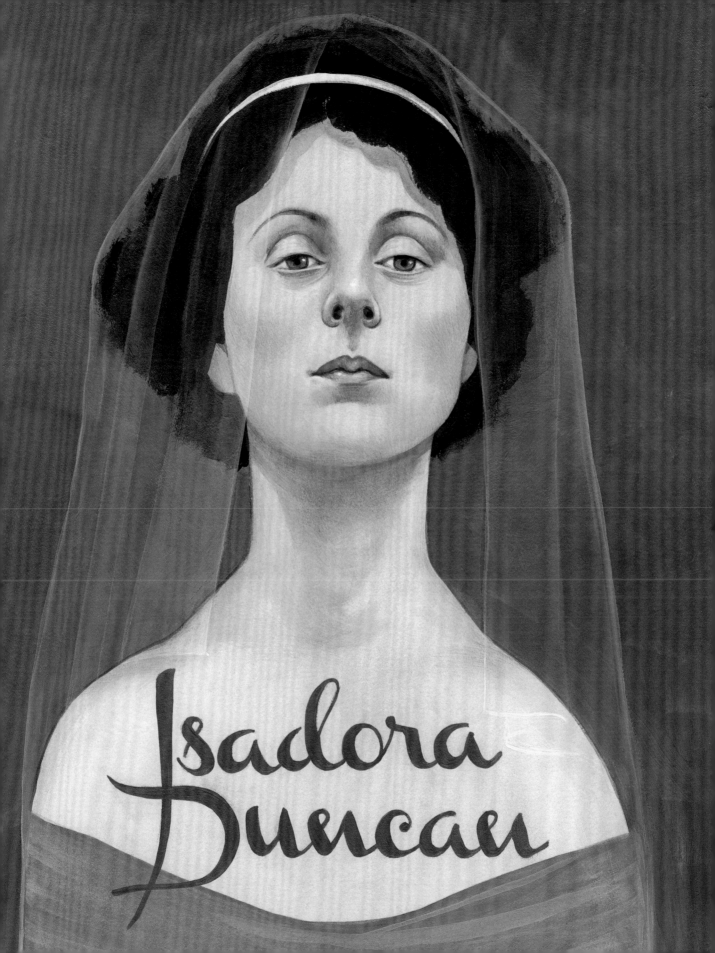

Isadora Duncan

RAY KAISER EAMES

(1912–1988)

was a groundbreaking American artist, designer, and filmmaker and an important figure in twentieth-century design. At the beginning of her career, she exhibited as an abstract painter. Her graphic design work included magazine covers, posters, and advertising; she also designed textiles. Working in collaboration with her husband, Charles Eames, she made significant contributions to the fields of architecture, furniture design, industrial design, manufacturing, and the photographic arts. Although she was not widely celebrated in her lifetime, her husband, Charles, acknowledged her talent, saying, "Anything I can do, Ray can do better."

ray eames

QUEEN ELIZABETH I

(1533−1603)

ruled over England during a period when the arts flourished and that country was a major political and commercial power. The last of the five monarchs of the House of Tudor, she never married and is sometimes called the Virgin Queen. Her reign is referred to as the Elizabethan age. Elizabeth presented herself as devoted to the well-being of her subjects above all else. As a woman ruler in a patriarchal world, she proclaimed, "I know I have the body of a weak and feeble woman but I have the heart and stomach of a king, and of a king of England too."

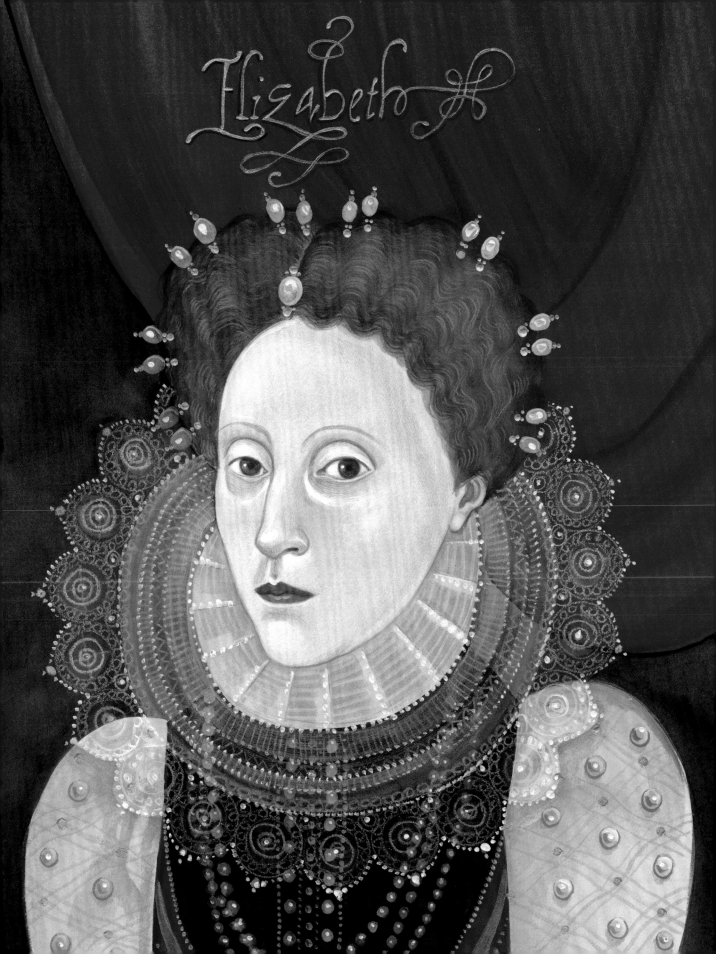

SAINT ELIZABETH OF HUNGARY

(1207–1231)

was born a princess and gave up her wealth, status, and possessions to care for the poor and needy. She liquidated her properties to build a hospital, where she nursed the sick and dying. Although her health began to deteriorate in her early twenties, Saint Elizabeth continued her work while living with great austerity. She died at twenty-four, was canonized in 1235, and is the patron saint of the Secular Franciscan Order, as well as brides, bakers, beggars, and charities, among others.

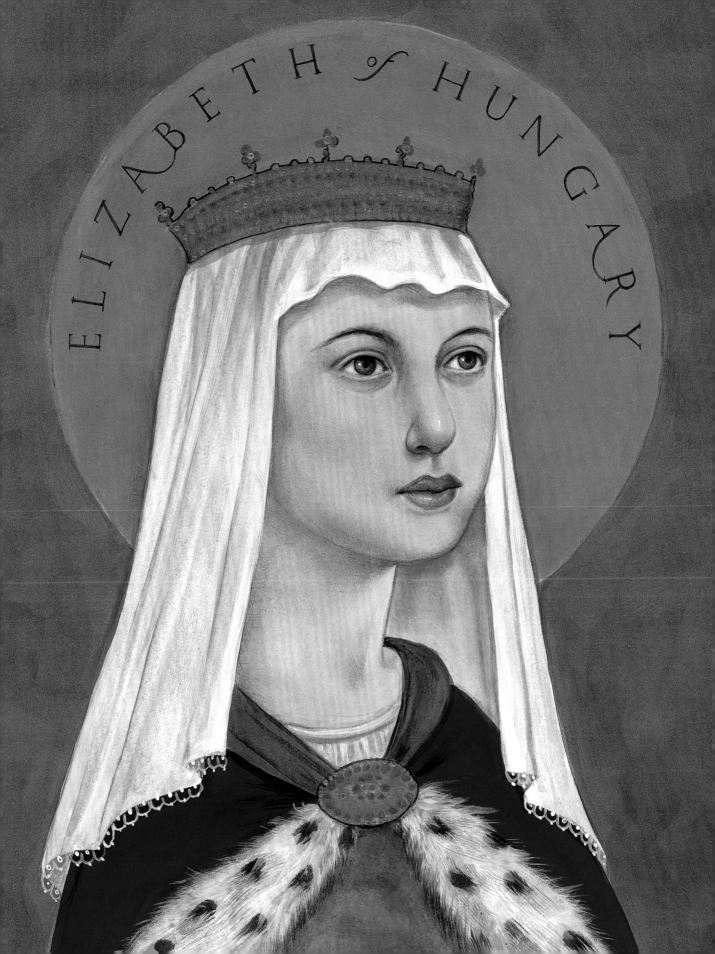

CHARLOTTE FIGI

(2 0 0 6 – 2 0 2 0)

was an American girl with a rare form of epilepsy who became a symbol of the possibilities of medical cannabis. Diagnosed in infancy with Dravet syndrome, by age five Figi was experiencing up to three hundred seizures per week and was confined to a wheelchair. Her plight inspired a group of Colorado hemp growers who were developing a particular strain of medical cannabis, and her parents tried it as a last resort. After taking the CBD oil extracted from their plants, she experienced far fewer seizures, which freed her to play, eat, and live like most children. Figi thrived until April 2020, when she died, possibly from complications related to COVID-19.

charLottefigi

EUNICE NEWTON FOOTE

(1819–1888)

an American amateur scientist, was the first person on record to link carbon dioxide and increased temperatures, laying the foundation for an understanding of the greenhouse gas effect. However, her achievements were largely forgotten. In the 1850s, Foote conducted experiments to study the warming effect of sunlight on different gases. Unfortunately, her work would be eclipsed three years later, when the Irish physicist John Tyndall made similar discoveries, apparently without knowing of her research. As a professional scientist, he had superior resources and was able to take his research further and claim ownership. Overlooked in her day, Foote has only recently been celebrated for her discovery.

EUNICE NEWTON FOOTE

ANNE
FRANK
(1929−1945)

was a German-born Jewish girl who wrote an insightful diary documenting her experiences while in hiding in Nazi-occupied Amsterdam during World War II. To avoid persecution, she and her family lived for 761 days in the Secret Annex of rooms in a building that contained offices and a warehouse. Their hiding space was in a sealed-off area with an entrance behind a concealing bookcase. Nobody knows who betrayed the family, but the Gestapo ultimately discovered them and sent the Franks to the Auschwitz death camp. Anne and her sister, Margot, were later transferred to the Bergen-Belsen camp, where they both died, probably of typhus, about two months short of the British liberation of the camp.

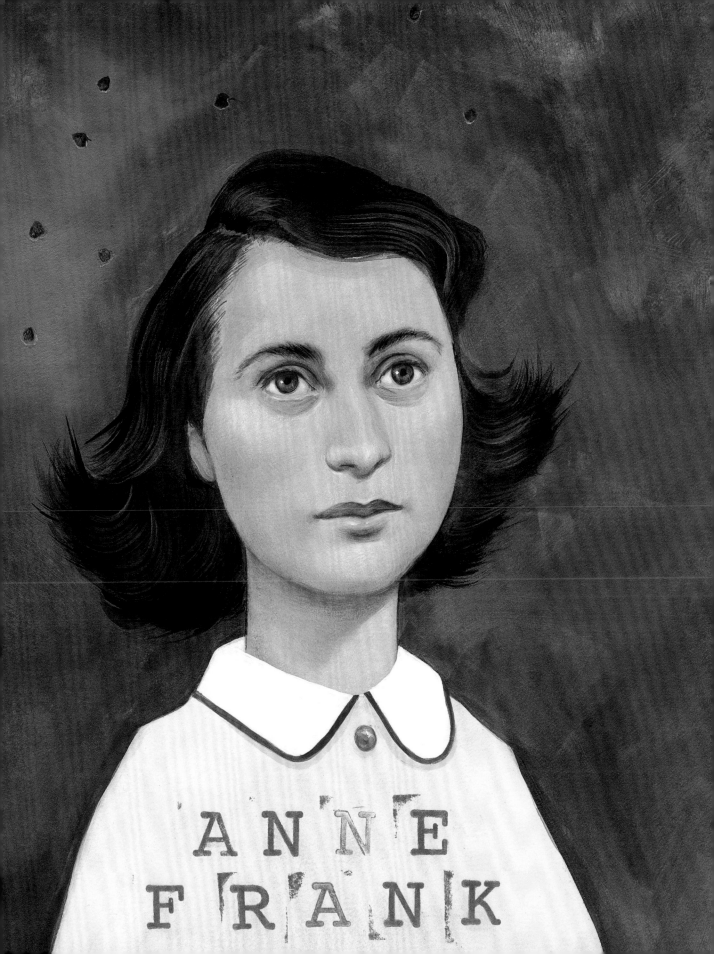

ROSALIND FRANKLIN

(1920–1958)

was an English chemist who used X-rays to take pictures of DNA that would pave the way for modern molecular biology. Her work was also central to the understanding of the molecular structures of RNA, viruses, coal, and graphite. One of Franklin's images of DNA served as the basis for the development of the double helix model by James Watson and Francis Crick. It is said that she was considered a "difficult" woman and her discoveries were minimized due to the rampant sexism in the scientific field. Watson, Crick, and Maurice Wilkins received the Nobel Prize in 1962 for their work on the structure of DNA, but Franklin had died of cancer at age thirty-eight four years earlier.

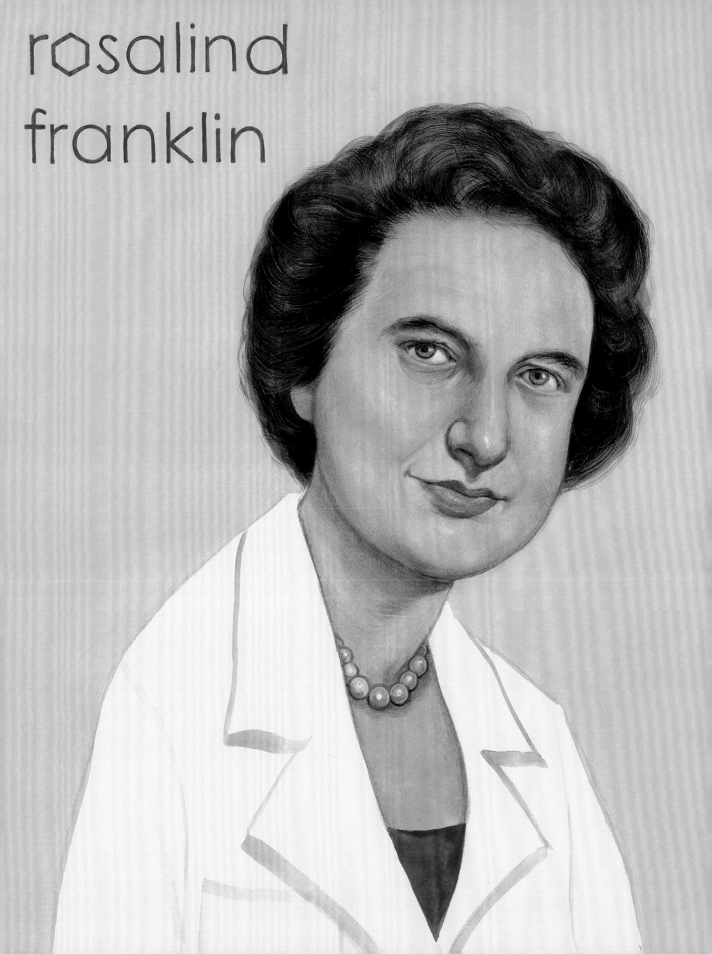

rosalind franklin

BARONESS ELSA VON FREYTAG-LORINGHOVEN

(1874–1927)

was a German-born avant-garde artist who may have created the famous artwork *Fountain* (a urinal), often attributed to Marcel Duchamp. Her authorship of this pivotal work of art, if true, would challenge Duchamp's reputation as the father of modern conceptual art. Duchamp wrote in a letter to his sister that a female friend had adopted the pseudonym Richard Mutt (as the piece is signed) and sent in a porcelain urinal as a sculpture to a New York art exhibit. The claim of her authorship remains controversial.

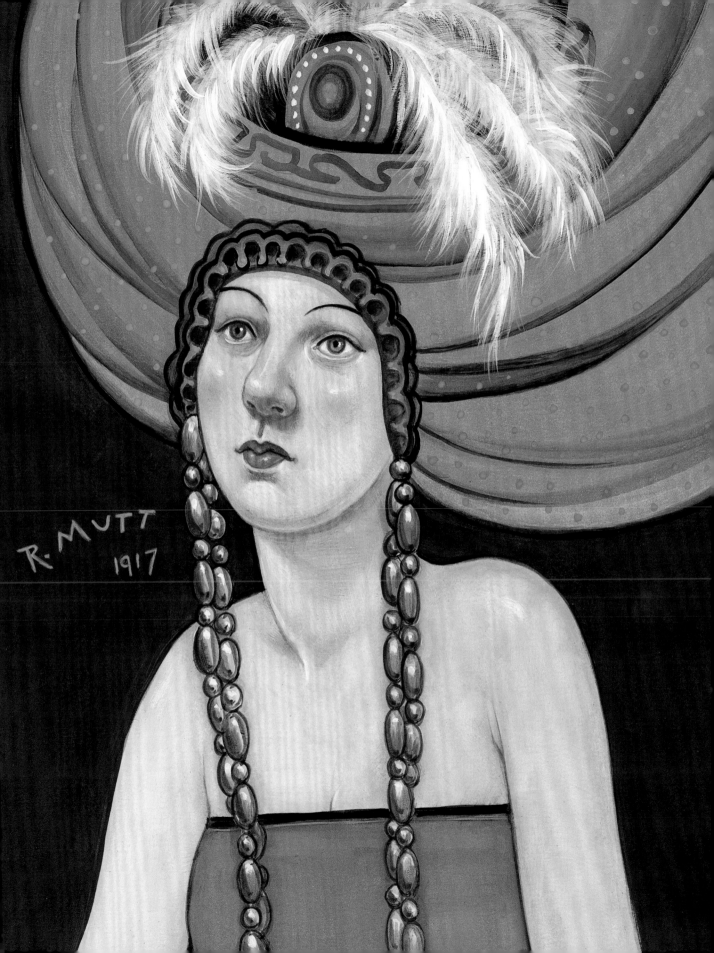

ELIZEBETH FRIEDMAN

(1 8 9 2 – 1 9 8 0)

America's first female cryptanalyst, helped smash Nazi spy rings in World War II. She and her team of cryptanalysts honed their skills while working for the U.S. government deciphering bootleggers' encoded messages during Prohibition. They remained the government's primary codebreakers and solved many cipher systems used by the Germans and their allies during World War II, decoding more than four thousand messages sent on forty-eight different radio circuits. She has received significant posthumous recognition.

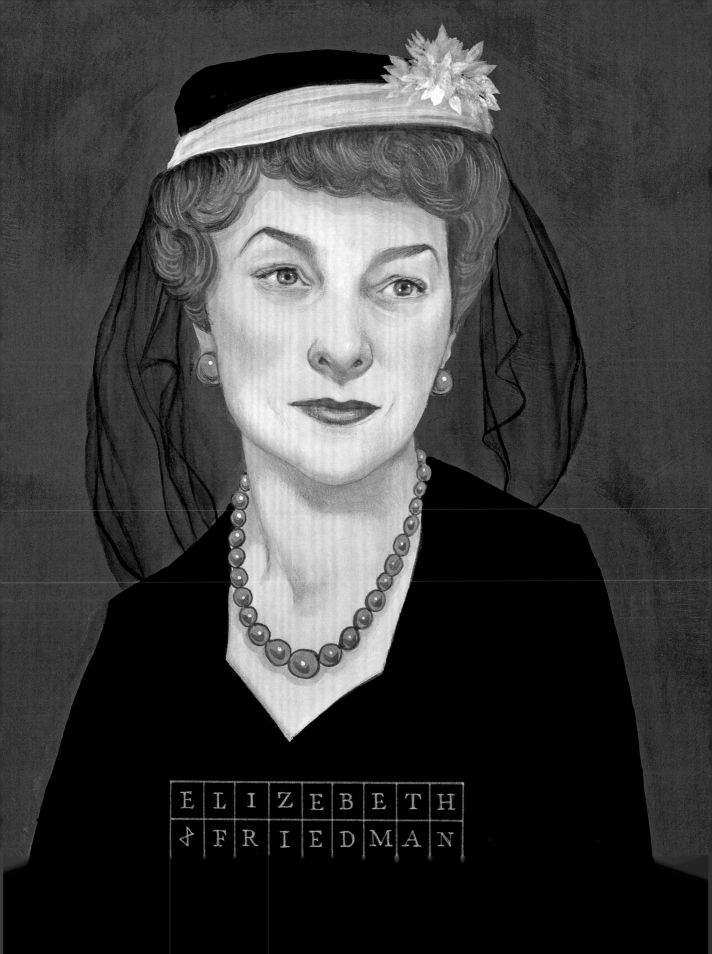

ELIZEBETH ♪ FRIEDMAN

JEANNE GENEVIÈVE LABROSSE GARNERIN

(1775–1847)

was a French balloonist, parachutist, and aviation pioneer. The first woman to pilot a balloon solo and the first woman to parachute from an altitude of three thousand feet, she completed many descents in towns across France and other European countries. In 1802 she filed an application on behalf of her husband, the balloonist André-Jacques Garnerin, for the frameless parachute, intended to "slow the fall of the basket after the balloon bursts," indicating how the descents were actually accomplished. She is believed to have made a parachute descent estimated at eight thousand feet, an extraordinary achievement for the time.

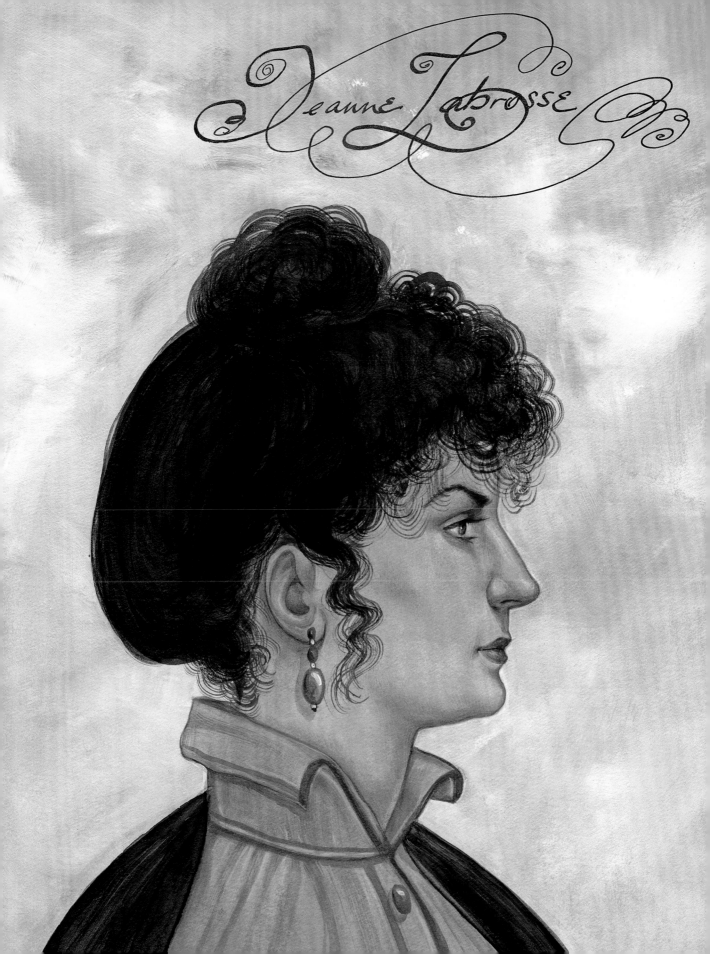

Jeanne Labrosse

ALICIA GARZA

(1981–)

is an activist and writer who cofounded the Black Lives Matter move-ment along with Patrisse Cullors and Opal Tometi. They mobilized after George Zimmerman was acquitted of murder in the death of seventeen-year-old Trayvon Martin in July 2013; at that point Gar-za's activism had already spanned two decades. The movement has changed the course of history, amplifying issues such as racial injus-tice in America and police brutality. In 2020, Garza was named as one of *Time* magazine's 100 Most Influential People of 2020. She was also included on the BBC's *100 Women* list the same year.

#ALICIAGARZA

RUTH
BADER GINSBURG
(1 9 3 3 – 2 0 2 0)

was the second woman to serve on the U.S. Supreme Court and has become a feminist icon. At Harvard Law School, where she was one of only nine women in a class of five hundred, Ginsburg excelled academically. She received her first judicial appointment in 1980, having taught at the Columbia and Rutgers schools of law. As an attorney she argued landmark equality cases that notably challenged laws that contributed to the marginalization of women. She faced sexism throughout her career but Ginsburg remained an outspoken voice for gender equality and civil rights and liberties. She was affectionately referred to as the Notorious RBG.

MARTY GODDARD

(1941–2015)

was a victims' rights advocate who invented the rape kit, which is used to collect forensic evidence from rape victims in order to identify their perpetrators. She took her idea to Louis R. Vitullo, who was working in the police crime lab in Chicago. He dismissed her and, according to a colleague, even yelled at her. Vitullo then proceeded to develop a kit very similar to hers and take credit for it. Only recently has Goddard been identified as the originator of this important tool. She continued to advocate for sexual assault victims but lived her later life in obscurity.

MARTY
Goddard

AMANDA GORMAN

(1 9 9 8 –)

is a writer and activist who made history as the United States' youngest inaugural poet. She read a five-minute poem titled "The Hill We Climb" at the Biden-Harris inauguration ceremony, earning international praise. Gorman overcame a speech impediment as a child and began writing at a young age. In 2014 she was named Youth Poet Laureate of Los Angeles, and three years later she became the country's first National Youth Poet Laureate. A cum laude graduate of Harvard University, Gorman addresses social issues such as feminism and racism in her poetry and activism. She looks forward to someday running for president.

Amanda Gorman

OLYMPE DE GOUGES

(1 7 4 8 − 1 7 9 3)

was a French writer and social reformer who advocated for equal rights for women and was the author of the pamphlet *Declaration of the Rights of Woman and of the Female Citizen*. She also favored allowing citizens to choose their form of government via referendum and vehemently opposed the slave trade in the French colonies. After the fall of her political party, the Girondins, in the summer of 1793, she was arrested, subjected to a mock trial, and sent to the guillotine.

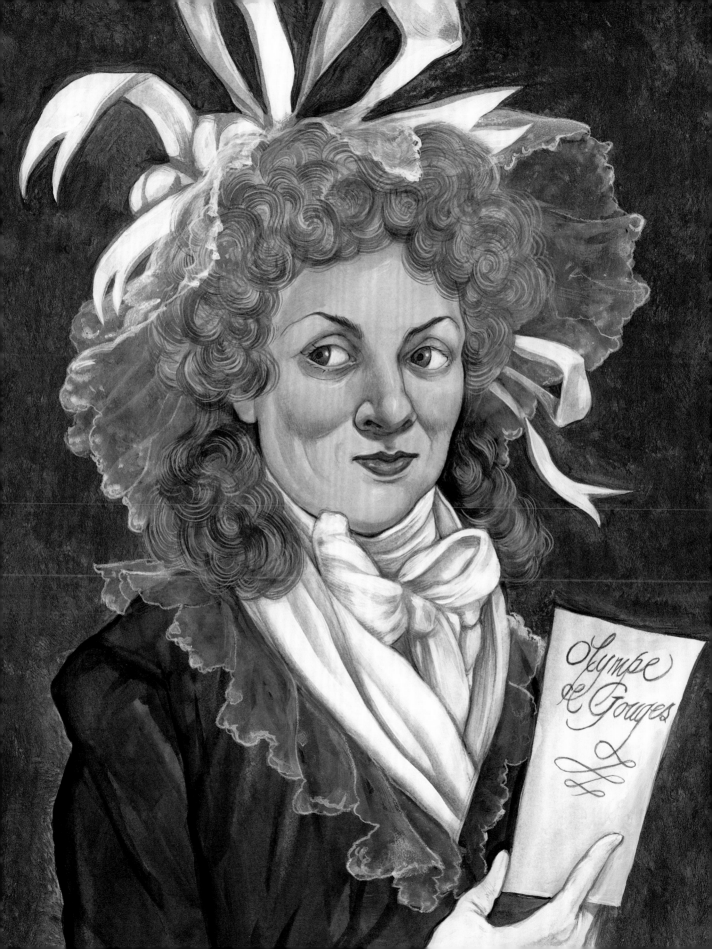

TOMOE GOZEN

(CIRCA 1157–CIRCA 1247)

is a legendary heroine and the subject of much speculation, a fearsome Japanese samurai warrior known for her valor. Most samurai at the time were men, but evidence now exists that there were more women in Japanese armies than long thought. Whether she actually existed remains a mystery, but today she is celebrated as a heroine of Japanese culture and has been the subject of TV shows, manga, video games, and novels.

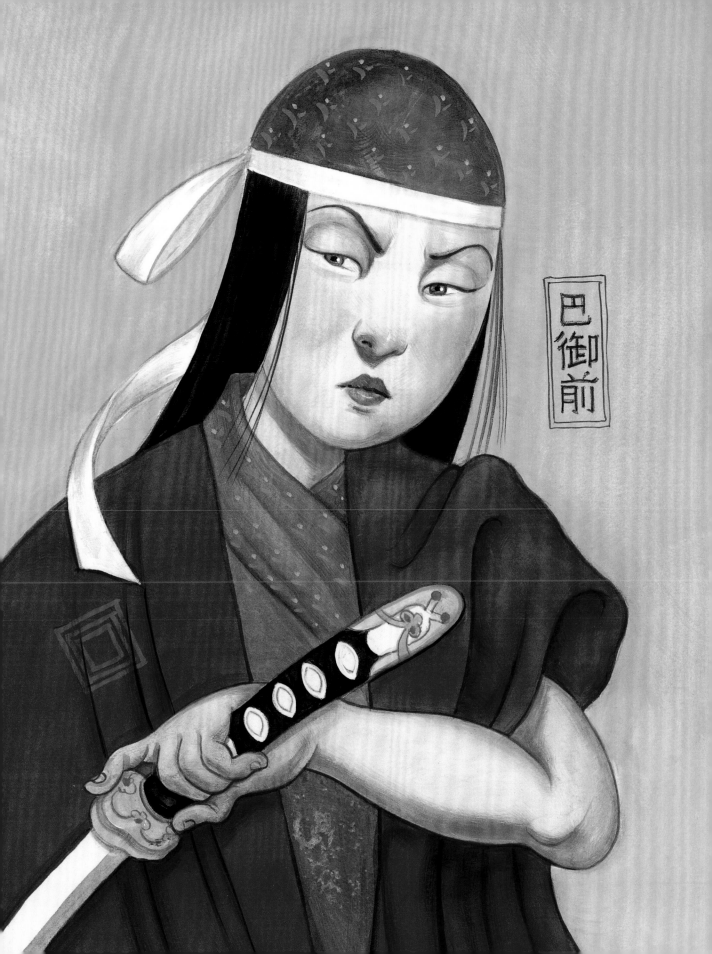

巴御前

TEMPLE
GRANDIN

(1 9 4 7 –)

is an animal behavior expert who is on the autism spectrum. She has developed a more humane approach to slaughtering livestock and serves as a consultant to the livestock industry. A professor of animal sciences at Colorado State University, Grandin is also a spokesperson on autism and an advocate for neurodiversity. Her 2010 TED Talk, "The World Needs All Kinds of Minds," has been viewed more than six million times.

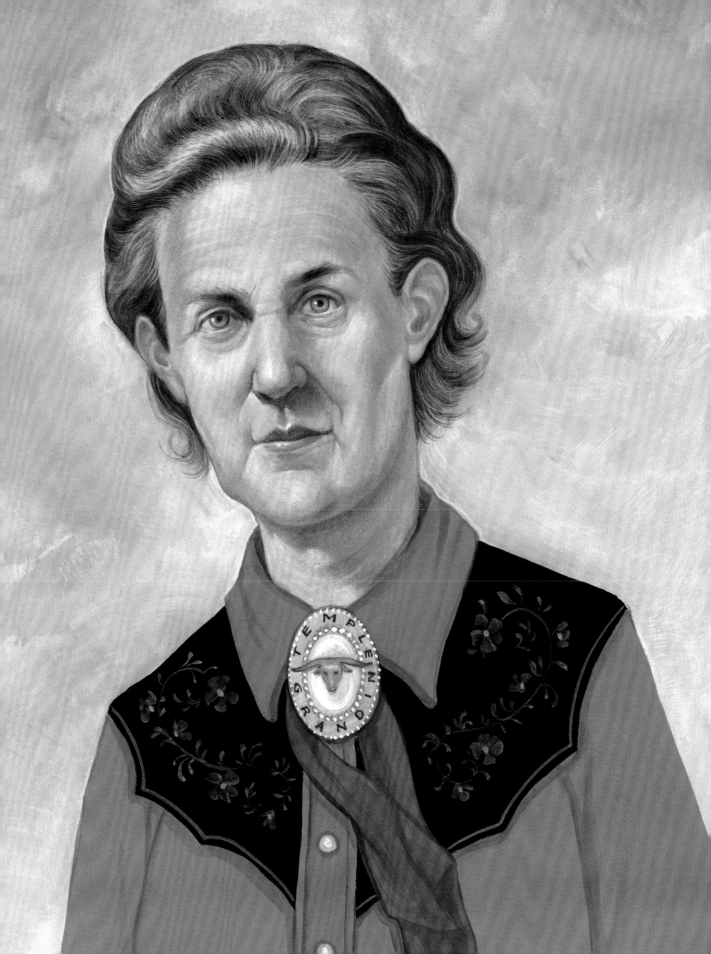

EILEEN GRAY

GRAY

(1878–1976)

was an Irish-born architect and furniture designer who embraced modernism; her furniture's structure and materials, including chrome steel and glass, were revolutionary. She later created one of the most iconic buildings of the modernist movement, the villa E-1027 on the French Riviera. For many years the building was credited to the architect Jean Badovici, Gray's ex-lover, or even Le Corbusier; only in 1967 was she acknowledged as the primary creator.

EILEEN GRAY

ELIZABETH TAYLOR GREENFIELD

(CIRCA 1820−1876)

known as the Black Swan, was born into slavery in Mississippi and became the most widely known Black concert artist of her time. Her family moved to Philadelphia, where they were emancipated. Her mother and sisters moved on to Liberia, but Greenfield remained in Philadelphia to study music. She began singing for private audiences and performed her first concert in Buffalo in 1851. At Metropolitan Hall in New York City, Greenfield sang in front of an all-white audience of four thousand. She later traveled to London, where she gave a command performance for Queen Victoria at Buckingham Palace, becoming the first African American concert artist to perform before British royalty.

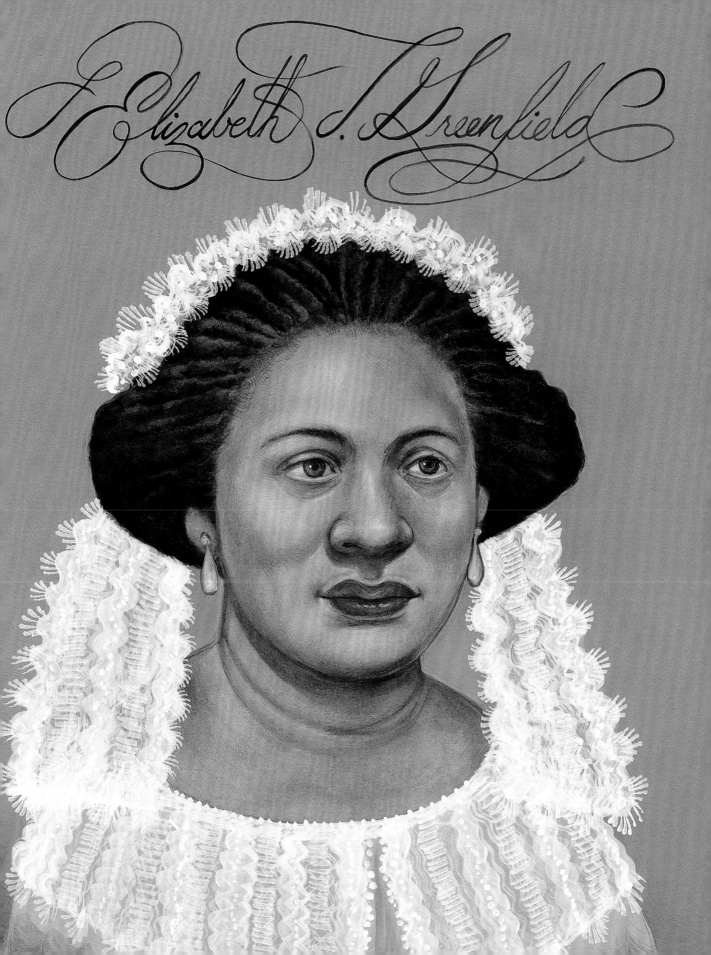
Elizabeth T. Greenfield

GUERRILLA GIRLS

(1985–)

is an anonymous group of feminist artists that formed in New York City to fight sexism and racism in the art world. To maintain their anonymity, members of the group wear gorilla masks in public, and some go by the names of dead female artists. The Guerrilla Girls employ statistics, eye-catching visuals, and humor in their activism. In 2014 the Whitney Museum of American Art acquired the group's portfolio of eighty-eight posters and ephemera from 1985 to 2012. They continue their activism to this day.

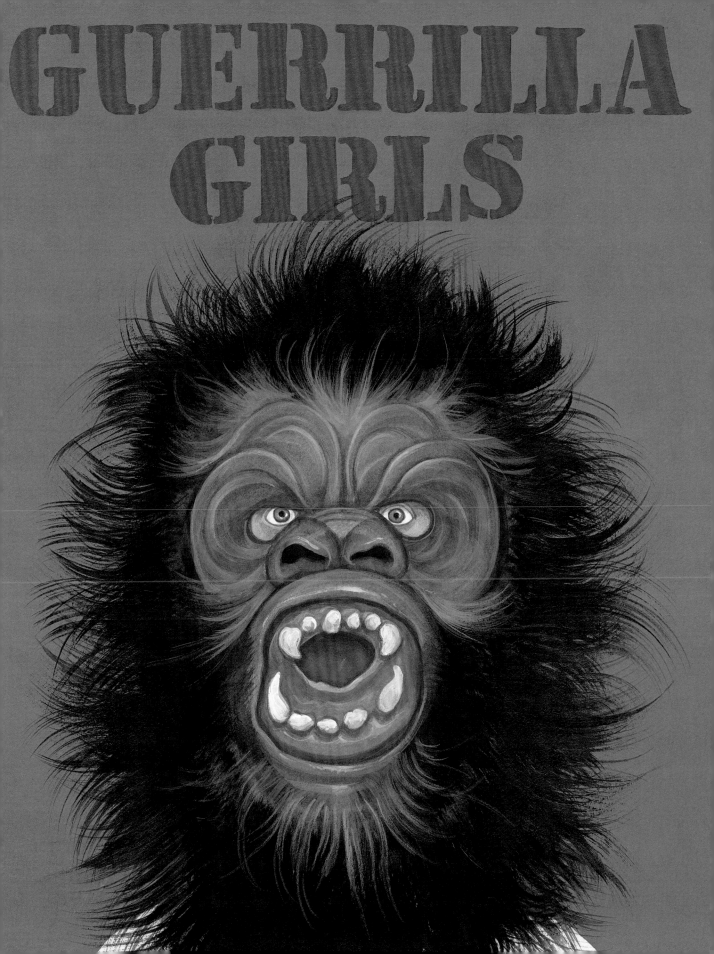

MARGUERITE "PEGGY" GUGGENHEIM

(1898–1979)

was a socialite, gallerist, art collector, and bohemian. Born into the wealthy New York City Guggenheim family, she began to acquire paintings and sculptures after receiving an inheritance, becoming a patron of up-and-coming abstract expressionist artists. She opened galleries in Paris and New York and eventually opened a museum in her palazzo on the Grand Canal in Venice, which housed her collection of art. The Peggy Guggenheim Collection continues to attract visitors from around the world today.

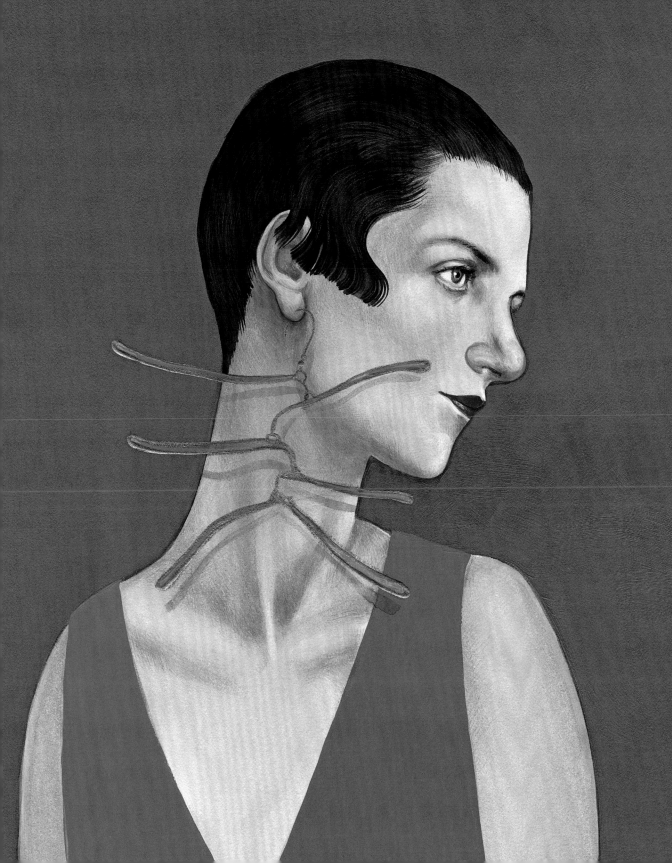

PEGGY GUGGENHEIM

LORRAINE HANSBERRY

(1930–1965)

was a writer, a civil rights activist, and the first African American woman to have a play performed on Broadway. She was also the youngest playwright ever to win a New York Drama Critics' Circle award, for *A Raisin in the Sun*. That play, which told the story of a struggling Black family on Chicago's South Side, was a huge success, running for 530 performances. The 2004 and 2014 Broadway revivals earned a total of five Tony Awards. *A Raisin in the Sun* continues to find new audiences, and television adaptations were nominated for Emmys in 1989 and 2008. Hansberry also wrote about feminism and homophobia. After her death at the age of thirty-four, her ex-husband adapted a collection of her writings into a play titled *To Be Young, Gifted and Black*, which had a long run Off-Broadway and is still produced in various forms.

Lorraine Hansberry

KAMALA DEVI HARRIS

(1 9 6 4 –)

is the first woman vice president in U.S. history. She is also the first Black American and first South Asian American to hold the office. In 2010, Harris became the first woman and the first person of color to be elected district attorney of San Francisco. She made history again as the first woman, first Black American, and first South Asian American attorney general of California. In 2017, Harris became the first South Asian American and just the second Black woman elected to the U.S. Senate, where she served until assuming the vice presidency. "While I may be the first woman in this office, I will not be the last," she promised in her victory speech. "Because every little girl watching tonight sees that this is a country of possibilities."

KAMALA HARRIS

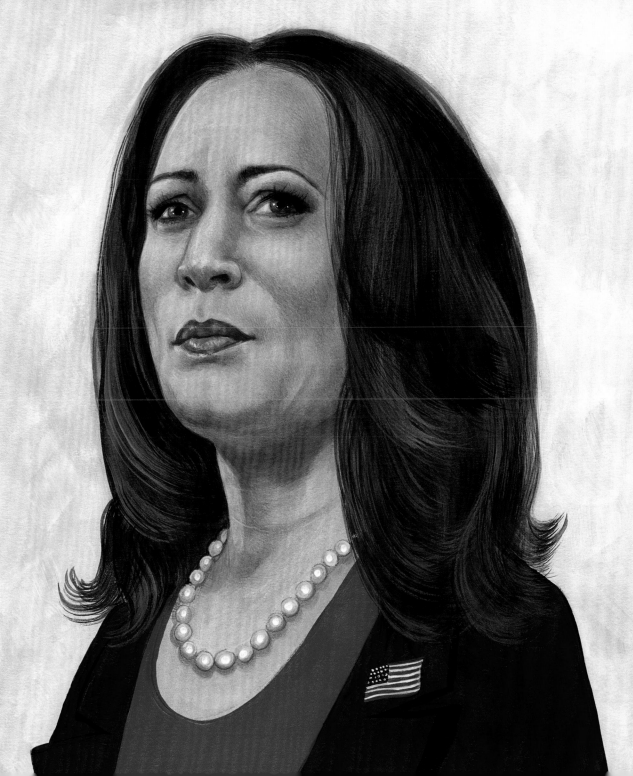

HATSHEPSUT

(DIED 1458 BCE)

was the longest-reigning female pharaoh. Her rule was a period of peace and prosperity. To pave the way for her rise from regent to pharaoh, Hatshepsut may have instructed artists to depict her as male. Known mainly for her ambitious building projects, including the construction of several prominent temples, Hatshepsut exercised a degree of power unprecedented for a woman in ancient Egypt.

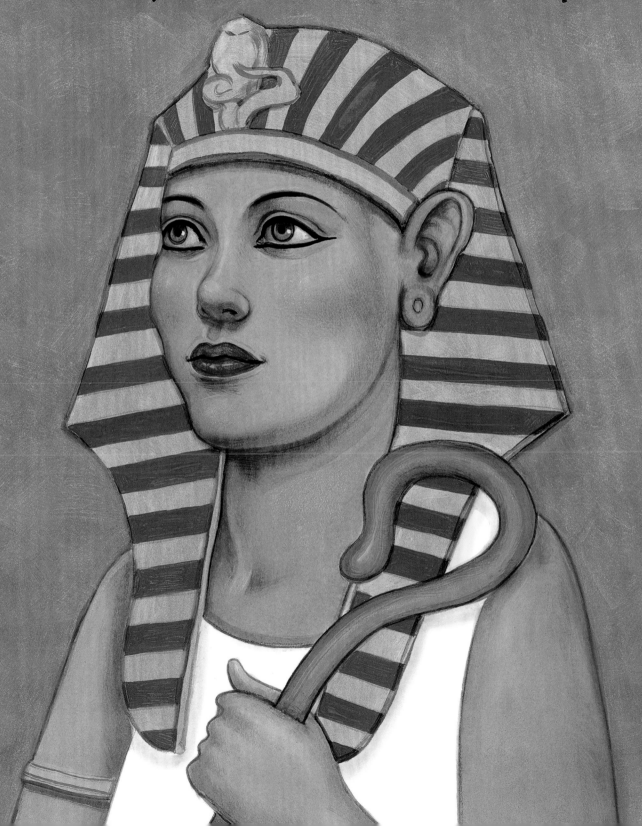

BEULAH LOUISE HENRY

(1887–1973)

nicknamed Lady Edison, was a prolific American inventor. Henry's renown even extended abroad: in 1937 a museum in Osaka, Japan, dedicated an exhibit to her. Among her most famous inventions designed to improve everyday life were a bobbin-free sewing machine and a vacuum ice cream freezer. She patented forty-nine items in total, including a new type of hair curler, a rubber sponge soap holder, a parasol with snap-on covers that allowed women to match the color to their outfit, and a device that produced multiple copies of a document on a typewriter without carbon paper. Henry reputedly said, "I invent because I cannot help it."

Beulah L. Henry

ADELAIDE HERRMANN

(1853–1932)

was an internationally famous vaudeville performer dubbed the Queen of Magic. She astonished audiences with her escape acts and her bullet catch, in which she stood in front of a firing squad and caught six bullets fired at her. Her phantom bride trick showed a woman swathed in white hovering over the stage while Herrmann passed a hoop back and forth over her body; the figure vanished at the end. Herrmann's Noah's Ark illusion depicted animals, including zebras, tigers, and elephants, emerging from a previously empty Ark. In a magazine article titled "The World's Only Woman Magician," she is quoted as saying, "I shall not be content until I am recognized by the public as a leader in my profession, and entirely irrespective of the question of sex."

ADELAIDE HERRMANN

SUSAN ELOISE HINTON

(1948–)

is an American author who as a teen wrote a best-selling young adult novel that effectively started the YA book genre. The book, *The Outsiders*, inspired both praise and outrage, facing bans due to its depictions of gang violence, delinquency, sexuality, substance abuse, and family dysfunction. Her decision to write from the male point of view was unusual and partly strategic. She thought that girls would read books for boys, but boys wouldn't read books for girls. Several of her YA novels, including *The Outsiders*, *Rumble Fish*, and *Tex*, have been adapted into movies.

S.E. Hinton

HIPPOLYTA

in Greek mythology, was the queen of the Amazons, a tribe of fearsome women warriors. Recent archaeological evidence suggests that the Amazonian legends may have had some basis in fact. The nomadic Scythians, who occupied a region that extended from the Black Sea to Mongolia from about the seventh through third centuries BCE, apparently had a relatively egalitarian society. The fact that they lived much of their lives on horseback made it easier for Scythian women to be as effective at hunting and fighting as the men. Through DNA testing, archaeologists have identified the bodies of many Scythians who were buried with their weapons as female. They also bore war injuries, just like the Scythian men's.

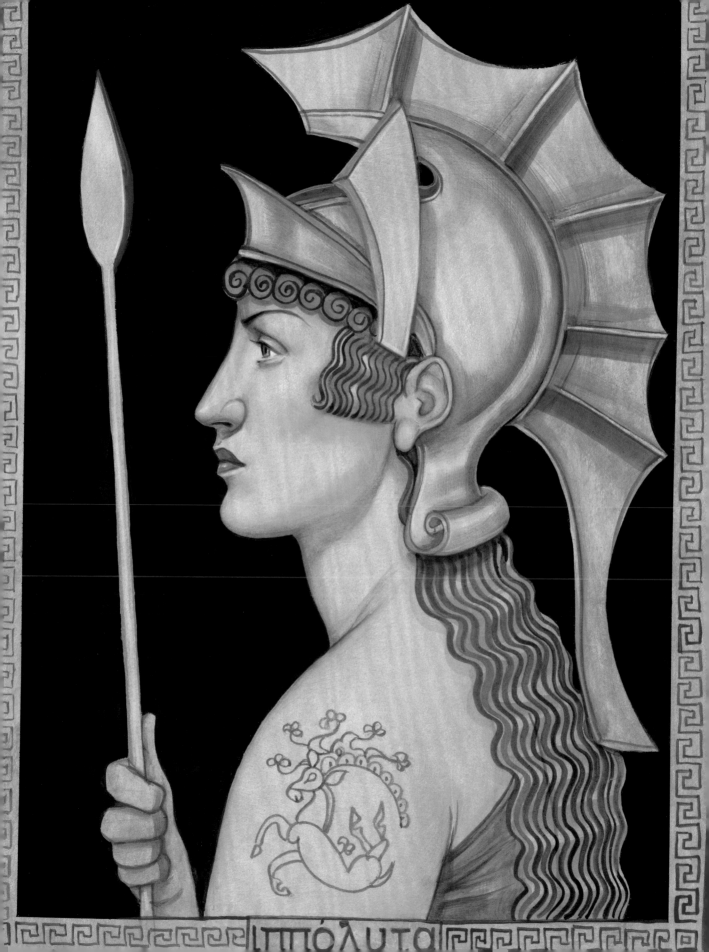

ΙΠΠΟΛΥΤΑ

BILLIE
HOLIDAY
(1 9 1 5 – 1 9 5 9)

born Eleanora Fagan, was a brilliant American jazz singer whose career spanned nearly thirty years. She had no formal musical training yet is considered one of the most influential jazz singers of all time. Nicknamed Lady Day, she started her career as a night-club singer in Harlem, and later played to much bigger audiences at venues such as Carnegie Hall. She recorded classics such as "God Bless the Child" and "Strange Fruit," a profoundly moving song about the lynchings of African Americans in the South. The controversial nature of the song prompted many radio stations to refuse to play it. Later in her life she was plagued by health and substance abuse problems and associated legal issues.

Billie Holiday

ZORA NEALE HURSTON

(1891–1960)

was an American folklorist and writer who today is a literary icon. Her novels, short stories, plays, and journalism—largely based on her fieldwork in the American South, Jamaica, and Haiti—centered on celebrating and preserving Black culture. She was a prominent writer in the Harlem Renaissance, and, although Hurston's work was not well known during her lifetime, she is now considered to be among the best writers of the last century.

Zora Neale Hurston

HYPATIA

(CIRCA 360–415)

was a mathematician, astronomer, and philosopher who lived in Alexandria, Egypt. She is the earliest female mathematician whose life is relatively well documented. An important thinker of the Neo-platonic school, she taught philosophy and astronomy. Hypatia was brutally murdered by a mob of Christian zealots, who stripped her, tortured her, and killed her. Her great accomplishments and violent death have resulted in Hypatia's being adopted as a symbol and martyr by various causes over the centuries; today many regard her as a feminist icon.

SAINT JOAN OF ARC

(CIRCA 1412–1431)

was a peasant girl who became a beloved French heroine. Joan gained an audience with the dauphin, who would later be crowned Charles VII, and told him she had a divine mission to drive the English from France and place him on the throne. Despite having no military training, Joan somehow convinced him that she should lead the French army into the embattled city of Orléans, where she achieved a momentous victory over the English. She continued to lead French forces to several more victories. However, about a year after her initial triumph, Joan was captured by Anglo-Burgundian forces and tried for heresy and witchcraft, for which she was burned at the stake.

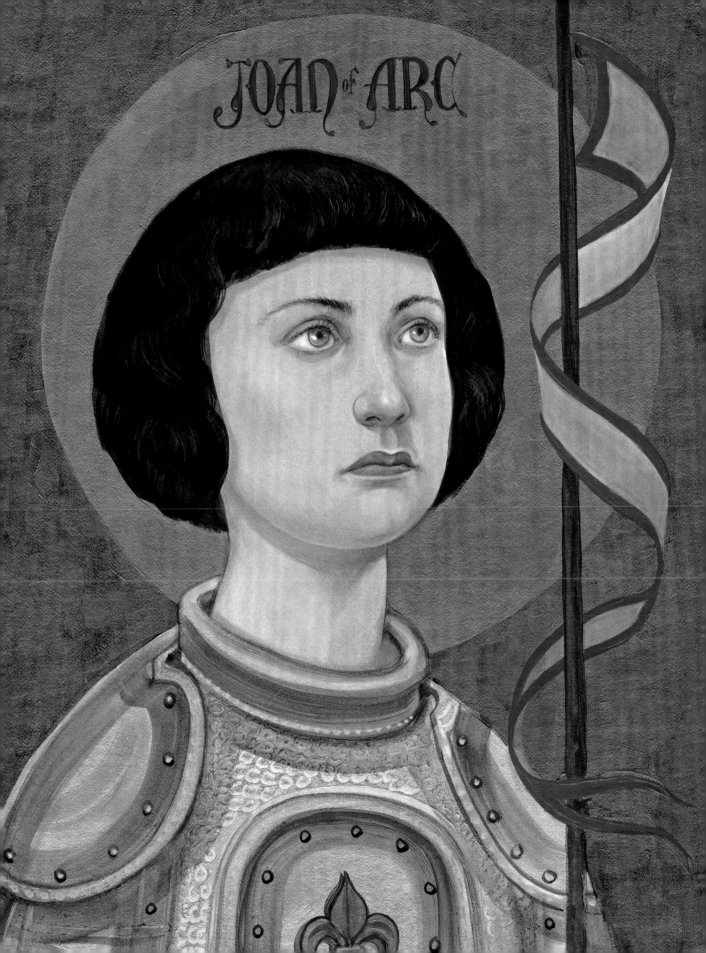

EMILY PAULINE JOHNSON

JOHNSON

(1861–1913)

also known by her Mohawk stage name Tekahionwake, was a popular author, poet, and performer who made important contributions to Canadian culture. Her father was a Mohawk chief and her mother was English. As an unmarried Indigenous woman and a successful entertainer, Johnson fought against the racial and gender prejudices of the time. She joined the New Woman group, an early international feminist movement seeking radical change, and was critical of a number of the Canadian government's policies affecting Indigenous people.

MARSHA P. JOHNSON

(1945–1992)

a Black transgender woman, played a central role in the gay liberation movement and was a pioneering transgender rights activist. She participated in the Stonewall uprising, where some credit her with having thrown the first brick. Johnson protested against police harassment and cofounded one of the country's first safe spaces for transgender and homeless youth. A sex worker herself, she advocated for other sex workers. She also organized on behalf of people with HIV/AIDS. Johnson suffered from mental illness and was often homeless. When her body was found in the Hudson River, police ruled Johnson's death a suicide without presenting any evidence. Those who knew her well dispute this finding, and the truth about her death remains unknown.

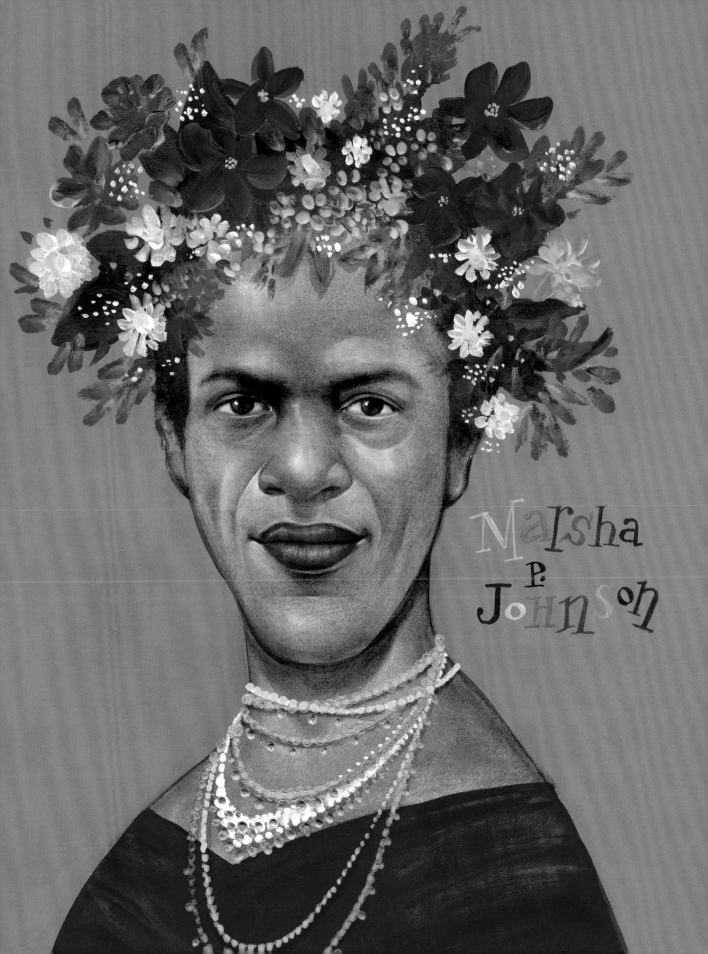

Marsha P. Johnson

ALBERTA ODELL JONES

(1930–1965)

was an attorney and a civil rights advocate, one of the first Black women to pass the Kentucky bar, and Louisville's first Black female prosecutor. Among her earliest clients was a young boxer who later changed his name from Cassius Clay to Muhammad Ali. Jones was active in the NAACP and attended the March on Washington. She formed the Independent Voters Association of Louisville, which was dedicated to helping African Americans register to vote. Jones was murdered by an unknown person, and the motive for her murder is still a mystery.

JEFFREY CATHERINE JONES

JONES

$(1944-2011)$

an American transgender woman illustrator and comics artist, was one of the preeminent painters in the fantasy art genre. She drew comic pages for, among others, *Creepy*, *Eerie*, *Vampirella*, and Wally Wood's *Witzend*, and painted covers for more than 150 books in a variety of genres. Jones created two enigmatic strips for magazines: "Idyl" for *National Lampoon* and "I'm Age" for *Heavy Metal*. She also produced art for several comics publishers, including DC Comics and Skywald Publications. The renowned fantasy artist Frank Frazetta called Jones "the greatest living painter."

J·CATHERINE
JONES

CHRISTINE JORGENSEN

(1 9 2 6 – 1 9 8 9)

was an American transgender woman and the first person to become famous in the United States for having sex reassignment surgery. After her World War II military service, she began taking estrogen. Jorgensen then went to Copenhagen in the early 1950s to receive further hormone treatment and surgery. Jorgensen was greeted as a celebrity when she returned to the United States in 1953, since news of her transition had already been published. As an actress and nightclub entertainer, Jorgensen won over audiences with her poise, beauty, humor, and charm, and she used her fame as a platform to advocate for transgender people.

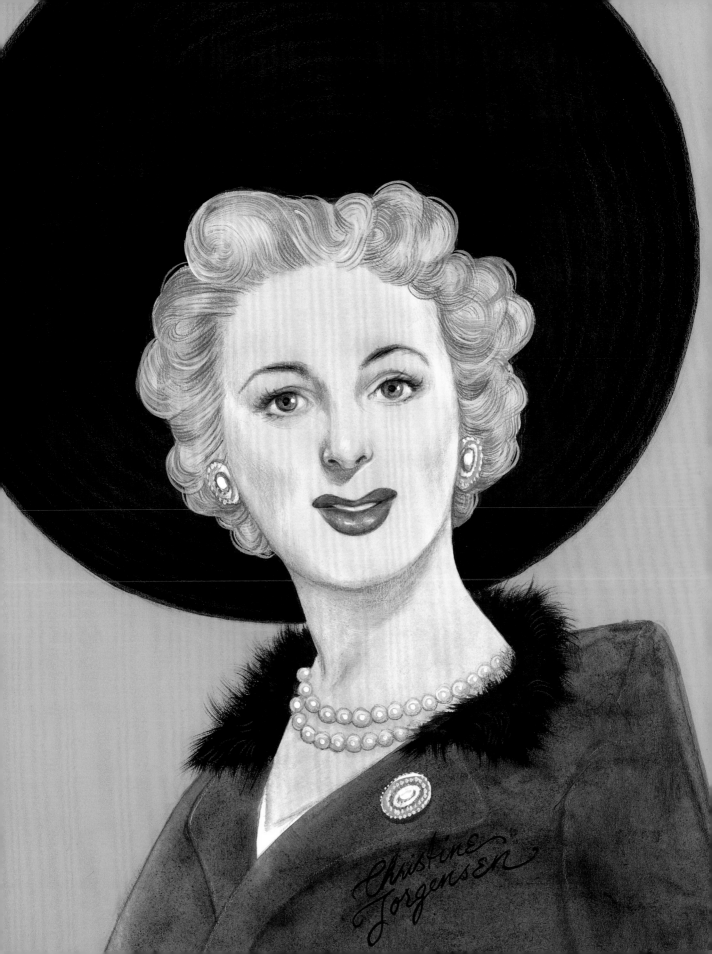

MARGARET KEANE

(1 9 2 7 –)

is widely considered to be the mother of the lowbrow, or pop surrealism, art movement. Her subjects are usually children and animals, all painted with larger-than-life eyes. For many years, even after their divorce in 1965, her second husband, Walter Keane, took credit for her popular work. It took a "paint-off" in court for Margaret to prove, in 1986, that she was in fact the artist behind the wide-eyed waifs. Both Margaret and Walter were instructed by a judge to create a painting in front of the jury. Walter demurred, citing a sore shoulder. Margaret created a painting in fifty-three minutes and was ultimately awarded four million dollars in damages. While some critics have called her work grotesque and appallingly sentimental, she remains a beloved figure to those who appreciate her unique aesthetic.

Margaret Keane

MARGERY KEMPE

(CIRCA 1373–CIRCA 1440)

was a mystic and the author of what is arguably the first autobiography in English. Although she was illiterate, Kempe documented her spiritual journey from wife and mother to Christian visionary by dictating her thoughts, first to a scribe who may have been her son and later to a local priest. The result, *The Book of Margery Kempe*, challenged the patriarchy of the church; she was tried a number of times for heresy but never convicted. Her book offers a fascinating look at the life of a middle-class woman in the Middle Ages.

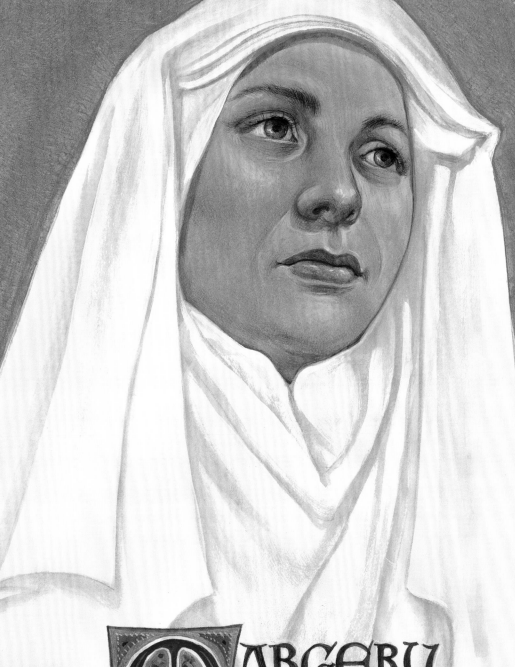
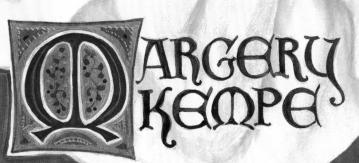

CORITA
KENT
(1918–1986)

was an educator, social justice advocate, designer, and artist. For thirty-two years, she was also a Roman Catholic nun. Kent's primary medium was silkscreen and her art is often compared to Andy Warhol's. Her exuberant and vibrant pop art often contains messages of love and peace, and the large and colorful typography in her work contains both religious and secular social commentary. Her art is included in the permanent collections of New York's Whitney Museum and the Museum of Modern Art. There are currently plans to open a new space dedicated to exhibiting her work in Los Angeles.

NOOR INAYAT KHAN

(1914–1944)

was a British spy who served in the secret Special Operations Executive during World War II. Khan was the first female wireless operator sent from the UK into Nazi-occupied France to assist the French Resistance. Her job was to maintain a link between London and Resistance networks, sending and receiving messages to coordinate crucial missions. Due to the dangerous nature of the work, an operator's life expectancy was about six weeks. Indeed, she was betrayed to the Germans and ultimately executed at Dachau concentration camp. Despite enduring brutal interrogation, Khan did not give the Gestapo a single piece of information. For her service to the UK, she was posthumously awarded the George Cross, which honors heroism and courage "in circumstances of extreme danger."

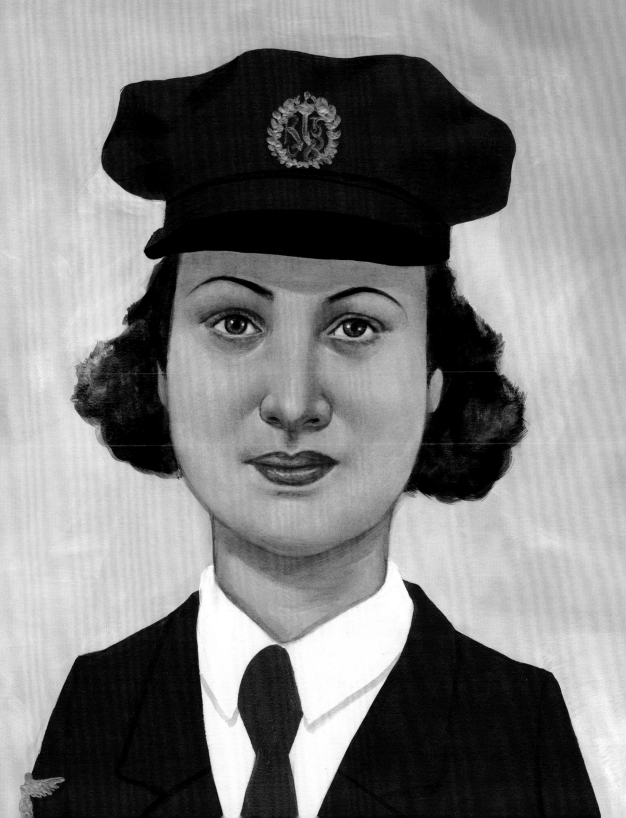

Noor Inayat Khan

KHUTULUN
(CIRCA 1260 – CIRCA 1306)

was the greatest female athlete in Mongolian history. A great-great-granddaughter of Genghis Khan and a cousin to Kublai Khan, Khutulun grew up with fourteen brothers and learned at an early age how to successfully fight them. She participated in public competitions, winning horses from those she defeated and reputedly amassing a herd of ten thousand. Khutulun refused to marry any man unless he could first beat her at wrestling; although many tried, none succeeded. The Puccini opera *Turandot* is said to be based on her life.

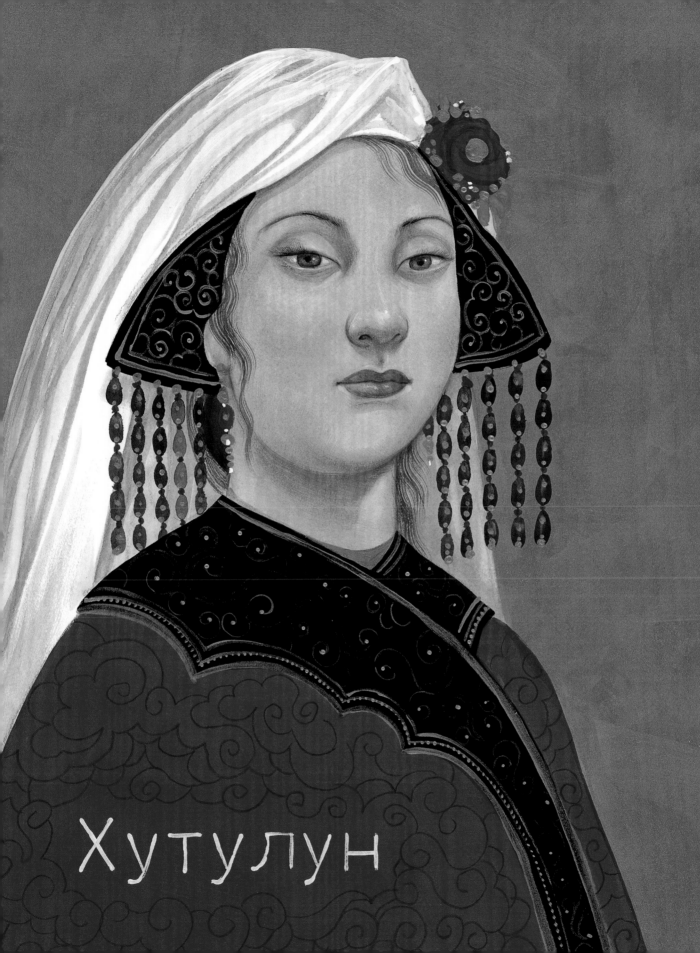

Хутулун

HILMA
AF KLINT

(1862–1944)

a Swedish artist, was arguably Europe's first modernist abstract painter. Her visionary works were informed by spiritualism; she belonged to a circle of five women who tried to make contact with godlike entities they called the High Masters, conducting séances to reach them. Af Klint's paintings stemmed directly from her complex belief system. She specified that after her death her work be locked away for at least twenty years. Her wish was respected, and her paintings were finally introduced to an international audience in the 1980s.

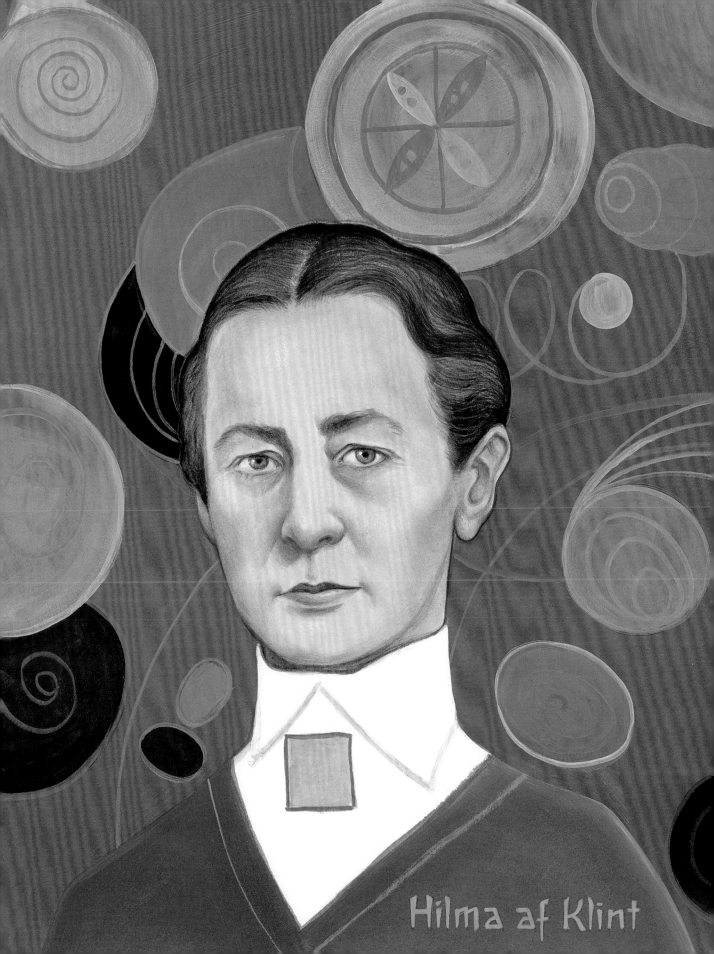

Hilma af Klint

JULIANE
KOEPCKE

(1 9 5 4 –)

is a German Peruvian mammalogist who, as a teenager, was the lone
survivor after her plane was hit by lightning over the Peruvian rain
forest in 1971. She fell nearly two miles from the sky, still strapped in
to her seat. Amazingly, Koepcke survived the fall, but she then faced
the challenge of being lost and alone in the rain forest, wearing only a
summer dress. She walked for eleven days before she was found. The
other ninety-one people on the flight, including Koepcke's mother,
perished.

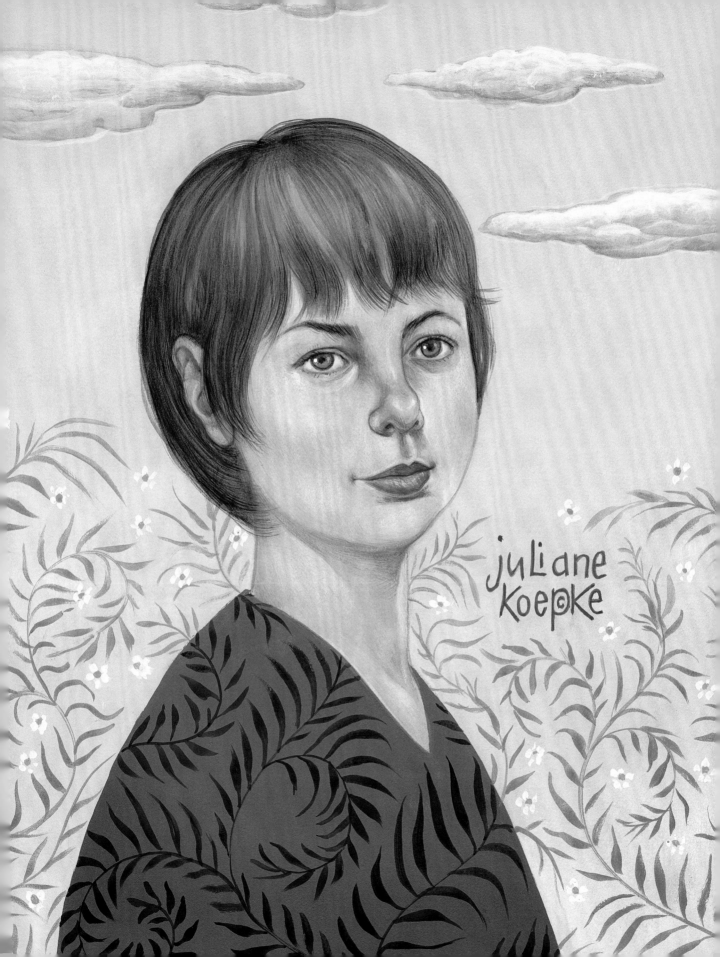

ELISABETH KÜBLER-ROSS

(1 9 2 6 – 2 0 0 4)

was a Swiss American psychiatrist whose work with terminally ill patients was controversial at the time. In her international best seller *On Death and Dying*, she first presented her theory describing the five stages of grief: denial, anger, bargaining, depression, and acceptance. Kübler-Ross worked to remove the stigma surrounding death and bereavement. After proclaiming that she was ready for death and even welcoming it, Kübler-Ross died at age seventy-eight.

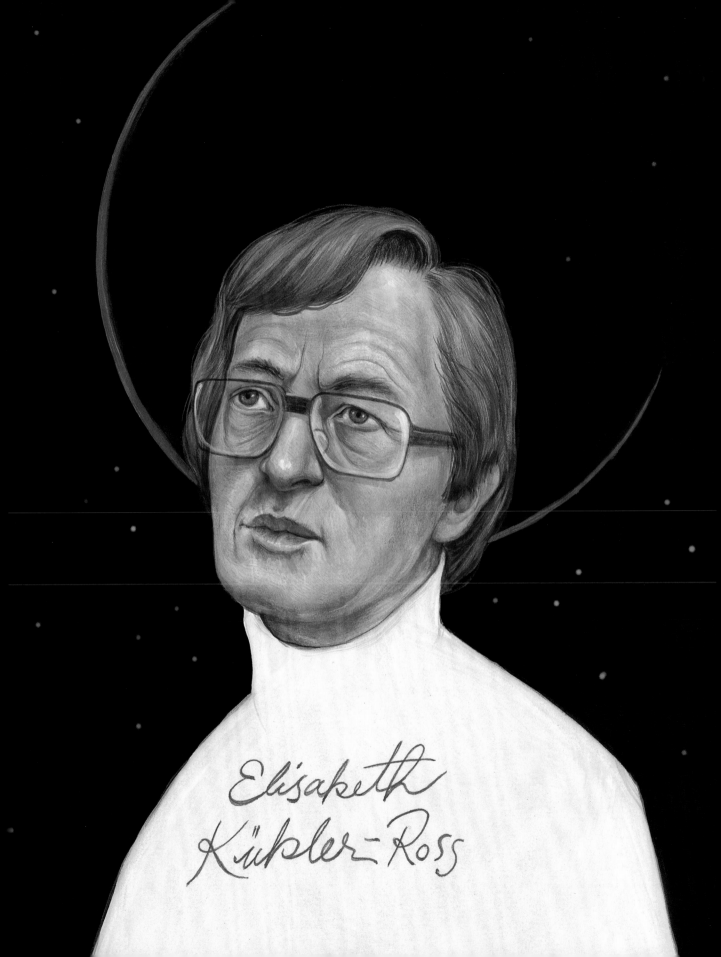

Elisabeth
Kübler-Ross

LOUISE LABÉ

(CIRCA 1524–1566)

is the most well-known and celebrated woman writer of the French Renaissance. Her works, some of which are overtly feminist, went against the prevailing literary and social norms of her time. Labé's love poetry, with its frank expressions of female desire, was considered scandalous; she was accused of being a courtesan and condemned by reformers such as John Calvin. She died in her early forties, most likely of the plague.

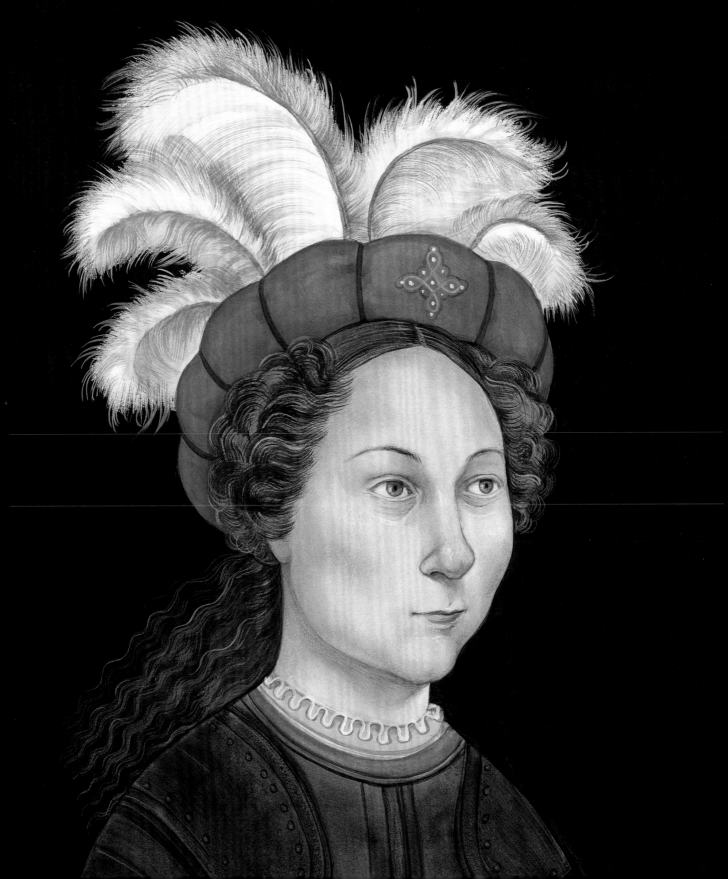

LOUISE LABÉ

LAKSHMIBAI

(1828–1858)

the rani (or queen) of Jhansi, was a major figure in the Indian Rebel-
lion of 1857 against the invading British. At the time, the British
were expanding their control over what is now India, imposing
their own social and religious practices while banning Indian cus-
toms in the process. When they seized the northern Indian state of
Jhansi, stripping the rani of her title, she trained and led her own
army, which included both men and women fighters, to oust them.
Lakshmibai fought valiantly but was ultimately killed in battle,
becoming a symbol of resistance against British rule.

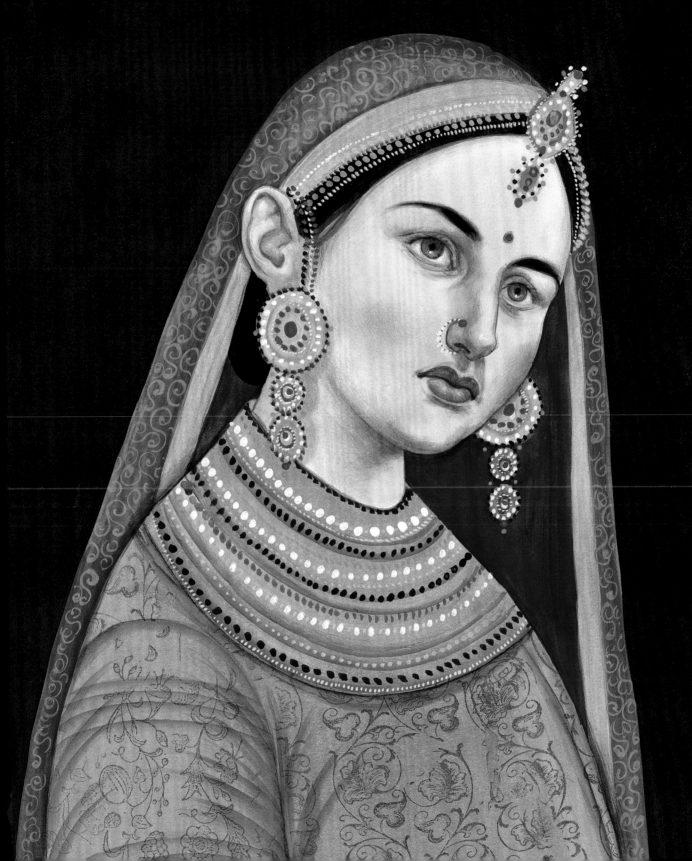

झांसी की रानी

HEDY
LAMARR

(1 9 1 4 — 2 0 0 0)

a glamorous Austrian American movie star who acted in more than thirty films, was also an inventor whose work on "frequency hopping" anticipated the technology used in Wi-Fi, GPS, and Bluetooth. The aviation pioneer Howard Hughes supported her scientific activities; she suggested aerodynamic improvements for his airplanes. Lamarr's frequency-hopping system, developed with the composer George Antheil, was designed to prevent the jamming of radio signals that guided torpedoes to their targets. They donated the system to the U.S. Navy during World War II. Neither she nor her estate ever saw a penny of profit from this invention, and she spent her final years in seclusion.

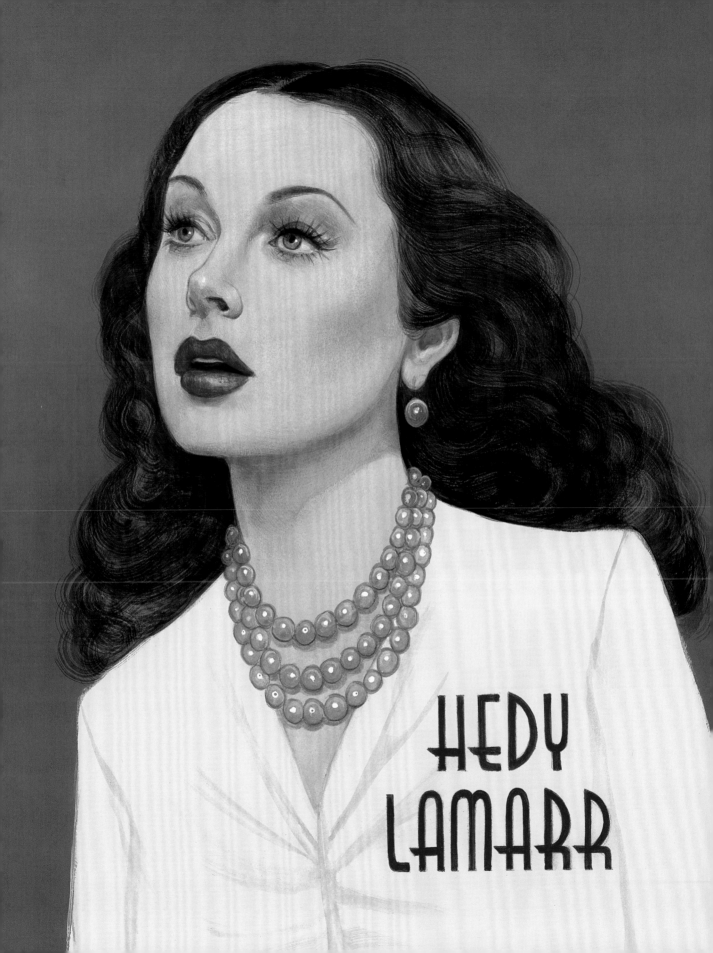

HEDY
LAMARR

LOUISE LECAVALIER

(1 9 5 8 –)

is a Canadian dancer and choreographer, an icon in the world of contemporary dance. Her androgynous look and extraordinary physical strength give her an otherworldly aura. Her signature dance move, the full-body barrel jump, is extremely challenging, and her intense movements seem to transcend the limitations of the human body. For almost two decades she was a principal dancer with the La La La Human Steps dance company. As a member of the company she collaborated on projects with artists including David Bowie and Frank Zappa. Since leaving La La La she has continued to choreograph and dance in award-winning performances throughout the world.

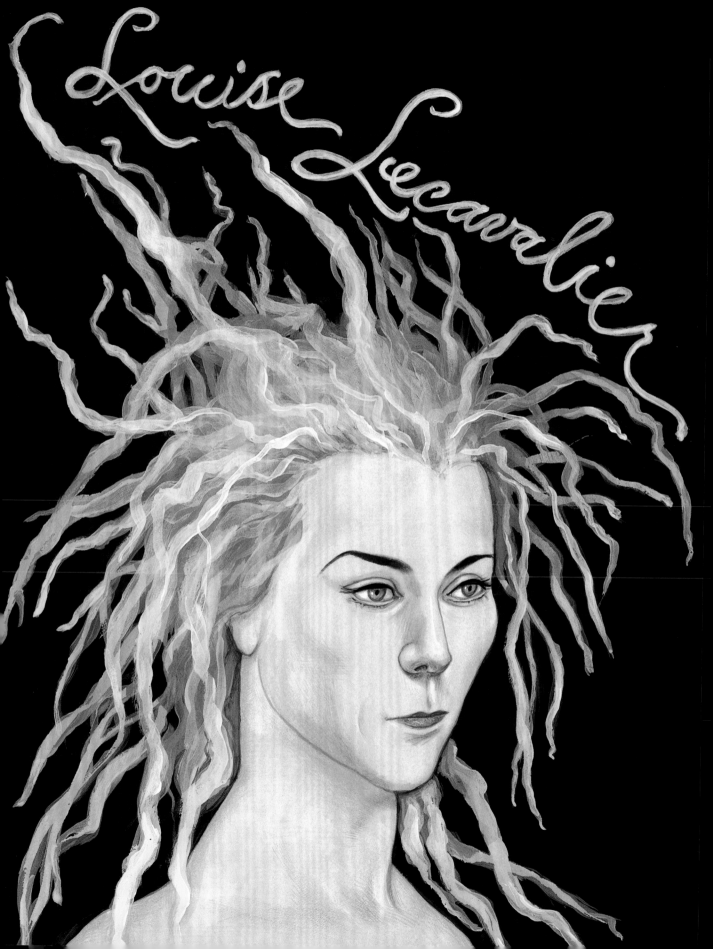

LAURA
LEE

(1982–2016)

was a tenacious advocate for people with Down syndrome. A graduate of George Mason University, where she was the first student with Down syndrome, Lee worked at the World Bank. She was also the first person with Down syndrome to testify before the Fairfax County School Board and the Virginia Board of Education. As part of her advocacy, Lee addressed the Virginia General Assembly, a U.S. congressional committee, and U.S. Department of Education officials. She regularly presented at national conventions for the Down syndrome community. Through her efforts and accomplishments, Lee changed perceptions of people with Down syndrome.

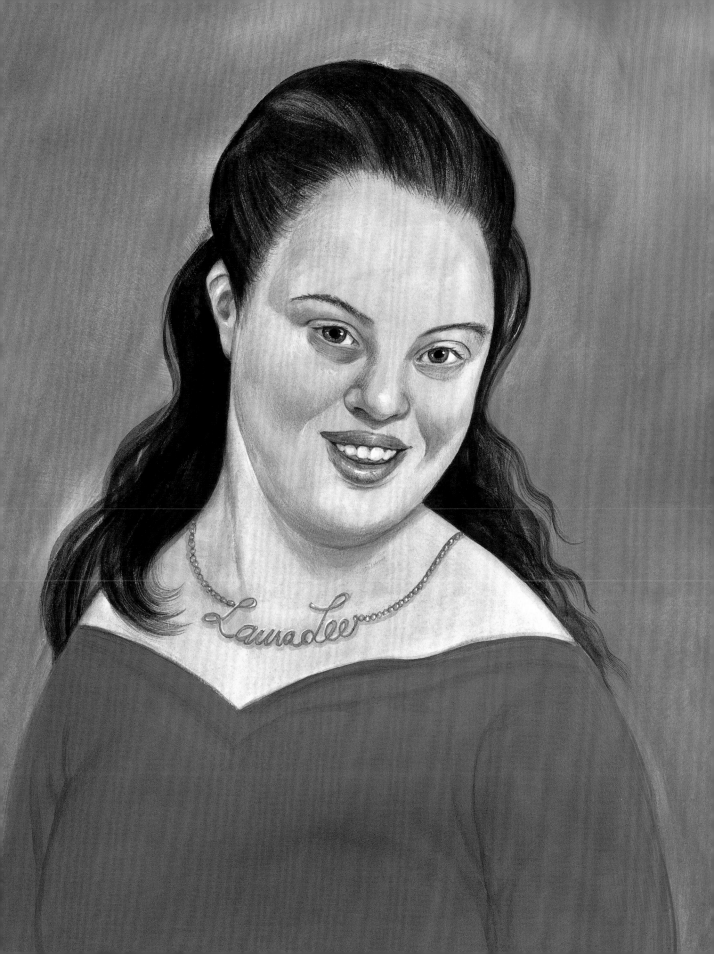

MABEL PING-HUA LEE

(1896–1966)

was a Chinese American suffragist. Born in Guangzhou, China, she immigrated to the United States with her mother in 1905. As a teen, Lee led a parade on horseback in New York City to advocate for voting rights. She studied history and philosophy at Barnard College. While completing her master's at Teachers College, Lee led the Chinese American contingent in another New York City parade in support of women's suffrage. In 1921 she became the first Chinese woman in the United States to receive a PhD in economics, from Columbia University. When women finally won the right to vote in New York, in 1917, she was unable to exercise her franchise because of the Chinese Exclusion Act, which denied U.S. citizenship to Chinese immigrants. It is not known whether she ever became a citizen or voted in the United States.

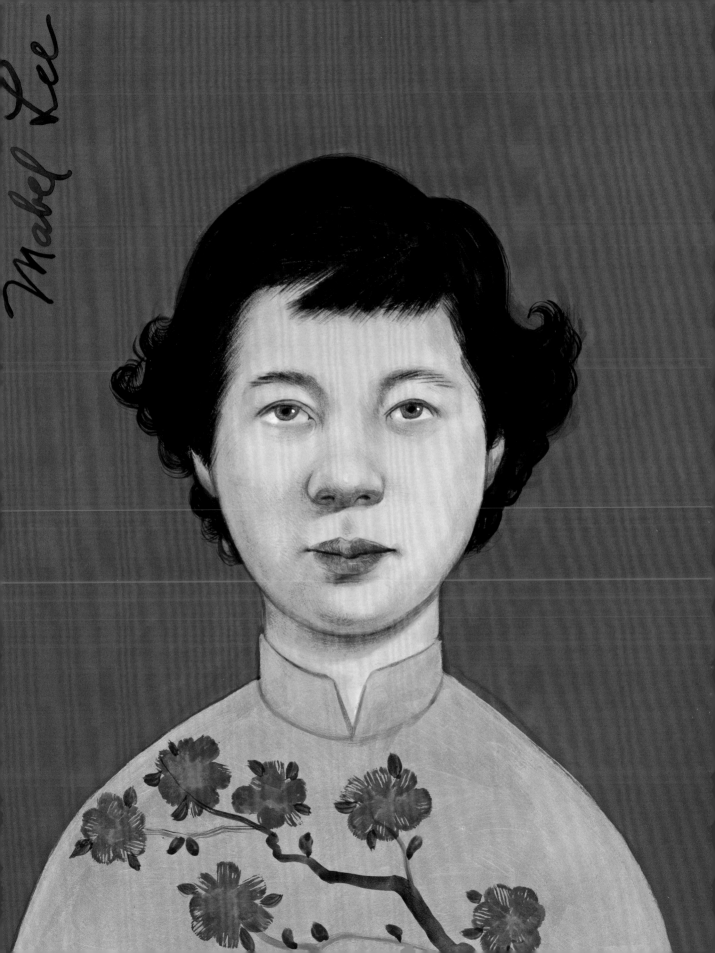

Mabel Lee

CLARA
LEMLICH
(1886–1982)

was a Jewish Ukrainian American suffragist, community organizer, and peace activist. In 1909, Lemlich led the Uprising of the Twenty Thousand, a massive strike of shirtwaist sweatshop workers in New York City's garment industry. Enduring multiple beatings from guards and police, she fought to improve factory conditions that included long hours, low pay, lack of advancement opportunities, and humiliating treatment of the mainly female workers. Lemlich also campaigned for consumers' and tenants' rights, protesting against inflated prices and evictions. She spent her final years in a nursing home in California, where she helped the orderlies organize a union.

קלרה למליך

QUEEN LILI'UOKALANI

(1838–1917)

was the first and only female ruler and the last sovereign monarch of the Hawaiian Kingdom. In the 1880s, a coalition of politicians and militiamen largely aligned with white businessmen's interests put in place a Hawaiian constitution limiting the power of the monarchy. The queen attempted to draft a new constitution to restore that power. In response, a group of pro-American conspirators, backed by U.S. Marines, who landed in 1893, overthrew the monarchy. After a failed uprising by her supporters in 1895, Lili'uokalani was placed under house arrest; she then formally abdicated. In 1898 the United States annexed Hawaii, which eventually became the fiftieth state.

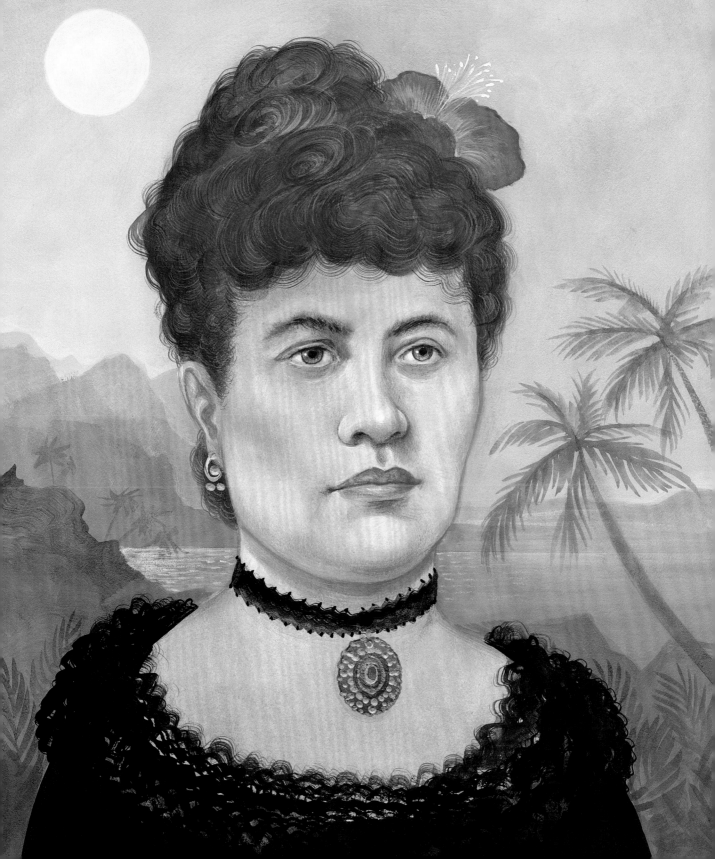

Queen
Lili'uokalani

ANNIE LONDONDERRY

(1870–1947)

was the first woman to bicycle around the world. A Latvian American who was born Annie Cohen Kopchovsky, she joined the many women who embraced the cycling craze of the 1890s. The bicycle gave women greater independence and revolutionized their clothing: heavy, full skirts were replaced by the more comfortable bloomers, which allowed for freedom of movement. Londonderry cycled over land and sailed across the oceans. An exceptional storyteller, she generated income along her journey by entertaining crowds, selling souvenirs, and displaying paid advertisements on her bike. Despite achieving considerable fame for her early adventures, she died in relative obscurity.

Annie
LondOnderry

ADA
LOVELACE

(1815—1852)

has been called the world's first computer programmer and is considered a tech visionary. A daughter of Lord Byron, she was a British countess who studied math and science in her youth. This was uncommon in an age when many girls were uneducated. Lovelace is mainly remembered for her work on Charles Babbage's mechanical general-purpose computer, the so-called Analytical Engine, which was never built. With her larger vision of a computer that could literally do anything given the correct programming, she was a century ahead of her time, and gave the world a first glimpse of what would eventually be universal computation.

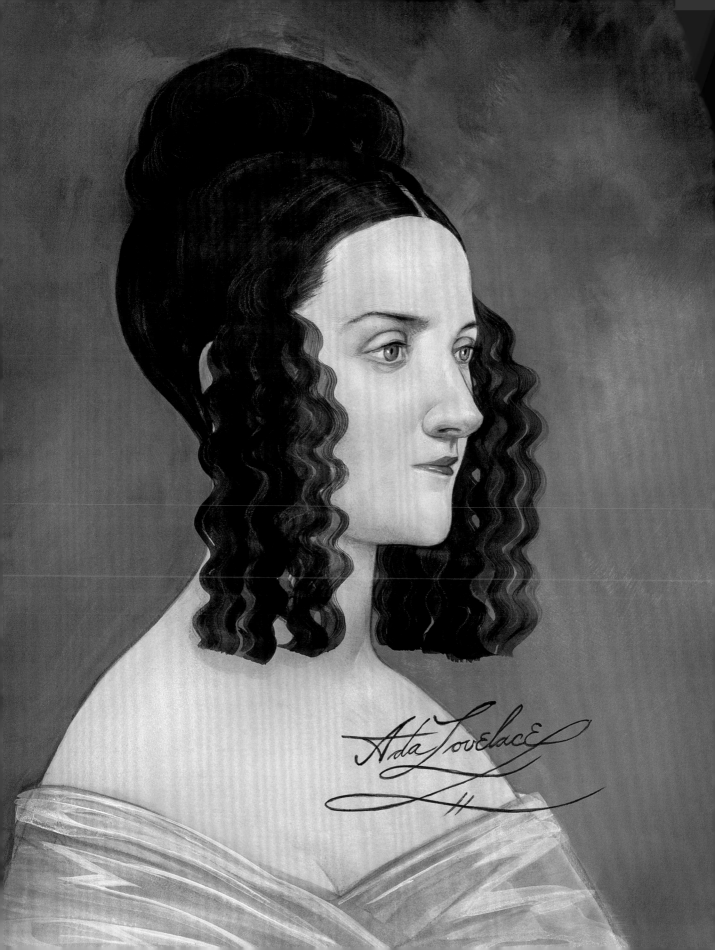

JEAN MACNAMARA

(1899–1968)

was an Australian doctor and pioneering scientist. Along with her colleague, the future Nobel Prize winner Macfarlane Burnet, she discovered that there is more than one strain of the polio virus, an insight that would be instrumental in the development of a successful polio vaccine in 1955. Macnamara advocated for adequate aftercare of the disabled, became renowned for her orthopedic work, and devoted much of her medical career to the care of children. In recognition of her achievements, she was appointed Dame Commander of the Most Excellent Order of the British Empire (DBE).

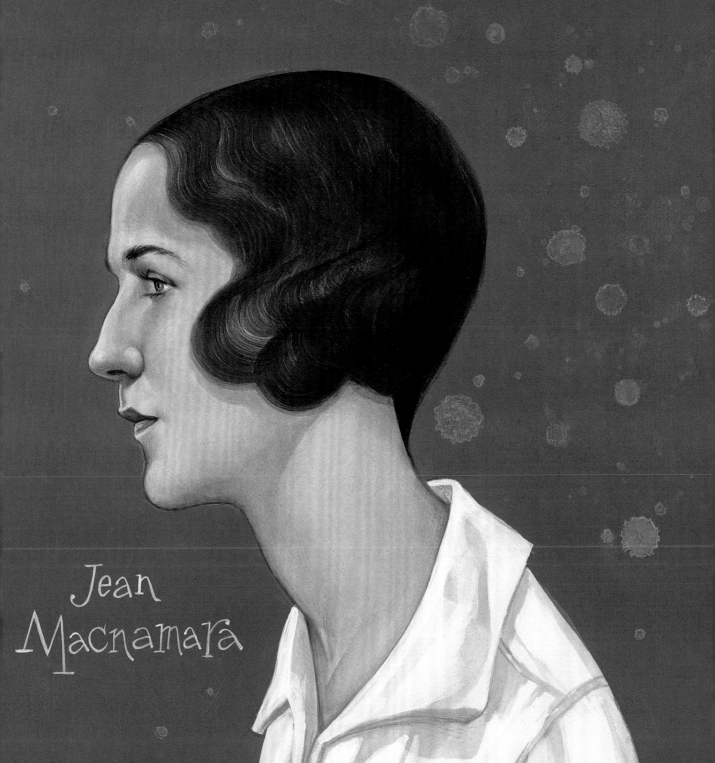

Jean
Macnamara

ELIZABETH MAGIE

(1866–1948)

an American writer and feminist, created the precursor to the board game Monopoly. Called The Landlord's Game, it reflected her progressive political beliefs and was a protest against the monopolists of the time, such as Andrew Carnegie and John Rockefeller. The game was meant as a practical demonstration of the system of land-grabbing, which Magie viewed as having unfair and often tragic consequences. About thirty years after she'd patented her creation, a man named Charles Darrow redesigned it and took full credit for the game, now called Monopoly, earning millions and, until recently, leaving Magie lost to history.

LIZZIE MAGIE

VIVIAN
MAIER
(1926–2009)

was an American street photographer whose extraordinary output was discovered and celebrated only after her death. For about forty years she lived in obscurity as a nanny and caregiver while producing a massive body of work. She shot around 100,000 photographs during her lifetime, mainly of the people of Chicago and New York; she also took pictures on her solo travels around the world. Maier's photos have been exhibited in galleries and collected and published in several books. In addition, she is the subject of a 2013 documentary film.

VIVIAN MAIER

ALICE MARBLE

(1913–1990)

was an American tennis player who won eighteen Grand Slam championships. Named the Associated Press Female Athlete of the Year in 1939 and 1940, Marble was a pioneer of the serve-and-volley style in the women's game. Her athletic, attacking style was considered very aggressive, if not unseemly, and paved the way for the power game we know today. In 1950, Marble advocated for the desegregation of tennis, championing the cause of the great Althea Gibson, who became the first African American to compete in the U.S. National Championship. After retiring from competition, Marble designed sportswear, lectured, and taught tennis; one of her students was Billie Jean King.

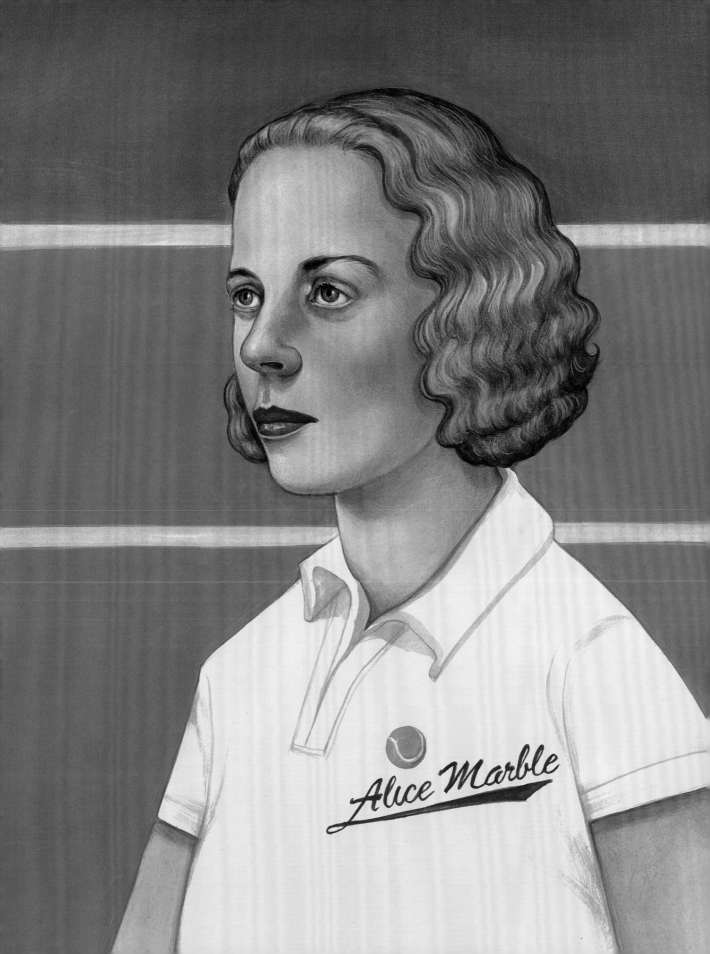

MILEVA MARIĆ

(1 8 7 5 – 1 9 4 8)

was a brilliant Serbian physicist and mathematician and the first wife of Albert Einstein. She was the only woman in her class at the Zürich Polytechnic. At that time opportunities for women in mathematics and physics were almost nonexistent. There is currently some debate as to the extent of Marić's collaboration with Einstein. Some believe that she made significant contributions to his groundbreaking early work. After their divorce she was ignored until recently.

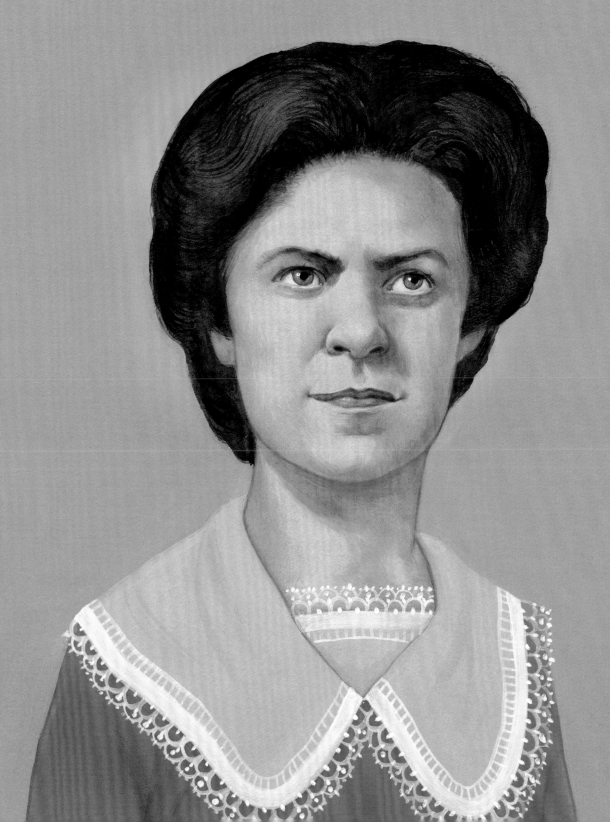

Mileva Marić

BERYL
MARKHAM

(1 9 0 2 – 1 9 8 6)

was an English adventurer and professional pilot who lived in Kenya. Markham achieved several firsts. As the first woman in Africa to earn a horse trainer's license, she trained several champion racehorses. The first woman to earn a commercial pilot's license in Kenya, she worked for years as a bush pilot. Most famously, Markham was the first person to fly solo, nonstop across the Atlantic Ocean from England to North America. Done against prevailing winds, this 1936 flight was a more difficult feat than the west-to-east crossing. Markham's memoir, *West with the Night*, is considered a classic of adventure writing. The impact crater Markham on the planet Venus is named after her.

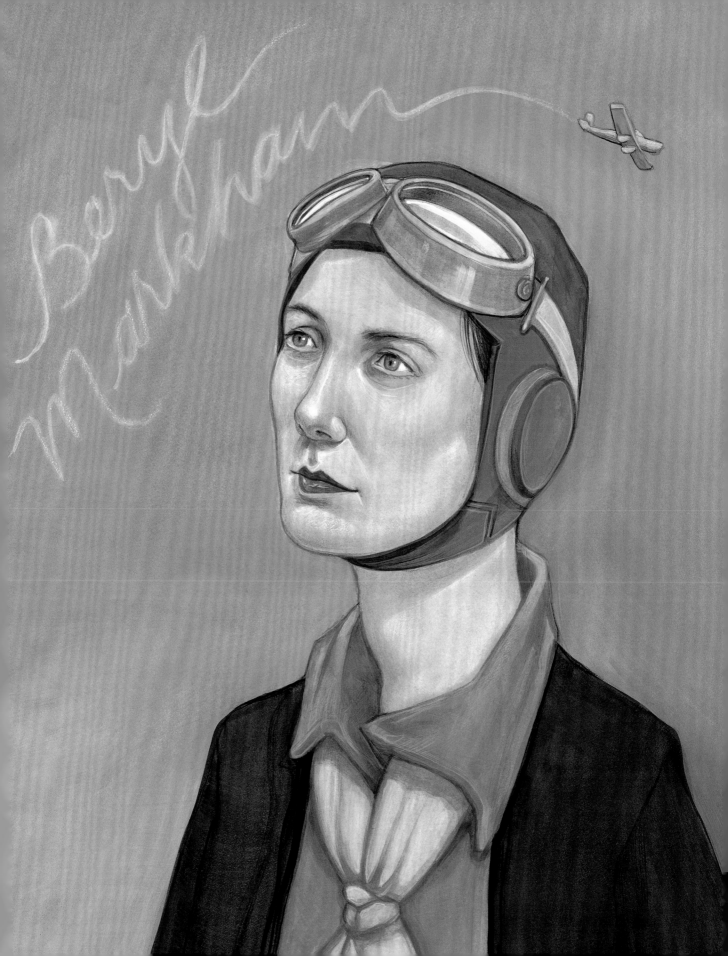

MATILDA
OF TUSCANY

(CIRCA 1046–1115)

was a powerful noblewoman who ruled much of north-central Italy.
She is one of very few medieval women recognized for her accom-
plishments as a military leader. A significant player in the most
important political and theological issues of her time, Matilda
defended the papacy, financially and militarily, against secular
powers. A patron of the arts, she also donated land and offered eco-
nomic support to churches and monasteries in the area over which
she ruled.

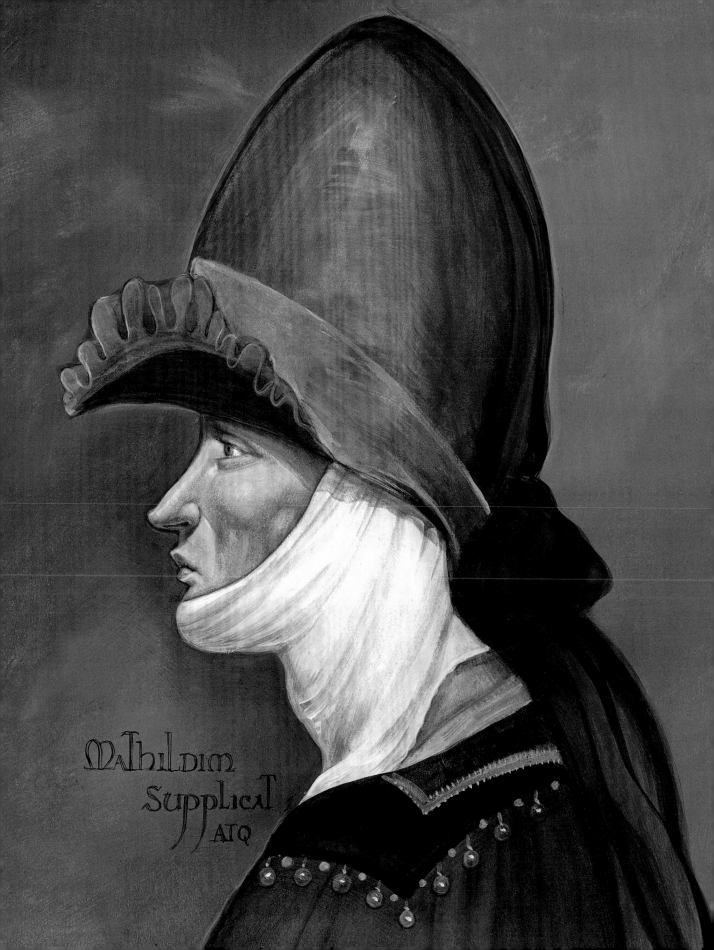

ROSE MARIE McCOY

(1 9 2 2 – 2 0 1 5)

was an influential songwriter who published more than eight hundred songs in her lifetime. Artists including Elvis Presley, Nat King Cole, Big Maybelle, Ruth Brown, Linda Ronstadt, Eartha Kitt, and Bette Midler recorded her songs, which McCoy often cowrote with collaborators. Among her most famous hits was "It's Gonna Work Out Fine," cowritten with Sylvia McKinney. Ike and Tina Turner reached number 14 on the Billboard Hot 100 with their version, which earned them their first Grammy nomination, in 1962. In 2008, McCoy was inducted into the Arkansas Black Hall of Fame.

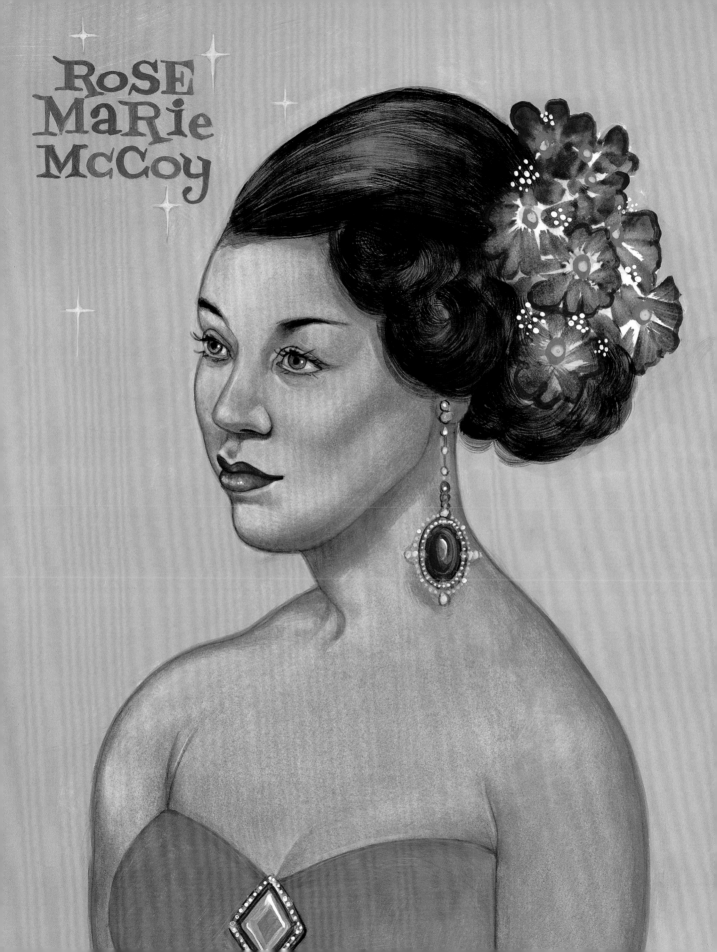

ROSE
MARIE
McCOY

HATTIE McDANIEL

(1893–1952)

was a comedian, singer-songwriter, and radio, movie, and television actress who made history as the first African American to be nominated for and win an Academy Award, in 1940. She won the best supporting actress Oscar for portraying Mammy, a house slave, in *Gone with the Wind.* McDaniel accepted her honor in the whites-only Ambassador Hotel in Los Angeles. Allowed to attend as a favor to producer David O. Selznick, she was seated at a remote table, apart from the other nominees. The actress tended to be typecast as a domestic worker, and the NAACP criticized her for accepting such stereotypical roles. McDaniel endured racism for her entire career, and even her wish to be buried in Hollywood Cemetery was denied because of her race. Despite her acting success, she died in debt at age fifty-nine.

Hattie McDaniel

MARGARET MEAD

(1901–1978)

was the best-known anthropologist of her time. She journeyed to the South Pacific territory of American Samoa to research issues relating to adolescence and socialization. Based on her studies of child-rearing practices, she developed the idea that children learn through "imprinting," or watching adult behavior. *Coming of Age in Samoa*, her first book, was a best seller. A popular author and speaker in the 1960s and '70s, Mead addressed subjects such as world hunger, nuclear proliferation, environmental pollution, race relations, and women's rights.

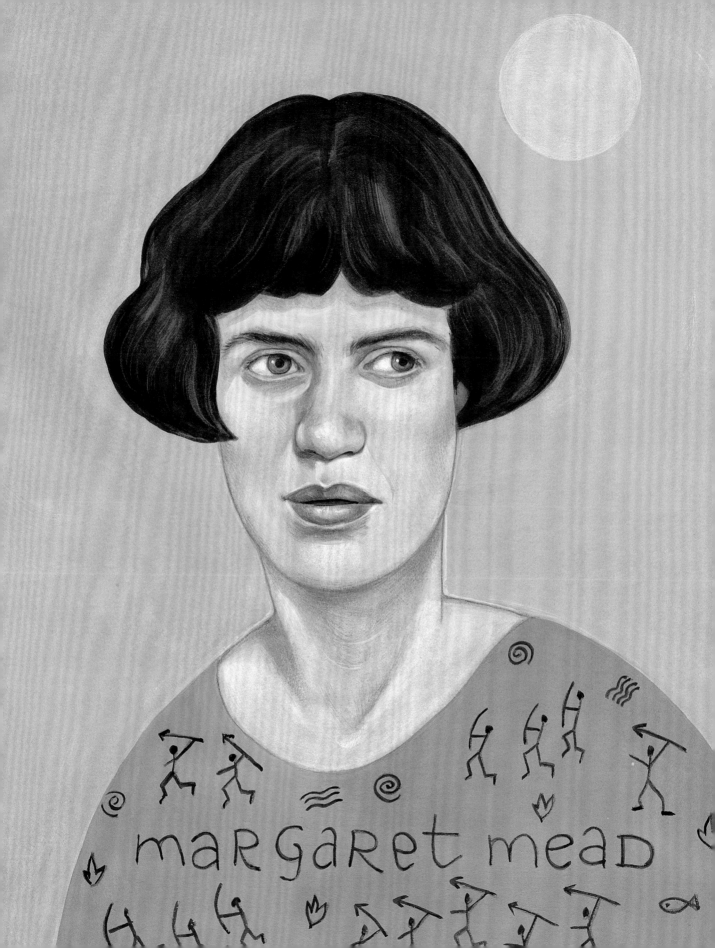

MARGARET MEAD

LISE MEITNER

(1878−1968)

was an Austrian-born physicist who contributed to the discovery of nuclear fission, which led to the development of the atomic bomb and nuclear power. While collaborating with Otto Hahn and Fritz Strassmann on experiments on the uranium atom in Germany, the Jewish Meitner had to flee the Nazis. Her partners carried on their work, with Meitner advising Hahn, who described the puzzling results of an experiment to her in a letter. She reviewed the findings with her nephew, also a physicist, and realized her partners had split the nucleus of a uranium atom, which had been thought impossible. Meitner explained the physics of the process in a paper she published with her nephew; they called it "fission." But it was Hahn who, in 1944, won the Nobel Prize for discovering nuclear fission. He never acknowledged Meitner's role. Meitner was invited to work on the Manhattan Project but declined because she was opposed to the atomic bomb.

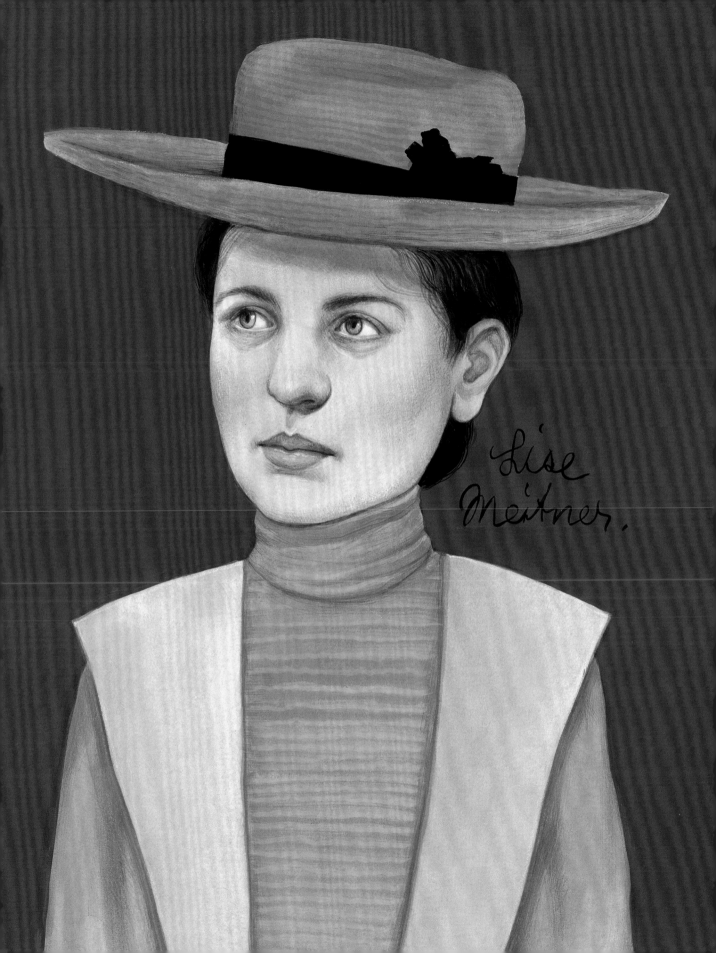

Lise Meitner.

MARIA SIBYLLA MERIAN

(1647-1717)

was an influential German-born scientific illustrator and naturalist. She is best known for her studies of insects, which were important to the advancement of the modern field of entomology. At a time when most people believed that life arose spontaneously from matter—thinking, for example, that moths sprang from old wool—Merian meticulously documented metamorphosis and conclusively linked caterpillars to moths and butterflies. Her work is celebrated for its scientific accuracy, and her depictions of insects in their natural context, including plants and other species, anticipated the field of ecology.

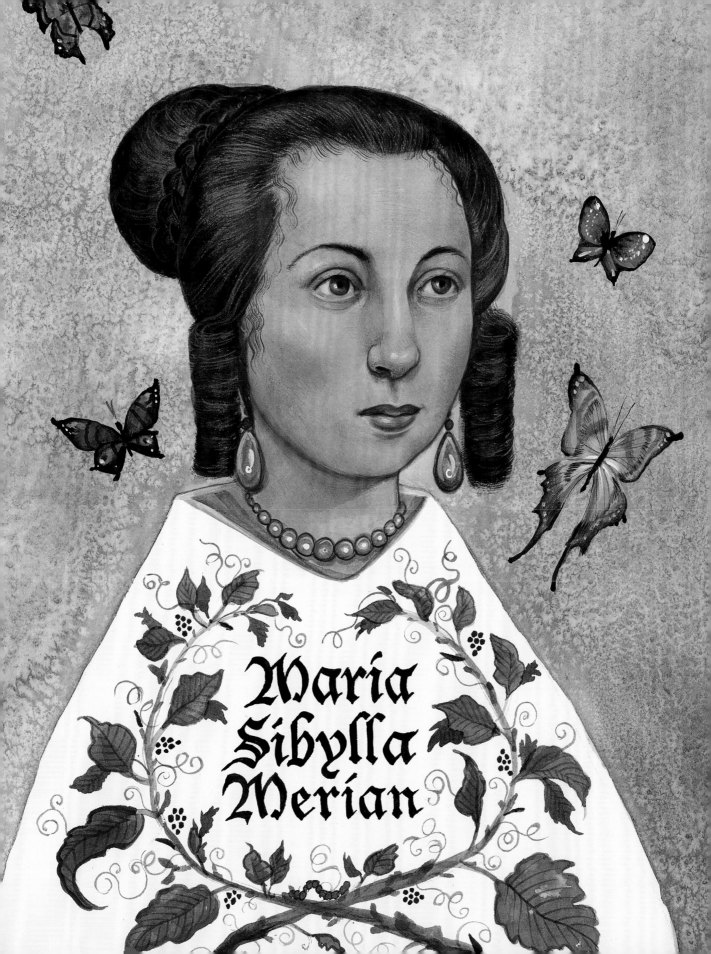

Maria
Sibylla
Merian

LADY MARY WORTLEY MONTAGU

(1689–1762)

was a British aristocrat who moved to Constantinople (now Istanbul) with her ambassador husband and returned to England with news of the first form of a smallpox vaccine. Having nearly died of the disease herself, she was left scarred by the illness. At the time smallpox was killing about four hundred thousand Europeans a year. In Turkey she witnessed something extraordinary: women lightly scratching people's skin and applying some matter from an infected person to provide immunity from the disease. She had her son inoculated there and promoted the procedure when she returned to London. Over time, vaccines became widely used and smallpox was eradicated.

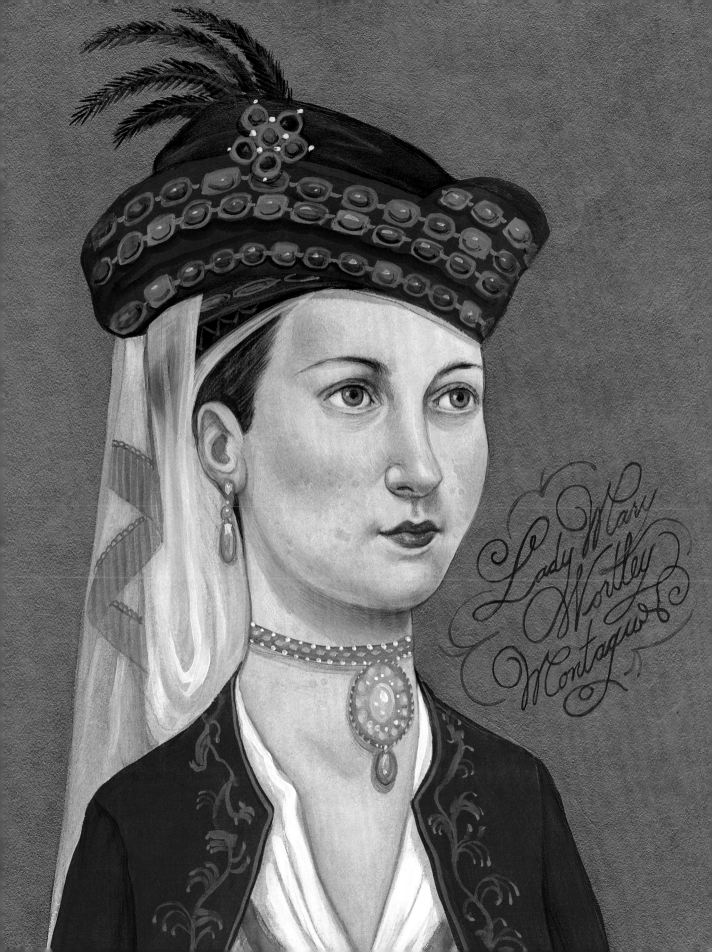

Lady Mary Wortley Montagu

MARIA MONTESSORI

(1870–1952)

one of Italy's first female physicians, was an innovator in childhood education. Montessori developed the method that bears her name based on the way children learn naturally; she believed children learn better when they choose what to learn. The Montessori method emphasizes enhanced social interaction, independence, and the inclusion of children with special needs. In 1907, she opened her first schoolroom, for a group of underprivileged children, in Rome. The students responded well to her pedagogical approach, which soon became popular in western Europe. Today there are numerous Montessori schools around the world.

maria montessori

TONI
MORRISON

(1931–2019)

born Chloe Ardelia Wofford, was an American novelist, essayist, book editor, and professor. Famous for her powerful and richly expressive examinations of the experience of Black women in an unjust world, Morrison won the Pulitzer Prize in 1988 for her novel *Beloved*. In 1993 she became the first African American woman to win the Nobel Prize in Literature, as an author "who in novels characterized by visionary force and poetic import, gives life to an essential aspect of American reality." President Barack Obama awarded Morrison the Presidential Medal of Freedom in 2012.

FLORENCE NIGHTINGALE

(1820–1910)

was a British social reformer, writer, and statistician who is considered the founder of modern nursing. Nightingale became known as the Lady with the Lamp during the Crimean War, when she and the team of nurses she had trained cared for injured British soldiers. By correcting horrific sanitary conditions and making other improvements to the soldiers' care, Nightingale reduced the death rate. She then founded the nursing school at St. Thomas' Hospital in London, which raised the profile of the profession and taught the methods she had developed through meticulous collection and analysis of data. Nightingale accomplished all this in a period and place when women faced considerable social restrictions.

Florence Nightingale

QUEEN NZINGA

(1 5 8 3 — 1 6 6 3)

ruler of Ndongo and Matamba, located in present-day Angola, was a resilient leader who fought against Portuguese colonization. Regarded as an excellent military and political tactician, she formed complicated alliances with former rival states to defend her territory. The queen led her army in a thirty-year war against the Portuguese, often employing guerrilla tactics. Nzinga's influence continued long after her death; during the twentieth-century war for Angolan independence, nationalists embraced her as a symbol of freedom. Her legacy is complicated due to her controversial strategies, but she endures as an icon of resistance.

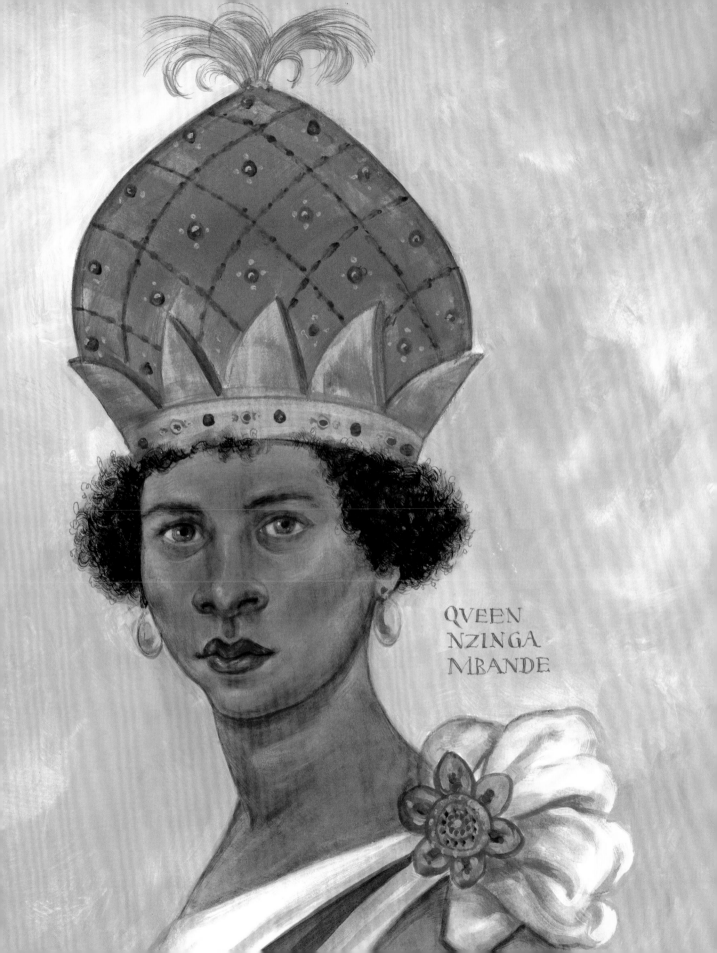

QVEEN
NZINGA
MBANDE

FREDDIE OVERSTEEGEN

(1925 – 2018)

was a Dutch Resistance fighter who killed Nazis and sabotaged their plans. She joined the Resistance at the age of fourteen, and together with her sister and a friend, Oversteegen would sometimes flirt with a Nazi, take him to a private spot, and then shoot him; at other times she would shoot Nazis in drive-bys from her bicycle. She never revealed how many she ultimately killed. Oversteegen and the two other girls also used dynamite to disable bridges and railroad tracks, and aided Jewish children by smuggling them out of the country. She lived to age ninety-two, but the Netherlands did not properly recognize her until 2014.

CECILIA
PAYNE-GAPOSCHKIN

(1 9 0 0 – 1 9 7 9)

was a British-born American astronomer and astrophysicist who
turned the astronomy world upside down when she concluded in her
PhD thesis that stars were composed of hydrogen and helium, not
heavy materials, as was previously thought. She was the first person
to earn a PhD in astronomy from Radcliffe College. Her PhD thesis
has been called the most brilliant ever written in astronomy. In 1956,
Payne was appointed a full professor at Harvard and became chair of
the astronomy department.

Cecilia Payne-Gaposchkin

AUTUMN PELTIER

(2 0 0 4 –)

is an Indigenous clean-water activist from Wikwemikong Unceded Territory in Canada. Inspired by her great-aunt, whom she succeeded as chief water commissioner of the Anishinabek Nation, she began her advocacy at the age of eight. Addressing the Global Landscapes Forum at the UN, Peltier sought to draw attention to the lack of clean drinking water in Indigenous communities, saying, "We can't eat money or drink oil." She has also appeared at the World Economic Forum in Davos, where she participated in a panel of young environmental activists at age fifteen.

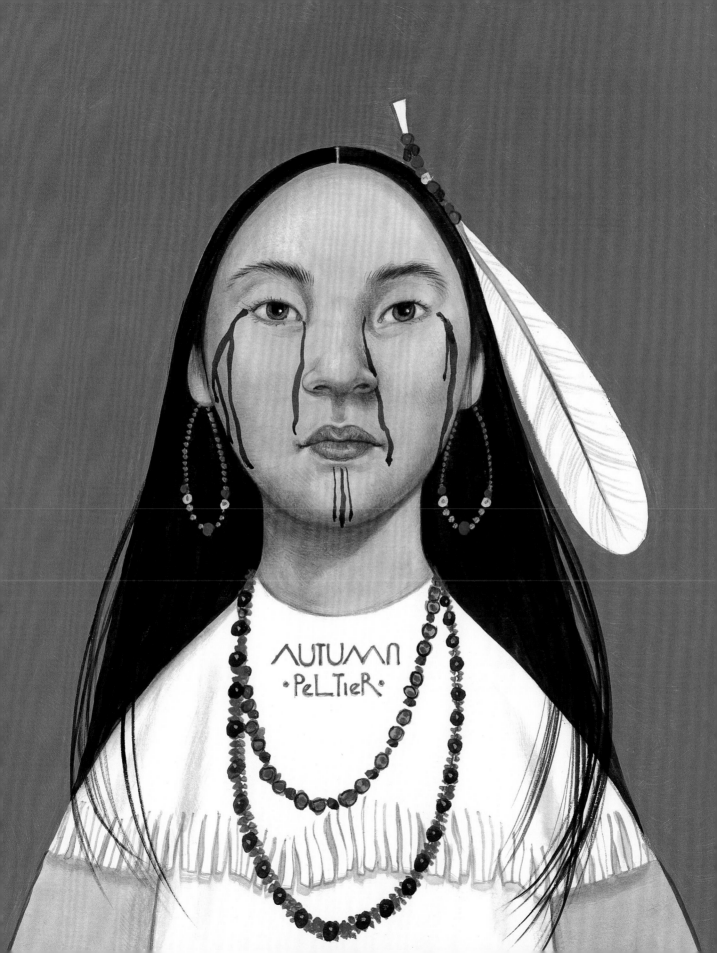

CANDACE PERT

(1946–2013)

was an American neuroscientist and pharmacologist who discovered the brain's opiate receptor. This was the basis for the later discovery of endorphins, which act as the body's natural painkillers. Although Pert's ideas remained anchored in science, her focus shifted to the connections between the mind, the emotions, and physical health. Her thinking about holistic wellness challenged the scientific wisdom of the time. This did not endear Pert to the scientific establishment, but she attracted a lay audience through several popular books. Today her ideas about the mind-body connection are taken far more seriously.

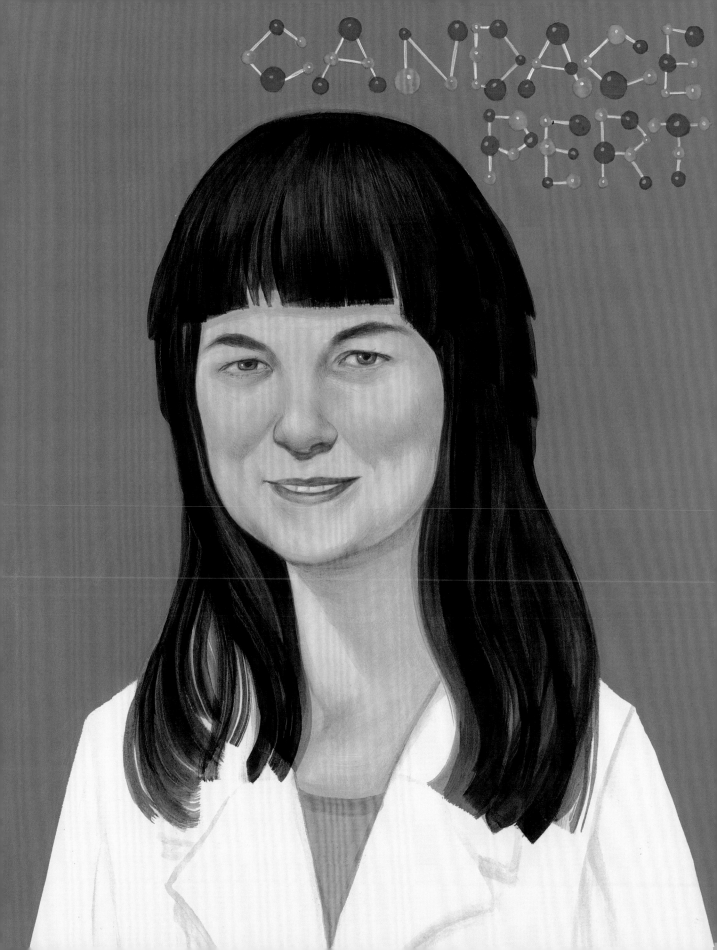

CANDACE PERT

IRNA PHILLIPS

(1901–1973)

was an American actress and writer for radio and TV who developed the modern soap opera. She created, wrote, and starred in what is widely considered the first daytime radio serial, *Painted Dreams*, which debuted in 1930. *The Guiding Light*, another of her radio soaps—so named because their sponsors were soap manufacturers—transitioned to TV in 1952, where it ran until 2009. Known as the Queen of the Soaps, Phillips introduced many conventions of the genre. Her TV serials included *Woman in White* (one of the first hospital soap operas), *Another World*, and the innovative, long-running *As the World Turns*. Although media critics dismissed her work, her programs were widely loved by her largely female audience.

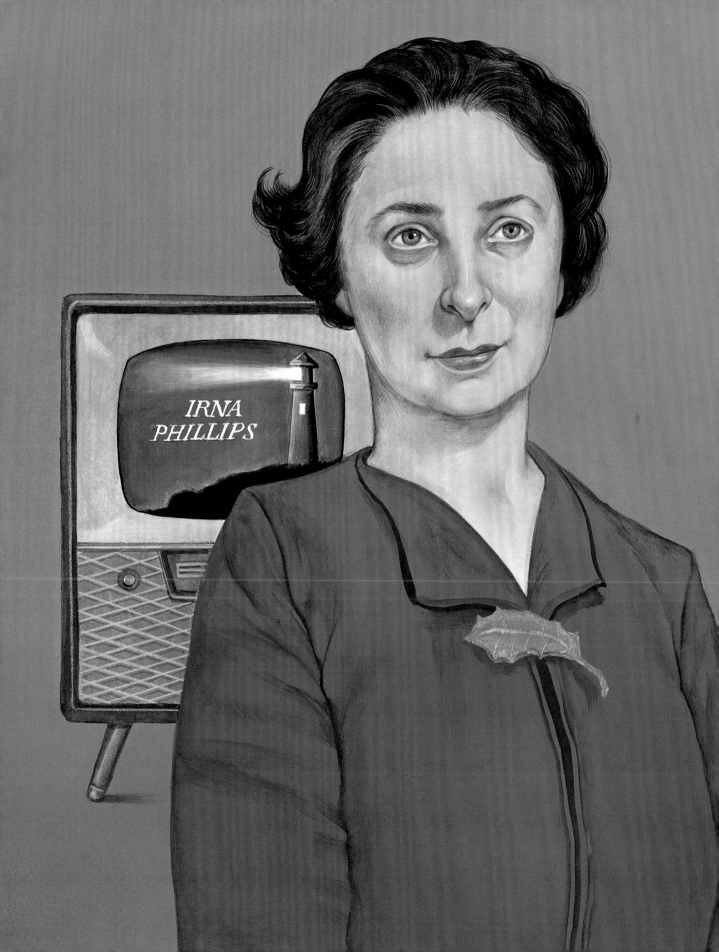

ZOFIA POSMYSZ

(1 9 2 3 –)

is a Polish journalist and author who is best known for her novel *The Passenger*, based on her experiences during the Holocaust. A resistance fighter in Nazi Germany, she was arrested for distributing anti-Nazi leaflets and survived imprisonment at both Auschwitz and Ravensbrück concentration camps. Posmysz drew on these memories for her autobiographical 1959 radio drama, *Passenger from Cabin 45*, which was later adapted for television and film. The drama was also the basis of her most famous novel, which has been translated into fifteen languages and adapted into an opera.

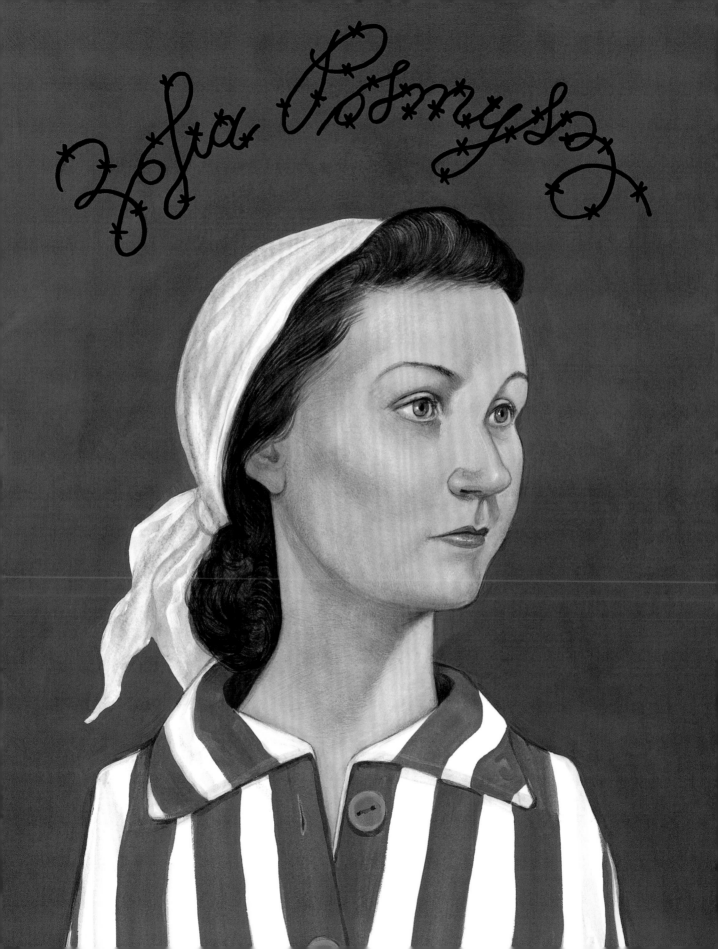

NI GUSTI AYU RAKA RASMI

(1939—2018)

was a virtuosic dancer who introduced the art of Balinese dance to the Western world. As a twelve-year-old member of a troupe called the Bali Dancers, she became famous for her exceptional charm and grace. Many Americans first saw the stylized dance form, which features elaborate costumes and sinuous movements, when the troupe appeared on Ed Sullivan's TV variety show as part of their 1952 tour. Among the celebrities the young dancer met on that life-changing tour were Frank Sinatra, Walt Disney, and the renowned ballerina Margot Fonteyn. Raka Rasmi is remembered as one of the finest Balinese performers and instructors of her era.

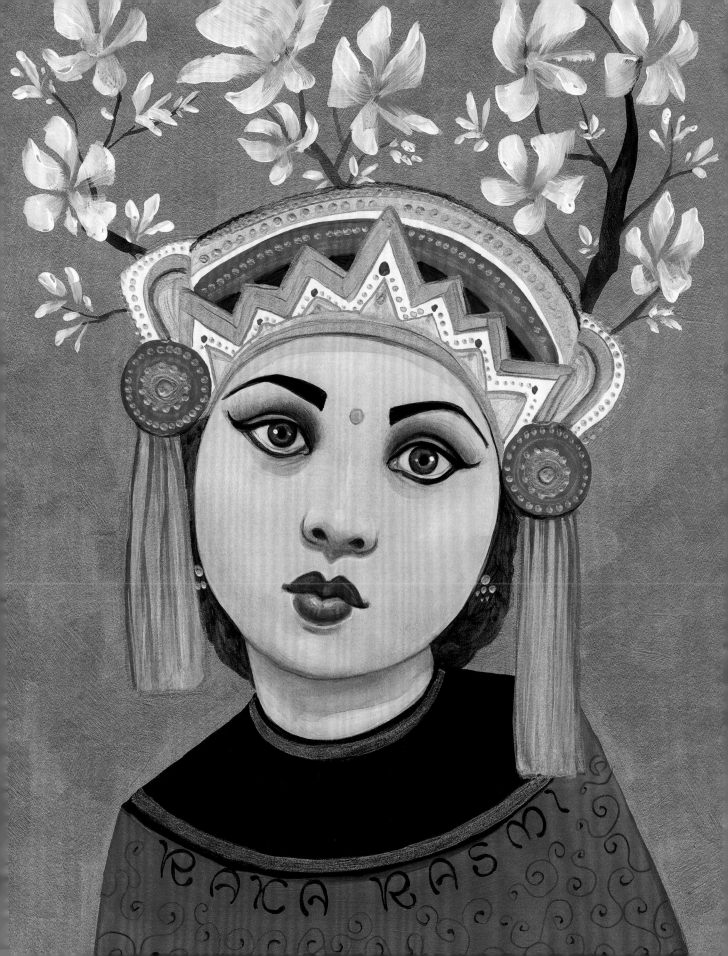

ÁNGELA
RUIZ ROBLES
(1 8 9 5 – 1 9 7 5)

was a Spanish teacher and writer who invented an analog precursor to the ebook. She developed the device, which she called the Mechanical Encyclopedia, in part to ease the burden on her students, who regularly carried around several heavy books. Her lightweight invention was easy to use and interactive; it also allowed for magnification and illumination of the texts and illustrations. Ruiz Robles believed her invention would facilitate learning and make reading more accessible and enjoyable. Although she obtained patents for her initial design in 1949, as well as an updated version in 1962, she never secured the financing to get either manufactured. Nonetheless, Ruiz Robles was clearly ahead of her time.

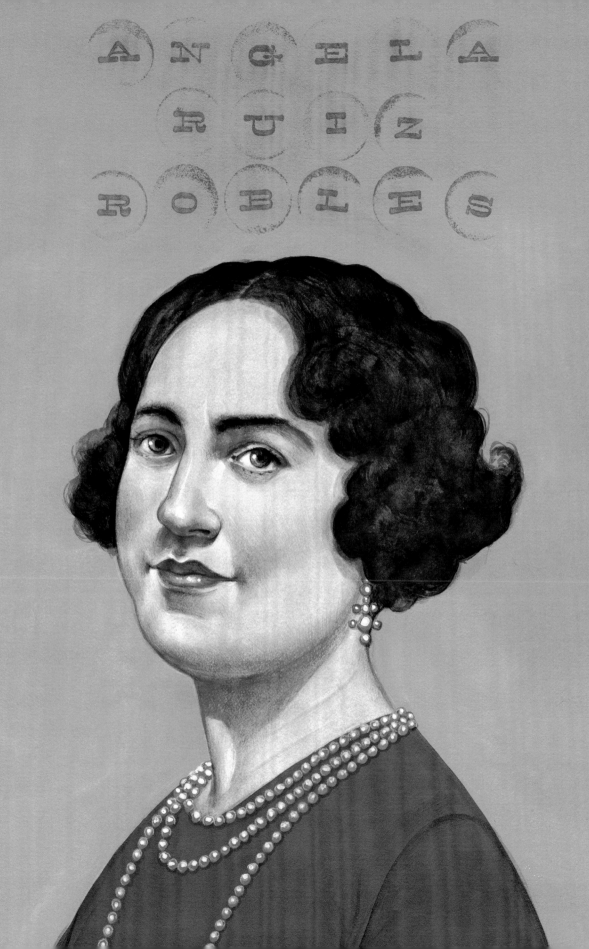

ANGELA
RUIZ
ROBLES

AUGUSTA SAVAGE

(1892−1962)

an educator and social activist who championed Black artists, was also an important portrait sculptor. She started sculpting as a child, using the natural clay from her yard in Florida. Her minister father thought this was sinful and punished her. However, she eventually found encouragement and recognition from others and moved to New York City to pursue her career. One of the leading artists of the Harlem Renaissance, Savage was commissioned to create the massive "Lift Every Voice and Sing," also known as "The Harp," for the 1939 New York World's Fair. Much of her work, including "The Harp," is lost to history because it was made of plaster, and Savage could not afford to cast her work in bronze.

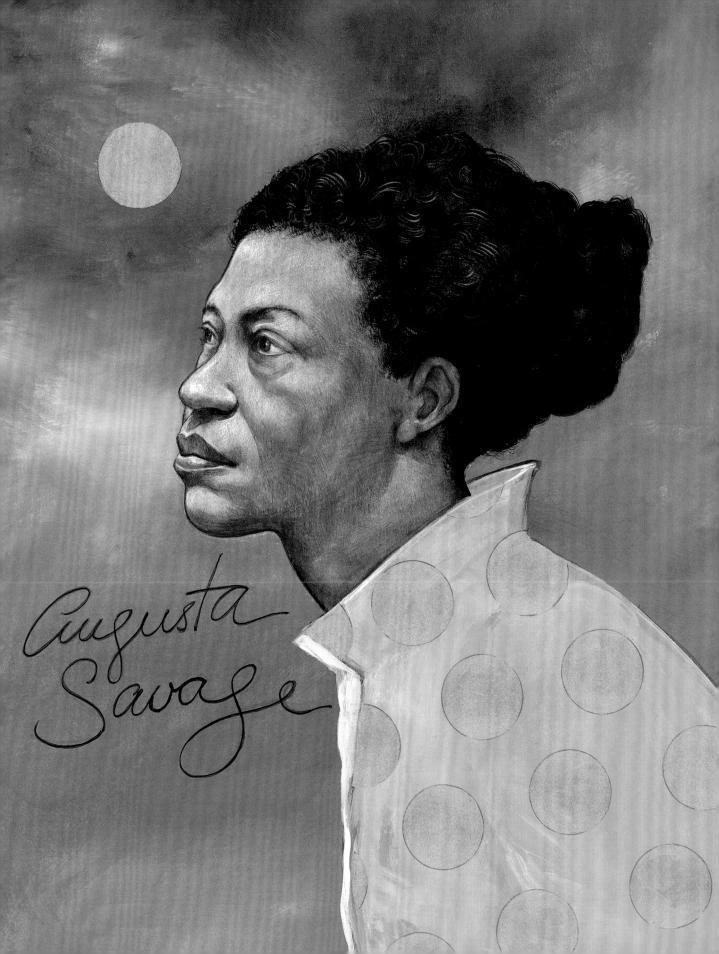

Augusta Savage

MILUNKA SAVIĆ

(1888–1973)

was a Serbian war hero who is reputed to be the most-decorated female combatant in modern history. When her brother was drafted to serve in the First Balkan War, she took his place, cutting her hair short and pretending to be male. Savić headed for the front lines and soon saw action, displaying heroism in numerous battles in the First and Second Balkan Wars. She again risked her life for family and country in World War I. Among her international honors were the French Croix de Guerre and Legion of Honor and the Russian Cross of St. George. After the war, she was taken out of active service and worked for some time as a cleaning woman. Despite her illustrious past, she died penniless.

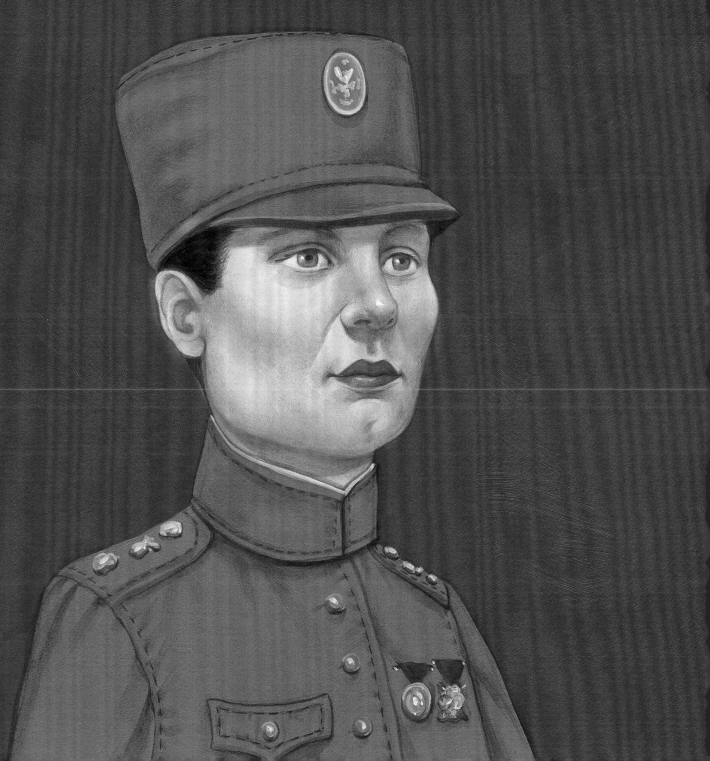

Милунка Савић

SOPHIE SCHOLL

(1921–1943)

was a German anti-Nazi political activist. While studying at the University of Munich, she became a member of the White Rose, a nonviolent student-run resistance group that published anti-Nazi leaflets. Seen distributing these leaflets, Scholl was arrested, convicted of high treason, and ultimately guillotined. She was twenty-one years old. Her final words were "Such a fine, sunny day, and I have to go . . . What does my death matter, if through us, thousands of people are awakened and stirred to action?"

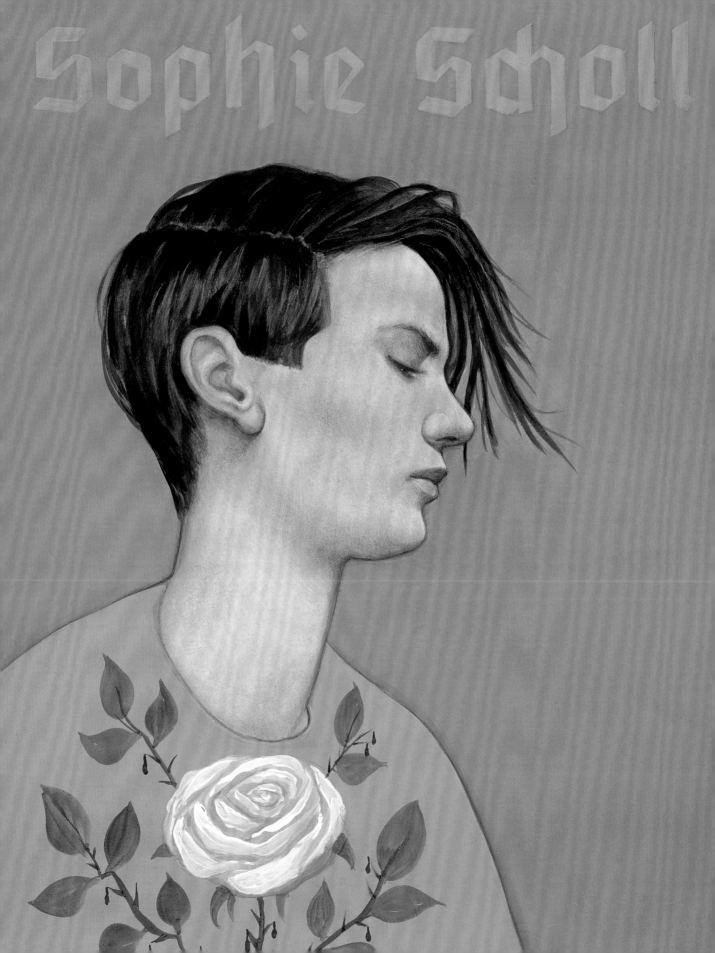

IRENA
SENDLER
(1910−2008)

a Polish humanitarian, social worker, and nurse, rescued numerous
Jews from the Nazis during World War II. She smuggled Jewish chil-
dren out of the Warsaw Ghetto, providing them with false documents
and shelter. The Gestapo arrested Sendler, but despite being tor-
tured, she never revealed any compromising information. On the
day she was to be executed, Sendler was released thanks to fellow
activists who had bribed her guards. She lived in Warsaw for the
remainder of her life and died at age ninety-eight.

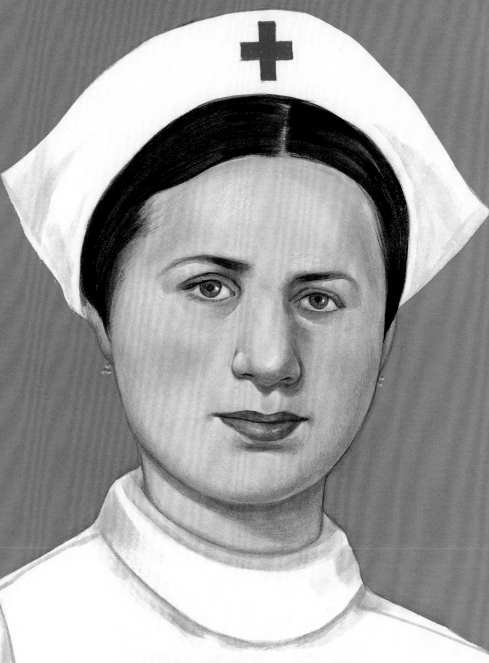

IRENA SENDLER

HUDA SHAARAWI

(1879–1947)

was a key figure in the Egyptian feminist movement. In 1908, she founded a female-run philanthropic organization to serve poor women and children. Soon after, Shaarawi opened a school that taught girls academic subjects, rather than the usual practical skills. She rebelled against the typical confinement of women to the home or to the harem, where she herself had been secluded. In 1923, as an act of protest, Shaarawi famously removed her face veil in a Cairo train station. That same year she founded the Egyptian Feminist Union, which advocated for women's rights, education, and freedom of movement.

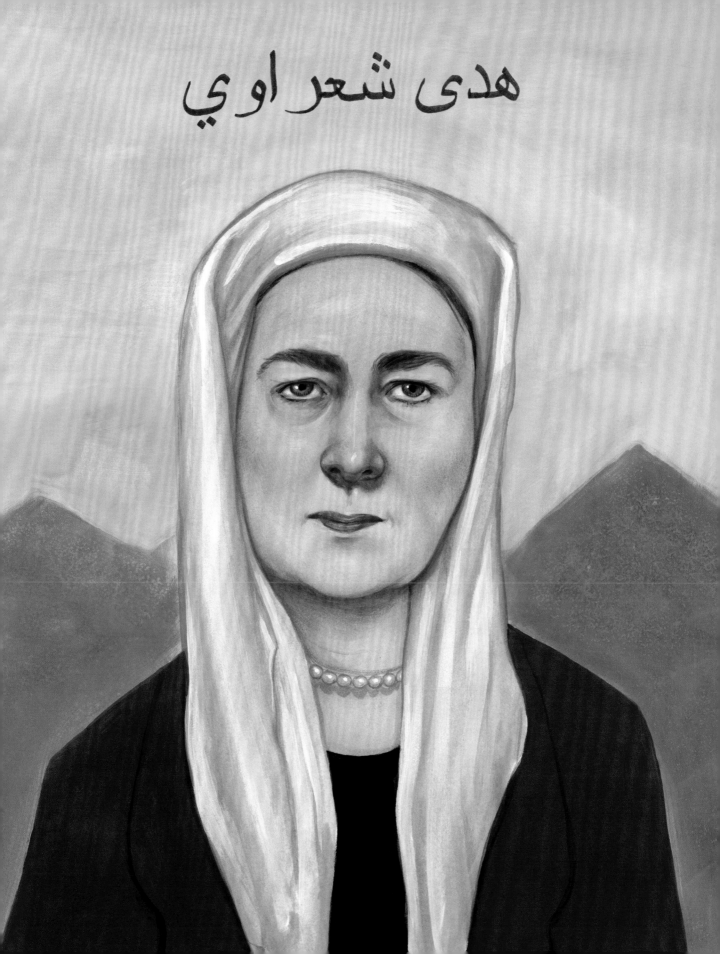
هدى شعراوي

DAPHNE SHELDRICK

(1 9 3 4 – 2 0 1 8)

was a wildlife conservationist who saved more than two hundred orphaned elephants in Africa and Asia. Born in Kenya, Sheldrick first bonded with elephants by caring for orphans her husband, chief warden at a national park, brought home. She became an expert on elephant care and grew to admire their intelligence and sensitivity. Sheldrick once told an interviewer, "They have all of the best attributes of us humans and not very many of the bad." Her work lives on through the David Sheldrick Wildlife Trust, which she founded in honor of her late husband. The organization rehabilitates wild species, fights poaching and the ivory trade, and protects wilderness areas. In recognition of her conservation work, Sheldrick was appointed Dame Commander of the Most Excellent Order of the British Empire (DBE) in 2006.

DAPHNE
SHELDRICK

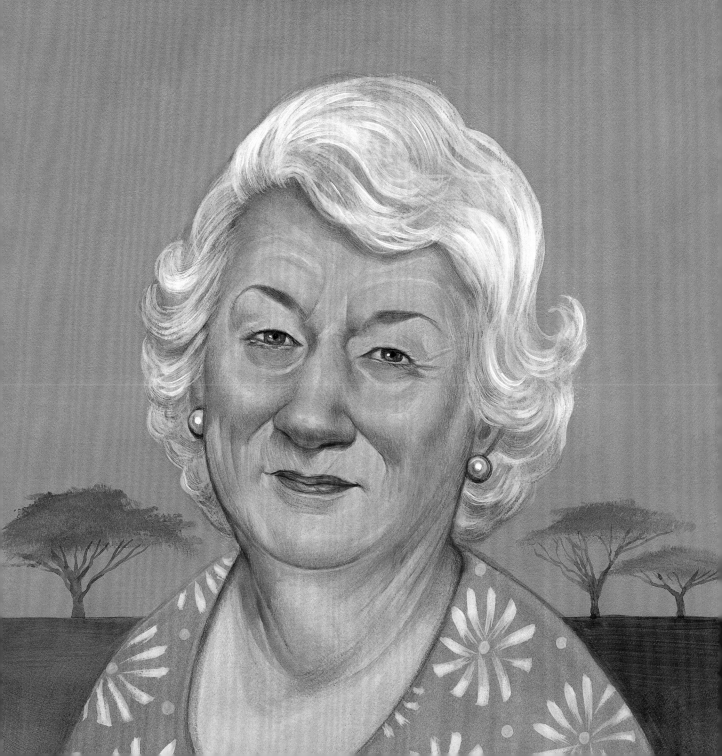

AMRITA SHER-GIL

(1913−1941)

a Hungarian Indian painter, was a pioneer of Indian modernism. Sometimes referred to as India's Frida Kahlo, she painted numerous self-portraits, developed a style that blended Indian themes with modernist techniques, and often depicted village life. Although Sher-Gil did not achieve commercial success during her lifetime, her paintings are now among the most expensive by an Indian woman artist. Because her works are considered so important to Indian culture, the government has ruled that they must remain in the country. As a result, fewer than ten of Sher-Gil's paintings have been sold outside of India. She died at twenty-eight, just days before the opening of her first major solo show.

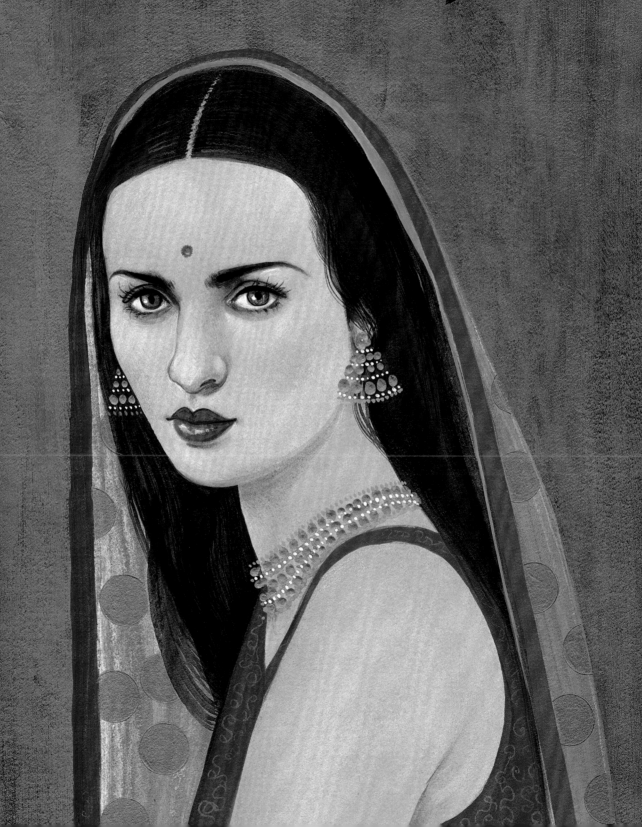

amritasher·gil

NINA
SIMONE

(1 9 3 3 – 2 0 0 3)

born Eunice Kathleen Waymon, was a legendary American pianist, singer, and songwriter as well as a voice of the civil rights movement. A child prodigy, she learned to play piano at the age of three and accompanied the choir at her mother's church. Simone's musical style drew on her classical training in addition to jazz, blues, folk, R&B, gospel, and pop. The singer lived for many years in France, where she was diagnosed for the first time with manic depression and bipolar disorder. Despite her personal difficulties, Simone continued to perform, ultimately in venues befitting her stature. In these later performances, she improvised freely and interacted with her captivated audiences. Simone died in her sleep at the age of seventy at her home in France.

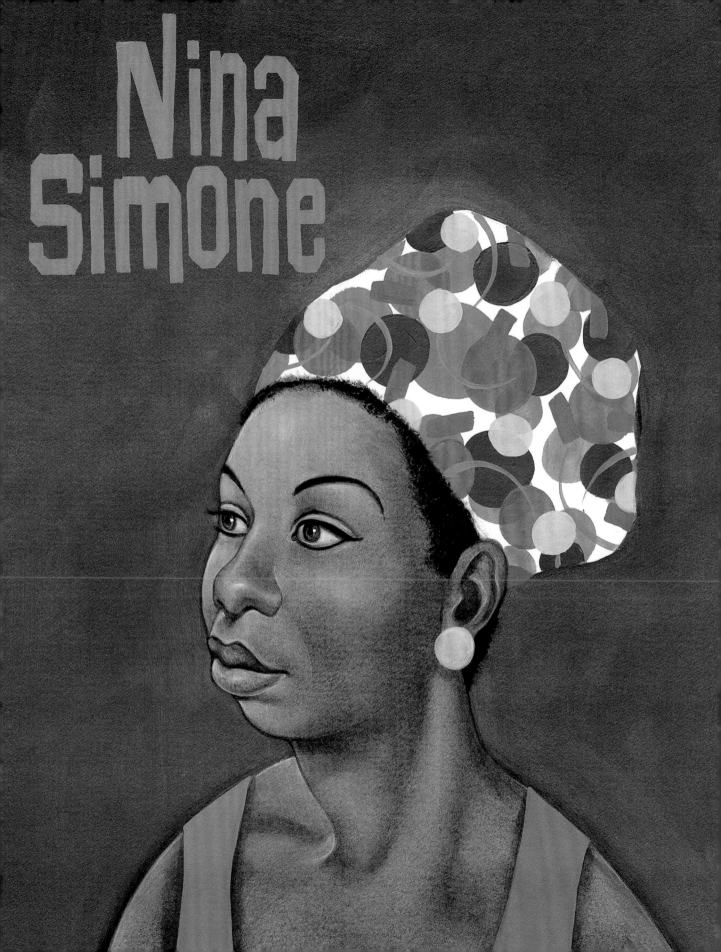

GLORIA
STEINEM

(1 9 3 4 –)

is an American writer, lecturer, political activist, and feminist orga-
nizer who emerged as a leader of the U.S. women's rights movement
in the late 1960s and early '70s. She graduated from Smith College
and became a journalist, writing about issues such as contraception,
sexual harassment, and abortion rights; covering political cam-
paigns; and cofounding *Ms.* magazine. Steinem continues to fight for
women's rights and social justice.

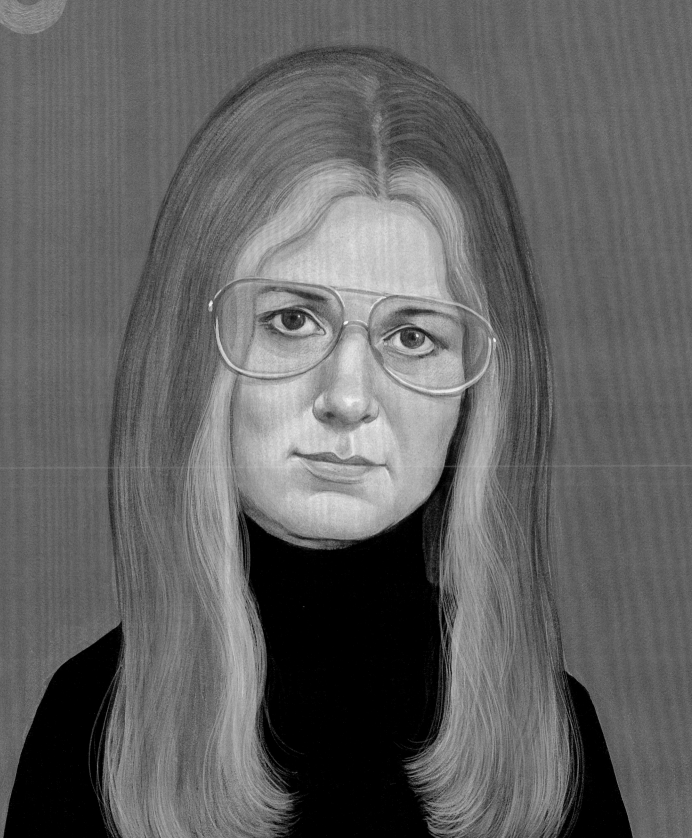
Gloria Steinem

NETTIE
STEVENS

(1861–1912)

was an American geneticist and biologist who identified what we now know as the X and Y chromosomes. In 1905 she published her findings, which supported the theory that the sex of an organism is determined by chromosomes. But that year another scientist, Edmund Beecher Wilson, came to the same conclusion, and many credited Wilson alone for this discovery. Although Stevens died at only age fifty, she published nearly forty papers in her brief yet remarkable career.

Nettie Stevens

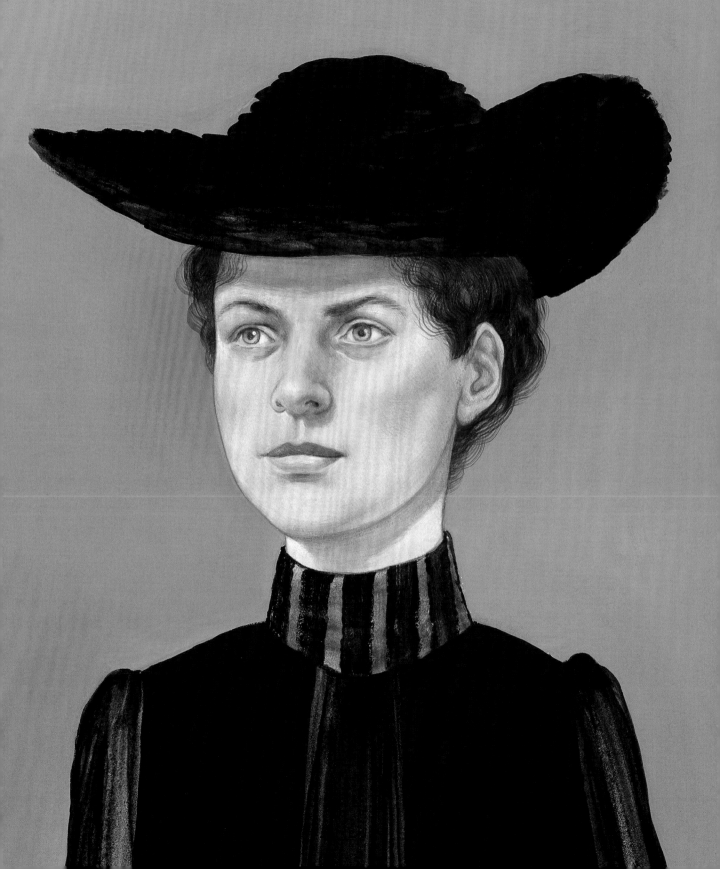

CEIJA STOJKA

(1933–2013)

was an Austrian Romany artist who survived three Nazi concentration camps and created more than a thousand paintings based on her experiences. Between the ages of ten and twelve, she suffered unthinkable cruelty as a prisoner at the Auschwitz, Ravensbrück, and Bergen-Belsen camps. It is estimated that between 200,000 and 500,000 of her fellow Romany were murdered during World War II. In 1992, Stojka became the Austrian spokesperson for the recognition of this genocide. She also addressed the discrimination that the Romany continue to endure in Europe.

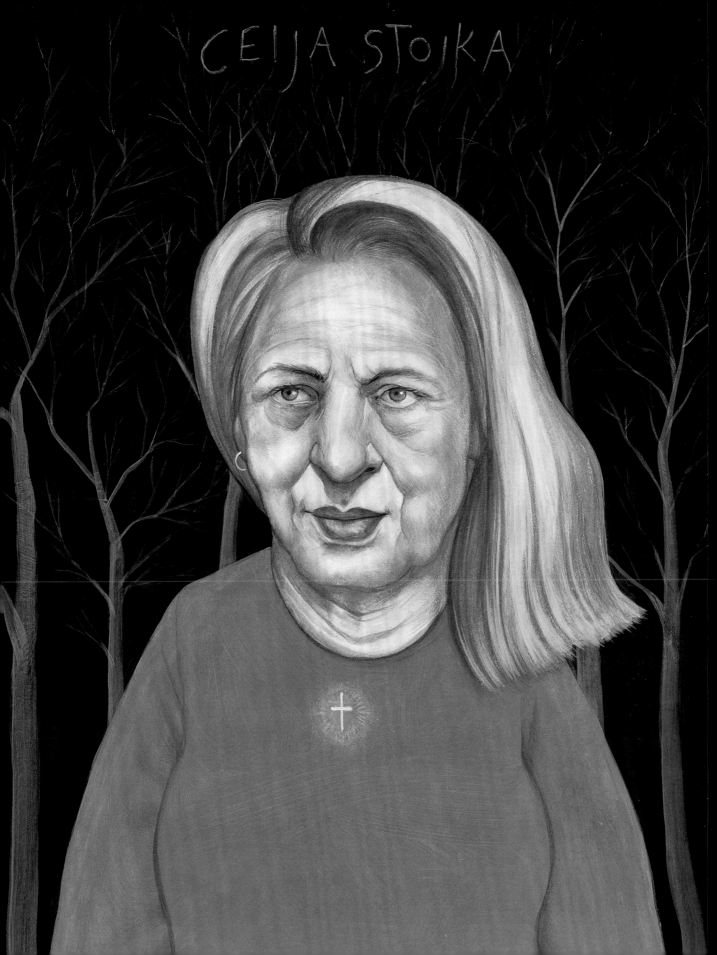

MARIA STRICK

(1577–CIRCA 1631)

also known as Maria Becq, was a prominent Dutch calligrapher, educator, and author. She began teaching at her father's school in Delft, then a great center for calligraphy. Strick took over the school on his death and later continued teaching in Rotterdam. Especially renowned for her italic script, Strick was the only woman to publish copybooks of calligraphy during the art form's golden age in Holland.

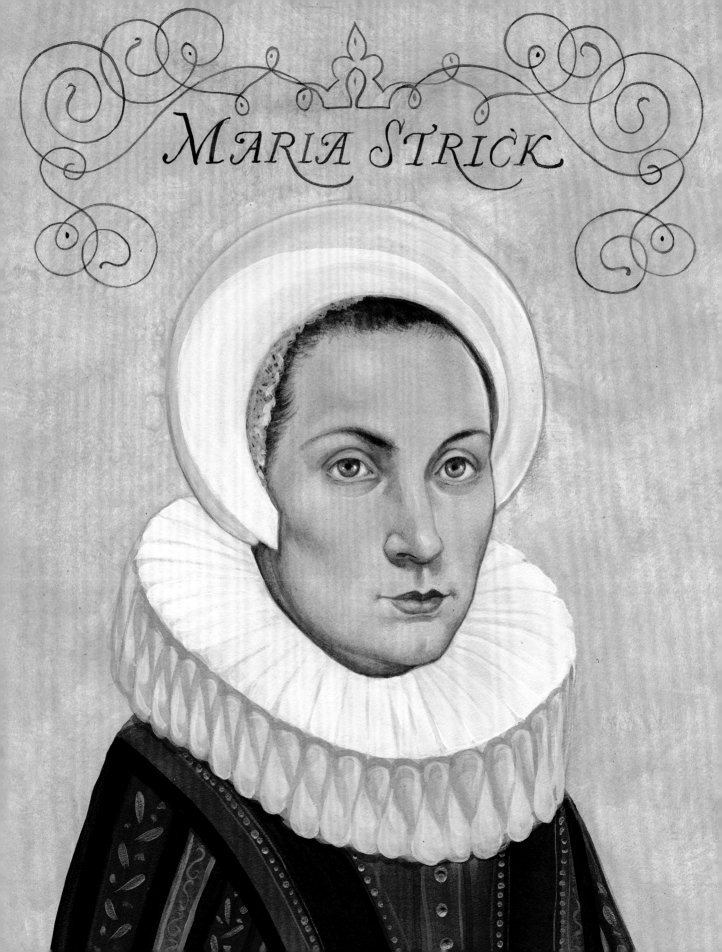

MARIA STRICK

YMA SUMAC

(1922–2008)

was a Peruvian American soprano with a mystical voice and a range of almost five octaves. She combined operatic trills with mambo rhythms, and Andean folk tunes with campy lounge music in a glorious mishmash of international styles. The diva cultivated an "exotic" image, performing in extravagant costumes and makeup. Sumac's claim to be a descendant of the last Inca emperor may have been a Hollywood invention, but it was endorsed by the Peruvian government. At the height of her popularity, she filled concert halls around the world. In later years, she enjoyed a new wave of popularity among young fans; in 1987 she appeared on *Late Night with David Letterman*. Sumac was the first Peruvian to be honored with a star on the Hollywood Walk of Fame.

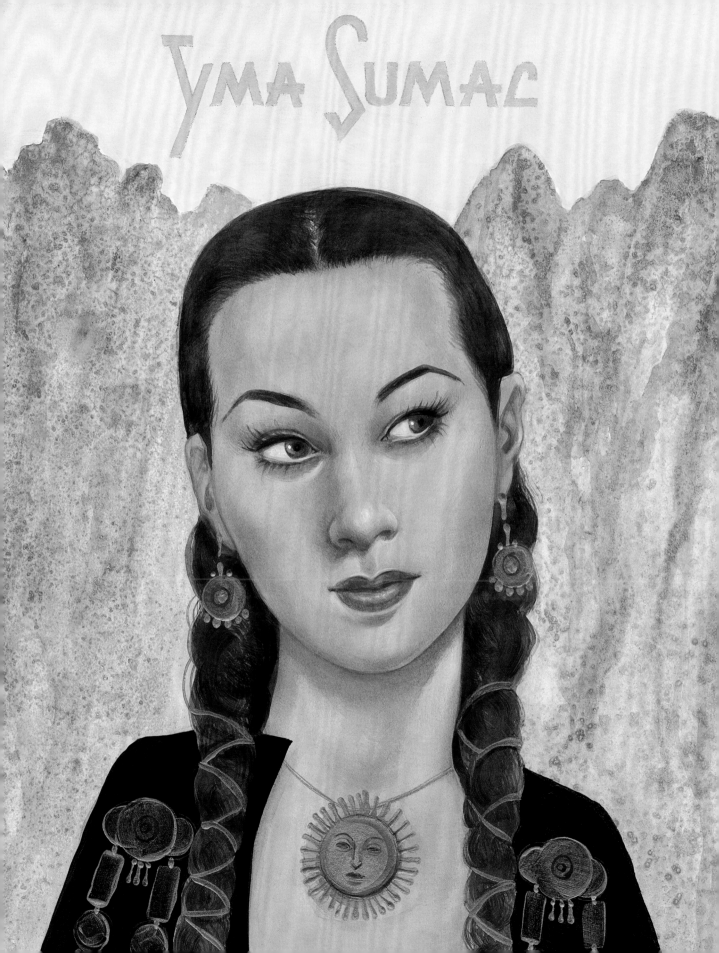

PEGGY JO TALLAS

(1944–2005)

was a soft-spoken Texas woman whose alter ego was the notorious bank robber dubbed Cowboy Bob. Tallas was living with her ailing mother when, in 1991, she first donned a cowboy hat, sunglasses, and a fake beard to rob a bank. She never used a weapon. Tellers remarked on the thief's politeness, while law enforcement marveled at the robber's calm and efficiency. Nobody suspected the culprit was a woman, which helped her elude capture until 1992. After serving several years in prison for her crimes, Talley was released and maintained a low, law-abiding profile—until, at the age of sixty, she returned to bank robbery. Talley died in a police shootout after her final heist; the gun she had wielded turned out to be a toy.

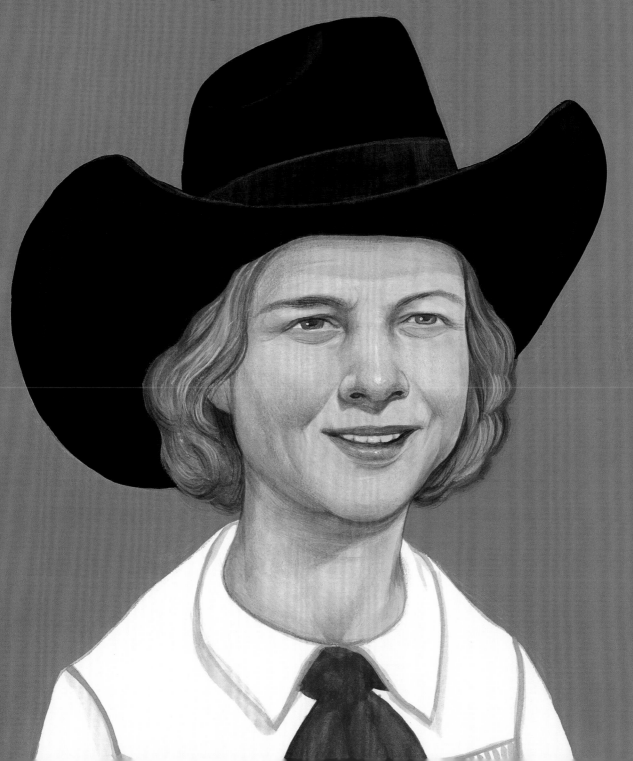

MARIA
TALLCHIEF

(1 9 2 5 – 2 0 1 3)

was the first Native American prima ballerina. Her father, Alex Tall Chief, was a member of the Osage Nation; at a time when her surname could have been a liability, her only concession was to change it to one word. Tallchief began rigorous ballet training at the age of twelve and moved to New York City as a teen to pursue her career. There she met George Balanchine, and when he cofounded the New York City Ballet, she joined the company. Her 1949 performance in the title role of *Firebird*, which Balanchine choreographed for her, made Tallchief a star. Inspired by her speed, athleticism, technical ability, and showmanship, Balanchine created some of his most beloved and enduring ballets for Tallchief. She was inducted into the National Women's Hall of Fame and received a Kennedy Center Honor in 1996. Three years later, Tallchief received the National Medal of Arts.

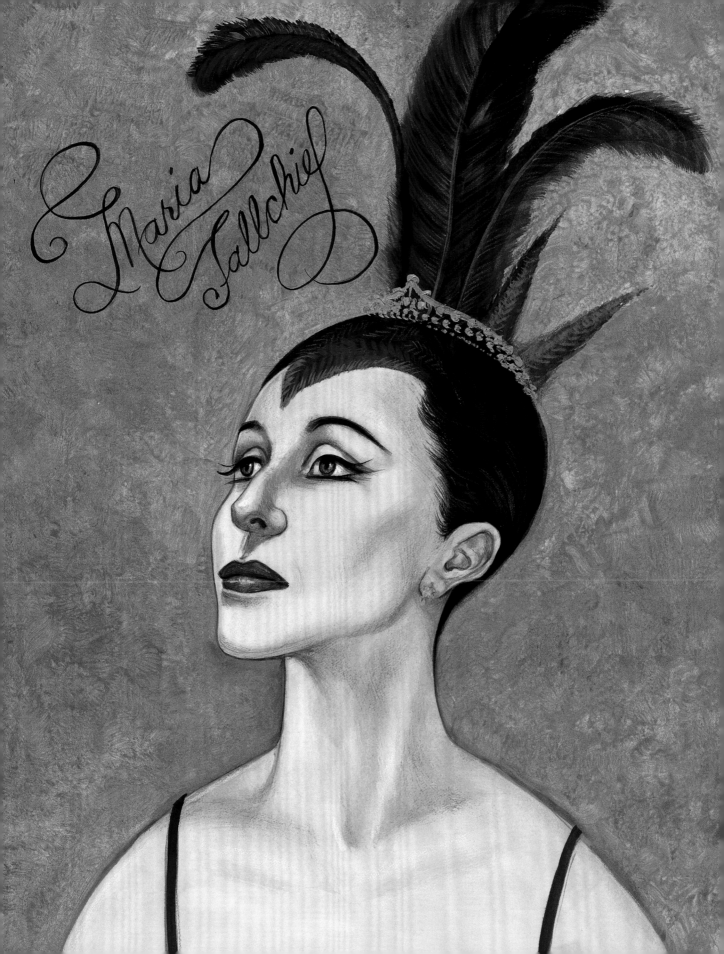

Maria Tallchief

QUEEN TAMAR

(CIRCA 1166−1213)

the first female monarch of Georgia, ruled for nearly thirty years during the kingdom's golden age. Although her father, King George III, designated her his heir, Tamar's ascension to the throne wasn't met with full support. Her authority was challenged in part due to her gender and the perception of her youth as a weakness. Nonetheless, Georgia reached its territorial, political, and cultural peak during Tamar's reign, and she is considered one of the kingdom's greatest medieval rulers. Centuries later, Tamar was canonized by the Georgian Orthodox Church. More recently, she achieved pop-culture fame as one of the featured leaders in the video game *Civilization VI: Rise and Fall.*

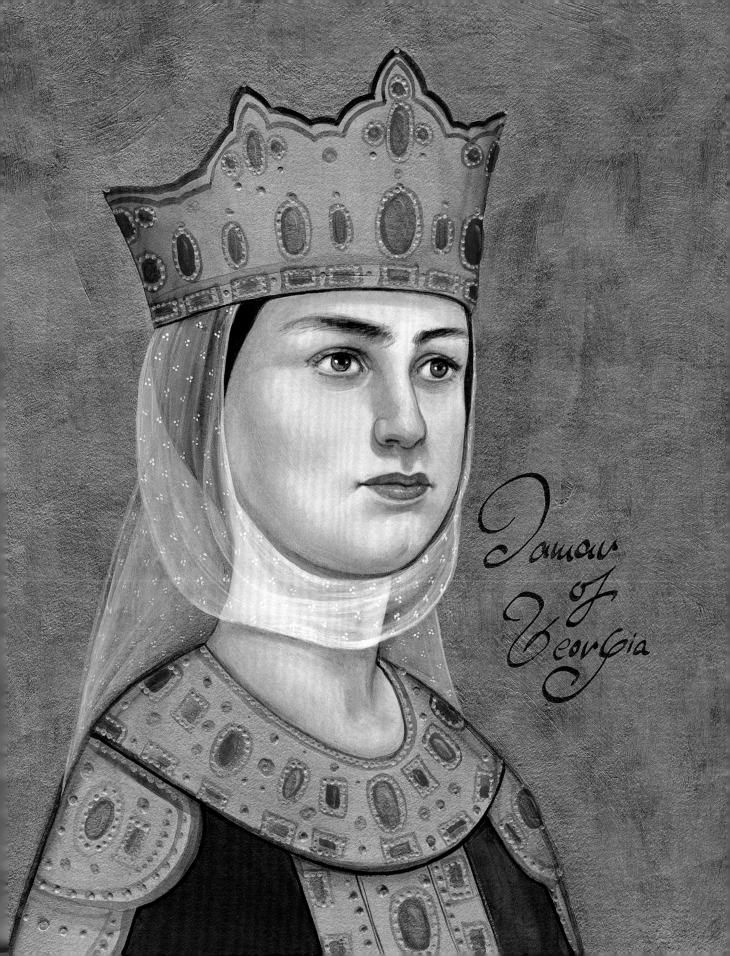

Tamar
of
Georgia

HELEN TAMIRIS

(1 9 0 2 – 1 9 6 6)

was a Jewish choreographer, dancer, teacher, and pioneer of American modern dance. One of the first choreographers to use Black spirituals and jazz in her work, Tamiris focused on social justice themes. She began her career as a ballerina but changed course to create dances that reflected contemporary American reality and incorporated more natural movements. Her most famous works addressed racism, violence, and human suffering. Perhaps because she did not develop a specific technique, Tamiris is not as well known as some of her contemporaries.

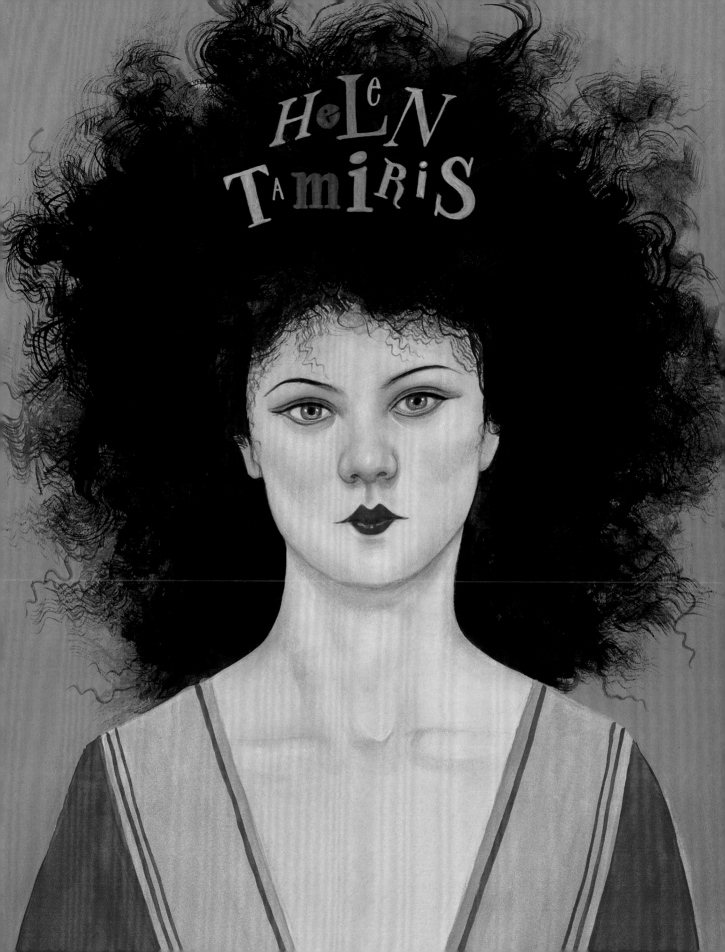

VALENTINA TERESHKOVA

(1 9 3 7 –)

is a Russian former cosmonaut who in 1963 became the first woman to fly in space. Tereshkova volunteered for the Soviet space program in 1961 despite having no experience as a pilot. She did, however, have experience as a parachute jumper, which was especially valuable because in those days, cosmonauts ejected from their spacecraft and performed parachute landings when returning to Earth. Her mission almost turned tragic due to an error in the navigation algorithm, but Soviet scientists quickly changed the trajectory of the capsule. Tereshkova orbited Earth forty-eight times over nearly three days in her space capsule, Vostok 6. Among the many honors she received were the Order of Lenin and the title Hero of the Soviet Union.

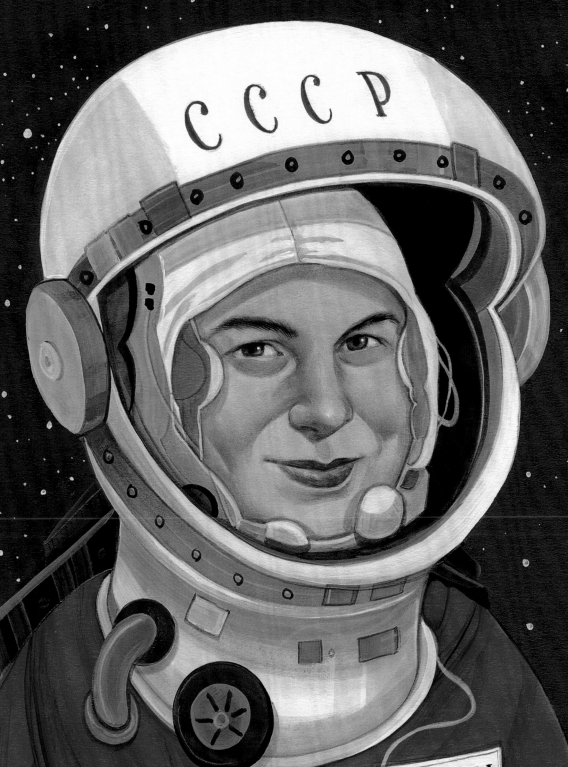

SISTER ROSETTA THARPE

(1915–1973)

an African American singer, songwriter, and guitarist, is now thought of as the Godmother of Rock and Roll. Tharpe's music—featuring her innovative electric guitar style and joyful stomping, singing, and shouting—was a precursor of that genre. The first gospel superstar, Tharpe took her music beyond the church, playing in nightclubs and concert halls. She paved the way for early rock-and-roll stars like Chuck Berry, Elvis Presley, and Jerry Lee Lewis. Johnny Cash and Little Richard praised her. In 1963, Eric Clapton, Jeff Beck, and Keith Richards traveled from London to Manchester to see her perform. Tharpe was finally inducted into the Rock and Roll Hall of Fame in 2018.

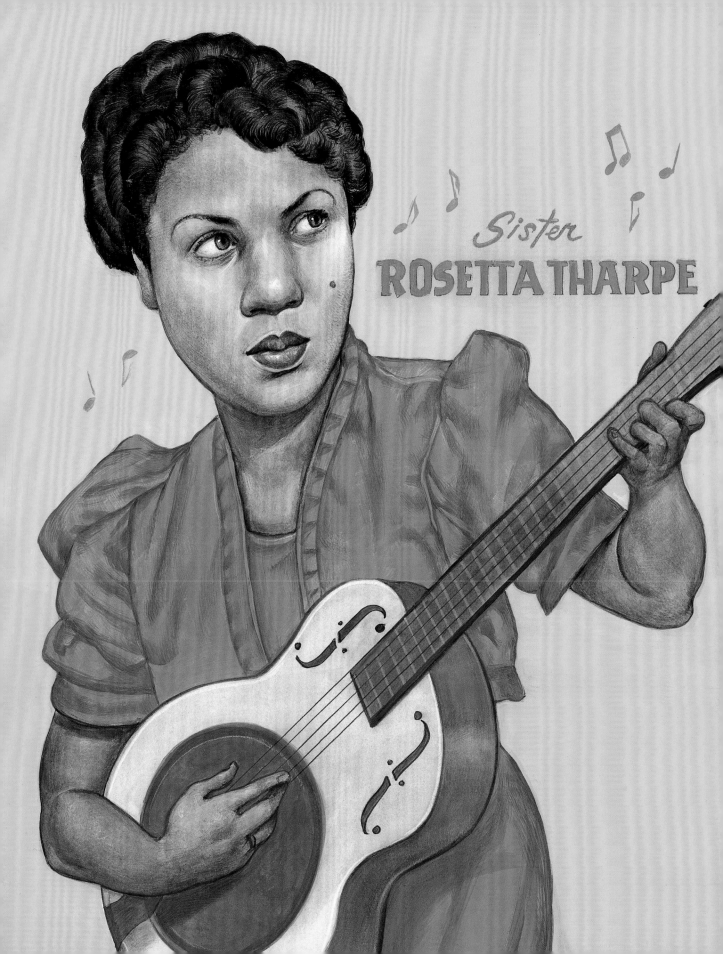

EMPRESS THEODORA

(CIRCA 497–548)

was one of the most powerful women in Byzantine history and a defender of women's rights. She began life in poverty, earned a living as a sex worker and actress, underwent a religious conversion, and met Justinian I while he was heir to the throne. Once Justinian became emperor, he married her and they ruled Byzantium as equals. Theodora worked to make divorce laws more favorable to women, protect trafficked girls, close brothels, and increase the penalty for rape. Her active role in politics was unprecedented for a woman in the Byzantine Empire.

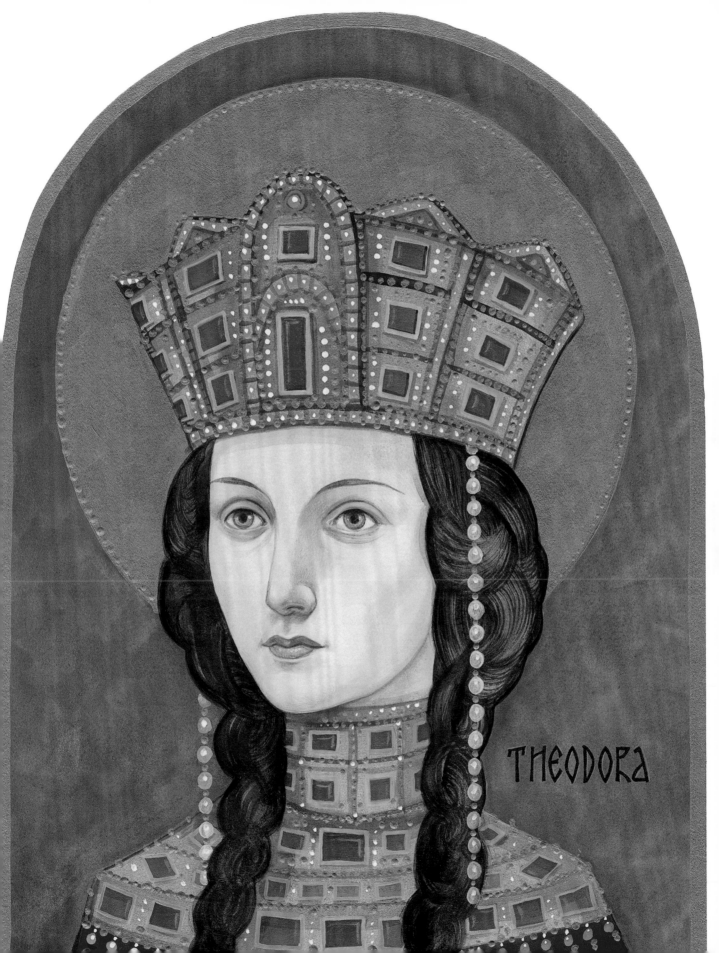

THEODORA

GRETA THUNBERG

(2003–)

is a Swedish environmental activist who has raised awareness of climate change as an international crisis and confronted world leaders for not doing enough to address this catastrophe. At age fifteen she began to skip school, spending her days on strike outside the Swedish Parliament. Her protest quickly went viral, other students began to protest as well, and similar strikes grew increasingly common across the globe. By 2019, these protests had become more coordinated, with some attracting as many as a million students. Twice nominated for the Nobel Peace Prize, Thunberg was named *Time* magazine's Person of the Year for 2019, the same year she made the *Forbes* list of the World's 100 Most Powerful Women.

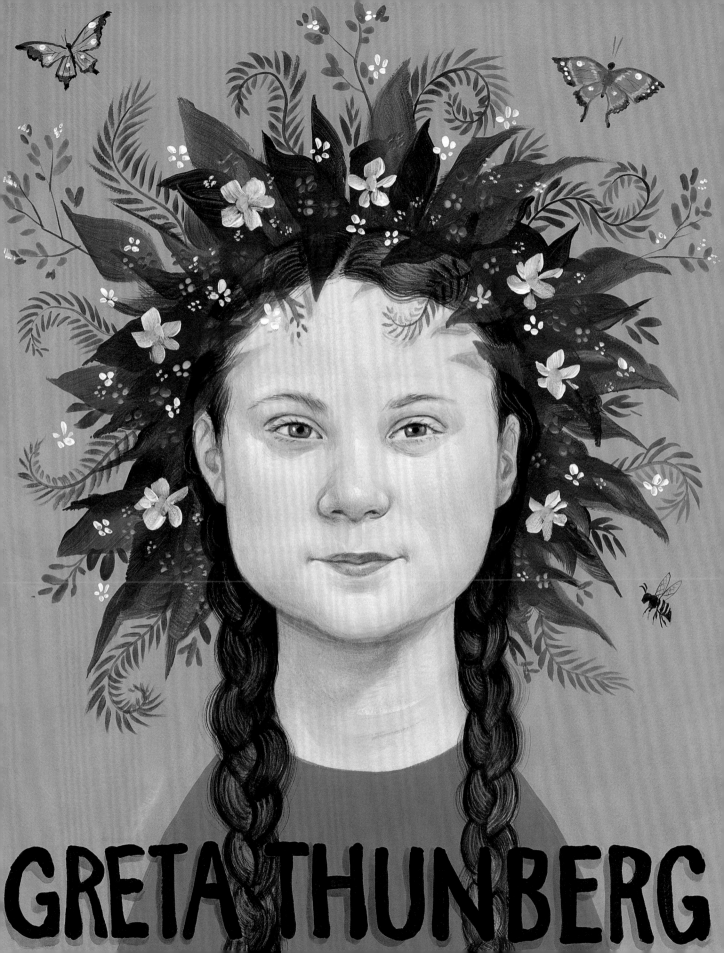

GRETA THUNBERG

TROTA
OF SALERNO

(TWELFTH CENTURY)

was a medieval medical practitioner and writer. One volume of the leading text on women's medicine in medieval Europe has been attributed to her. Trota's contributions to the three-volume work, known as the *Trotula*, focused on gynecology. Some of the treatments seem bizarre by today's standards, yet they offer a glimpse of the medical theories of the time. As the *Trotula* was edited, translated, and analyzed over the centuries, its authorship became obscured. One scholar attributed the three volumes to a single person, while another attributed it to a man. As a result, Trota had been erased from history until an authentic medical text by her was rediscovered in the twentieth century.

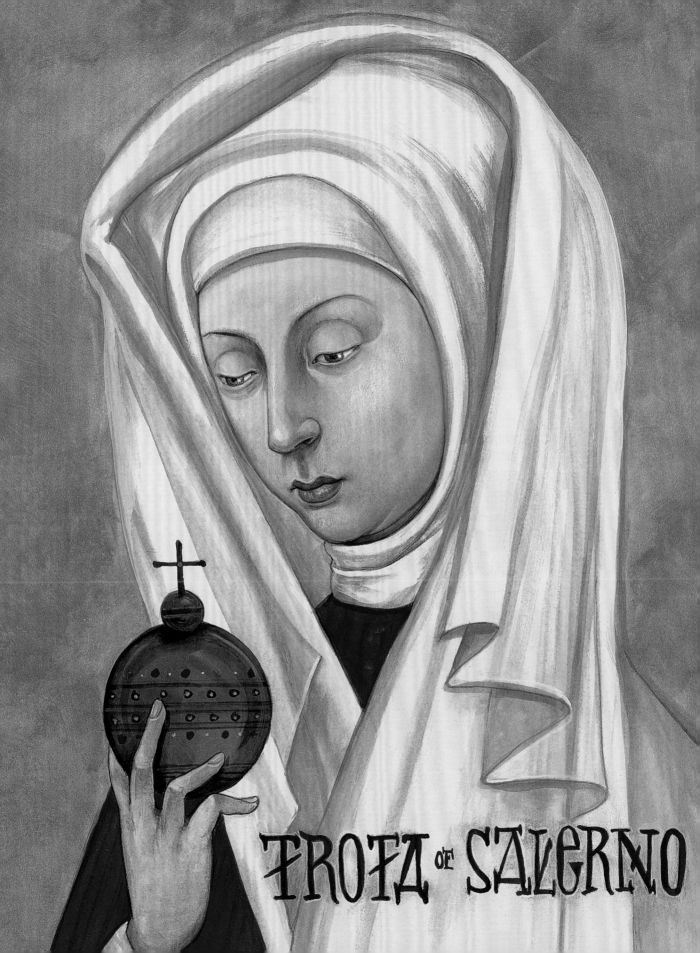

TROFA OF SALERNO

SOJOURNER TRUTH

(1 7 9 7 – 1 8 8 3)

was an abolitionist and women's rights activist. Born into slavery, she escaped to freedom with her infant daughter. Truth later went to court to obtain freedom for her son, making her one of the first Black women to successfully sue a white man. A powerful and charismatic speaker, she traveled the country advocating for the abolition of slavery. One of her most famous addresses, which become known as the "Ain't I a Woman?" speech, argued for equal rights for African American women. During the Civil War, Truth helped recruit Black men to join the Union army and helped obtain supplies for troops, which led to her meeting with President Abraham Lincoln. After the war, she assisted freed slaves with building new lives. In 2014, *Smithsonian Magazine* named Truth as one of the 100 Most Significant Americans of All Time.

Sojourner Truth

REMEDIOS VARO

(1908−1963)

was a Spanish-born artist who played a pivotal role in Mexico's sur-
realist movement yet gained little recognition in the United States
and Europe. While living in Paris, Varo associated with a group of
prominent surrealists; however, many men in that circle viewed
women as muses, not serious artists. She fled Europe during World
War II, settling in Mexico, where her creativity ultimately flourished.
Varo's dreamlike, finely detailed paintings incorporate references to
religion, magic, alchemy, mysticism, and psychoanalysis. She often
depicted women in confined spaces and utilized metaphors such as
cages and towers, which some have interpreted as her response to
women's oppression under patriarchy.

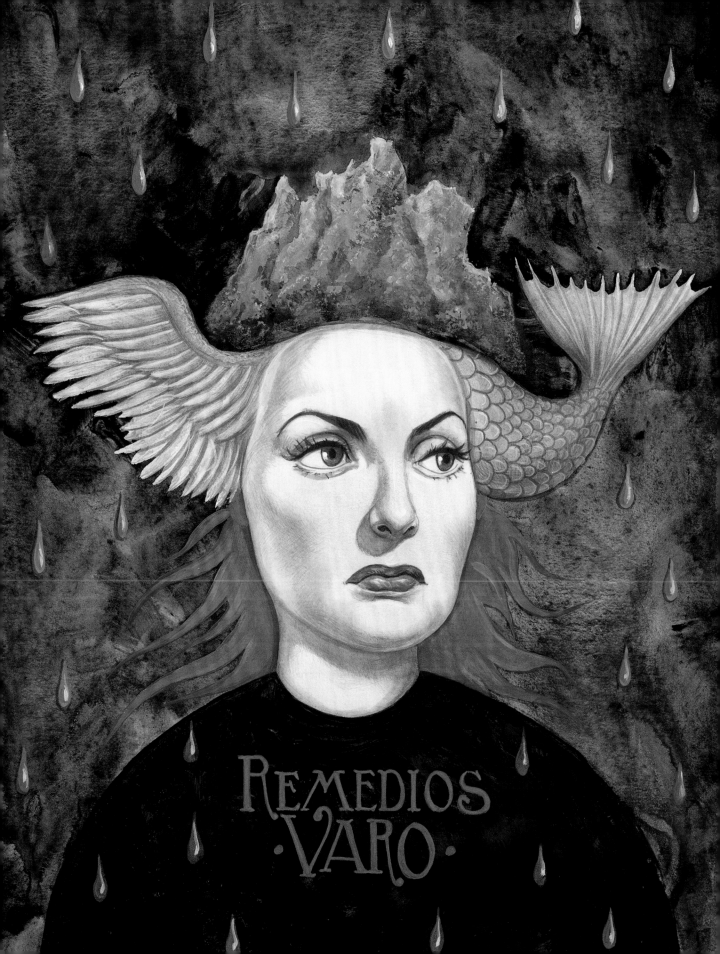

MAUD
WAGNER

(1877–1961)

was an American circus performer and the first female tattoo artist in the United States. An aerialist and contortionist, Wagner worked in traveling circuses and was featured in sideshows as an "inked woman." Her husband, Augustus "Gus" Wagner, promoted himself as the "world's champion hand tattoo artist." The Wagners were two of the last tattoo artists to work by hand, using the so-called stick-and-poke method, without the aid of motorized instruments. Their daughter, Lovetta, carried on the family tradition by becoming a tattoo artist herself.

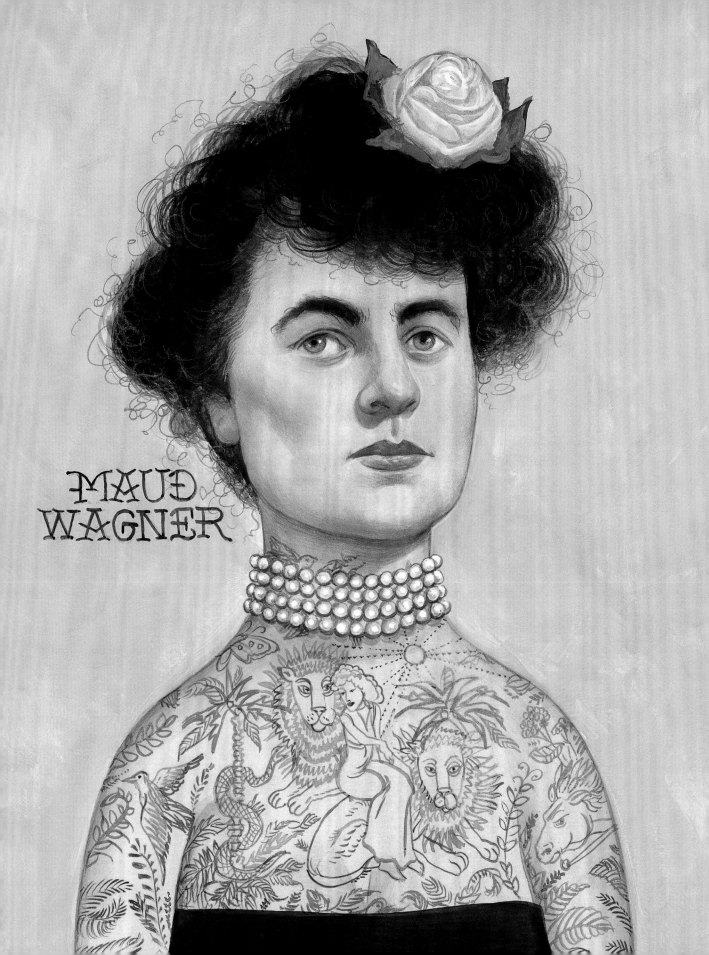

MADAM C. J. WALKER

(1867—1919)

born Sarah Breedlove, was an entrepreneur who rose from poverty to become the first female self-made millionaire in America. Motivated by her own hair loss, she developed a product specifically for Black women to promote hair growth. Under her new name, Walker established the business she would grow into an empire that offered a full line of African American hair care and beauty products and employed a sales force of thousands. As her wealth increased, so did her political and philanthropic activity, including her lifelong support of Black business, civic, educational, and cultural institutions. An outspoken anti-lynching campaigner, she was a major contributor to the NAACP's anti-lynching fund.

MADAM C.J. WALKER

MARY EDWARDS WALKER

(1832–1919)

was the only woman ever awarded the Congressional Medal of Honor, which she received for her service during the Civil War. Barred from serving as a medical officer because of her sex, she volunteered as a surgeon for the Union army; was captured by Confederate troops, who arrested her as a spy; and spent several months in prison before being released in a prisoner exchange. An author and a lecturer, Walker campaigned for women's rights and advocated for women's suffrage. She also rejected the traditional women's clothing of the time as impractical, restricting, and unhygienic. Walker dressed mainly as a man, enduring harassment and arrest for her attire.

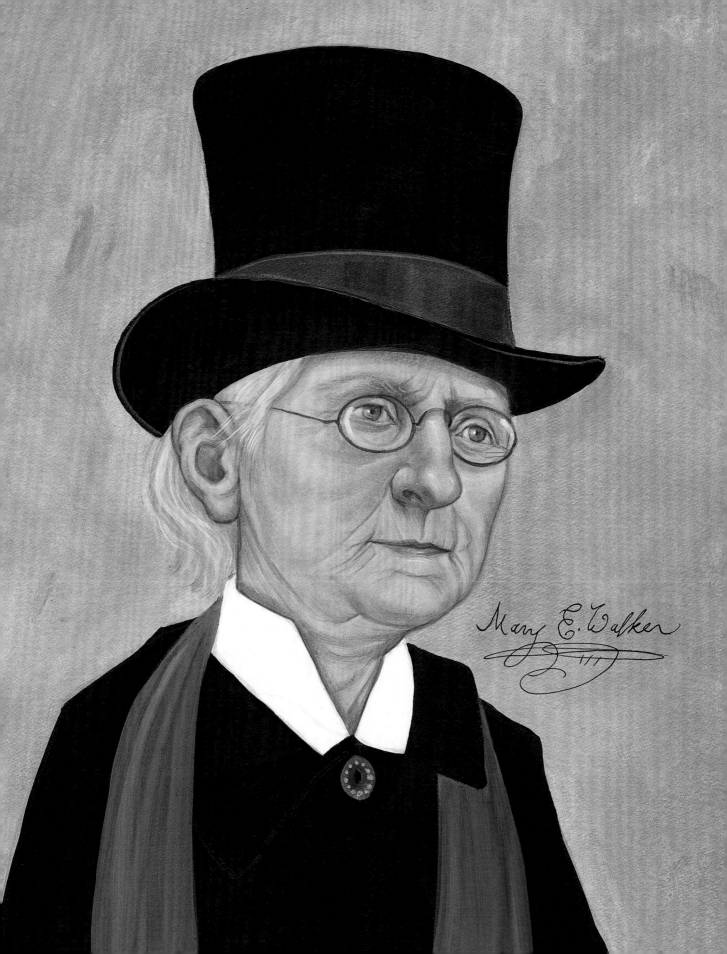

Mary E. Walker

ALOHA WANDERWELL

(1906–1996)

was a Canadian explorer, aviator, filmmaker, and author. Her adventures included landing a seaplane on an uncharted stretch of the Amazon River and filming some of the earliest known footage of Brazil's Bororo people, who'd had almost no contact with industrialized society. In Africa, she used crushed bananas and elephant fat to keep her Ford Model T running. The first woman to drive around the globe, Wanderwell filmed her travels along the way. Once hailed as "the world's most widely traveled girl," she died in relative obscurity.

ALOHA
WANDERWELL

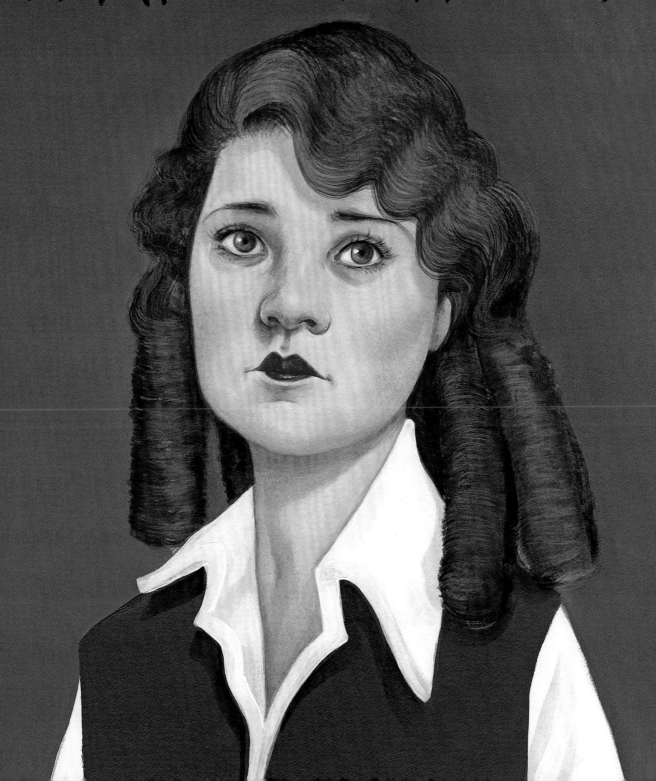

IDA B. WELLS

(1862–1931)

was an investigative journalist who campaigned for equal justice for African Americans. Born into slavery, Wells is best known for her courageous anti-lynching crusade. As a writer, editor, lecturer, and activist, she was a powerful advocate against Jim Crow. Wells was also a founder of the National Association of Colored Women's Clubs, which worked for civil rights and women's suffrage. Her tireless activism made her the most famous Black woman of her day. She was posthumously awarded a Pulitzer Prize in 2020.

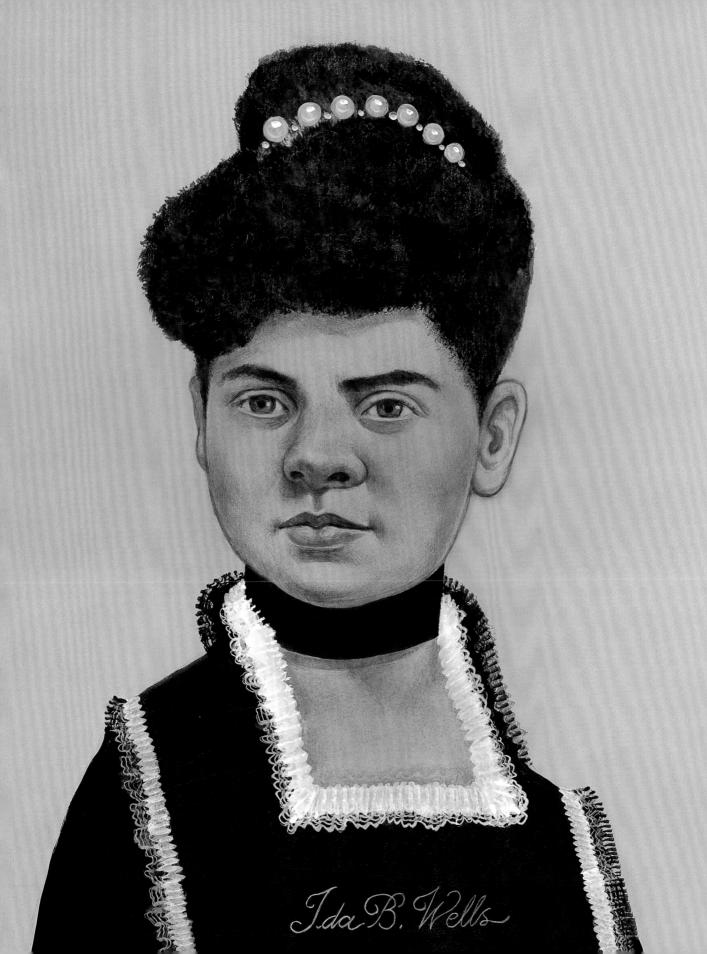

Ida B. Wells

GLADYS WEST

(1 9 3 0 –)

is an American mathematician whose calculations were instrumental in the development of the Global Positioning System, or GPS. In 1956, when West was hired at what was then known as the Naval Proving Ground, she was one of only four Black employees. Beginning as a so-called human computer, she progressed to ever more complex and significant assignments in a long and distinguished career with the U.S. military. Overlooked until recently, West has finally received recognition for her contributions. She was inducted into the Air Force Space and Missile Pioneers Hall of Fame in 2018, the same year the BBC featured her as part of their *100 Women* series.

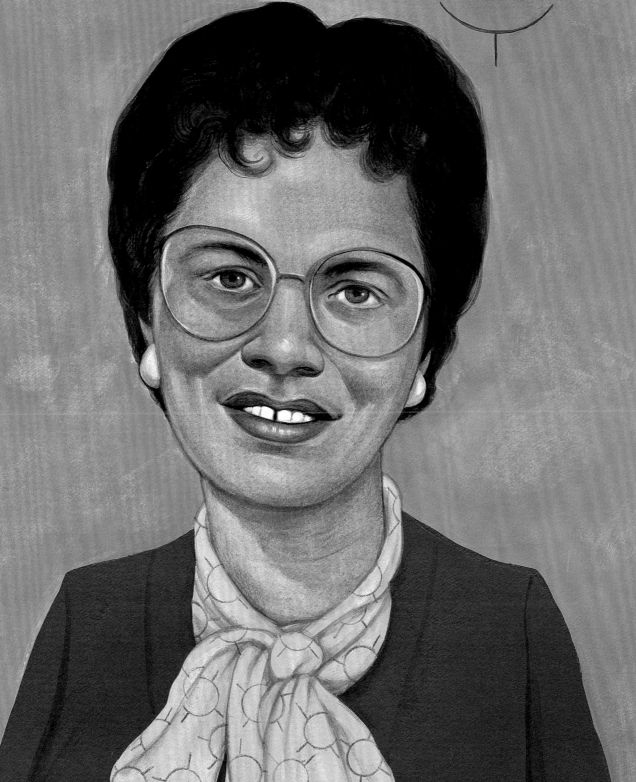

CAROLINE EARLE WHITE

(1833–1916)

was at the forefront of the animal protection cause at a time when animals were considered utilitarian and inhumane treatment was the norm. White cofounded the Pennsylvania Society for the Prevention of Cruelty to Animals, from which she and another reformer spun off the women's branch as a separate organization. Known as the WPSPCA, it established the first animal shelter in the United States, introducing humane animal sheltering and adoption to this country. In 1883, White founded the American Anti-Vivisection Society, the first U.S. organization to oppose the use of animals in science.

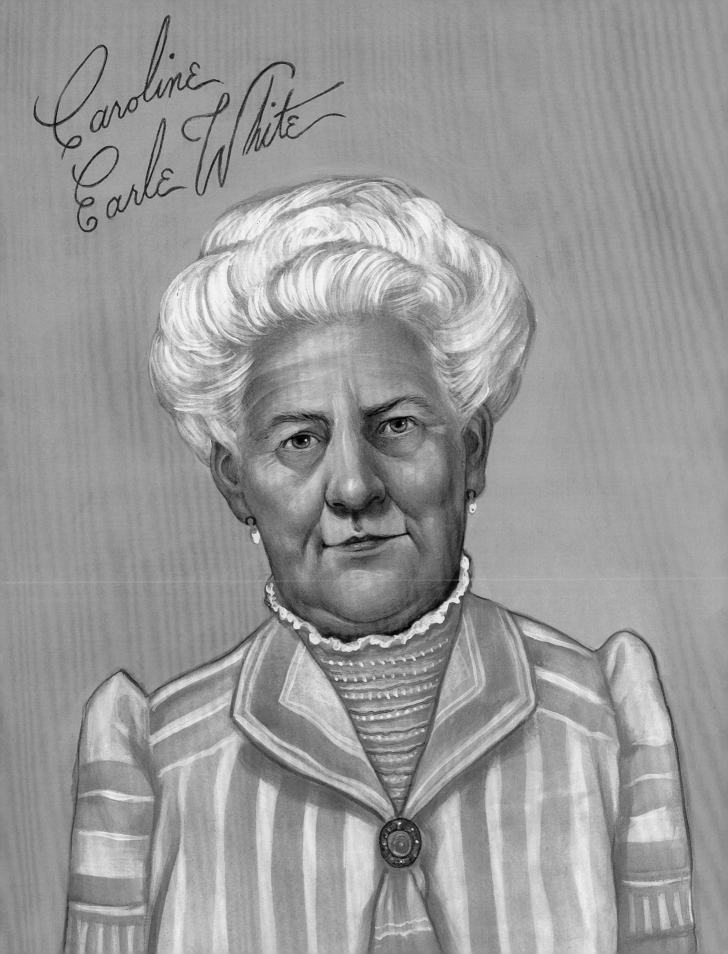

Caroline Earle White

ANNA MAY WONG

(1 9 0 5 – 1 9 6 1)

was the first Chinese American Hollywood movie star. She began her career in silent films and made the transition to sound at a time when most Asian parts were performed by white actors in yellowface. Typically cast as a dragon lady, temptress, or victim, Wong spoke out against the stereotyping of Asian Americans and advocated for Chinese American causes. In later years her options were further limited by the Motion Picture Production Code, which prohibited interracial romance. These factors led to her greatest Hollywood disappointment, losing the lead in *The Good Earth*, a Chinese character, to a white actor. Offered the part of a concubine instead, Wong refused the role.

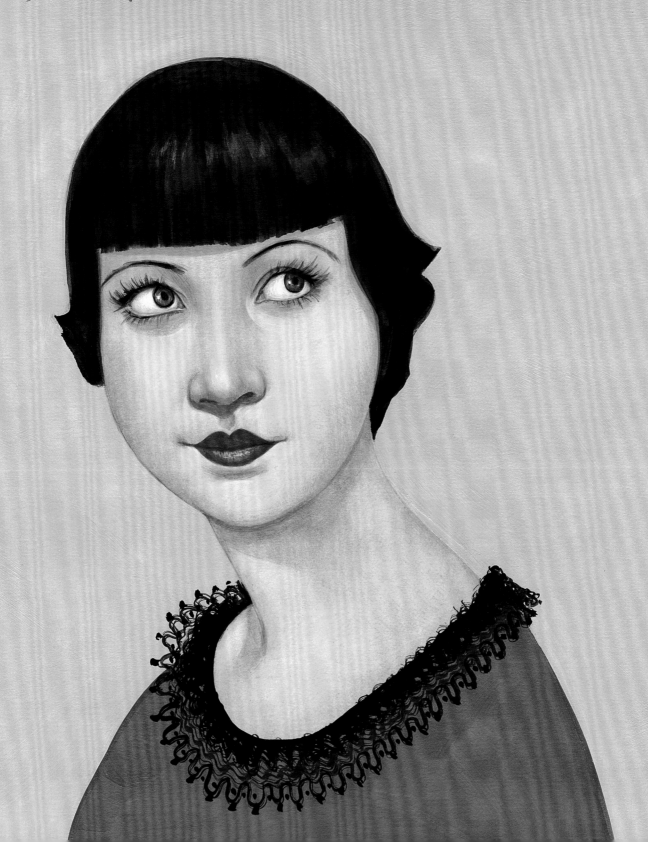

EMPRESS WU ZETIAN

(6 2 4 – 7 0 5)

also known as Wu Zhao, was the only female sovereign in Chinese history. During the Tang dynasty, she began her ascent as a favorite concubine of Emperor Taizong. Thanks to her intelligence and charisma, Wu's influence grew. After Taizong's death, she married his son, Emperor Gaozong, becoming empress consort. Wu effectively ruled from behind the scenes until Gaozong's death, after which she declared herself empress and changed the name of the dynasty to Zhou. Wu has been accused of corruption, infanticide, torture, murder, and, in later life, erotic encounters with younger men, which was shocking behavior for a woman at that time. Although she remains a controversial figure, some historians consider Wu one of the great leaders of ancient China.

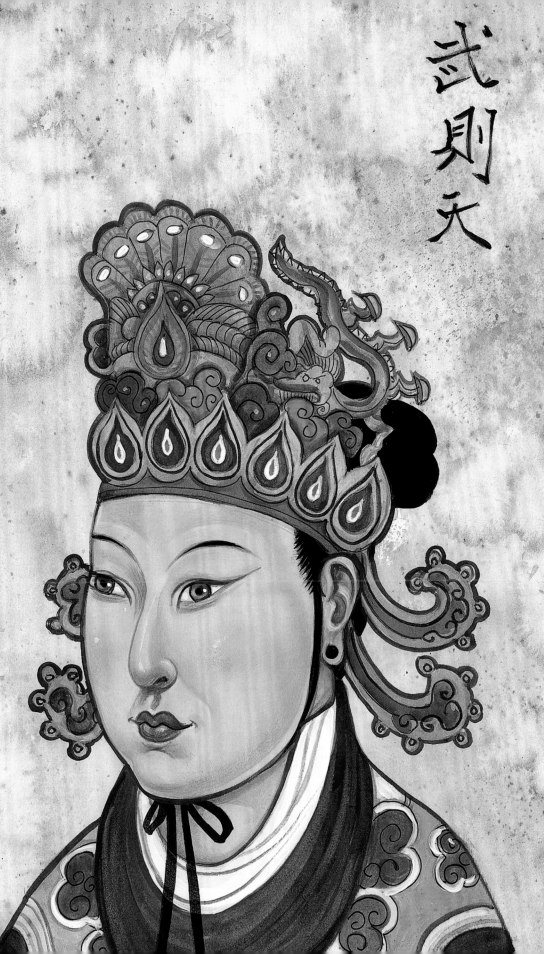
武則天

STELLA YOUNG

(1982–2014)

was an Australian journalist, comedian, and passionate disability rights advocate. Born with osteogenesis imperfecta, which made her bones fragile, she used a wheelchair for most of her life. However, she constantly asserted that she was more disabled by society than by her diagnosis. Young exercised her independence from an early age and left home to pursue an education and a career—accomplishments that she stressed were not exceptional and should and could be normal for all disabled people, were it not for the barriers of low expectations and lack of physical accessibility. Young used her visibility to demystify and destigmatize disability, demanding nothing less than full equality.

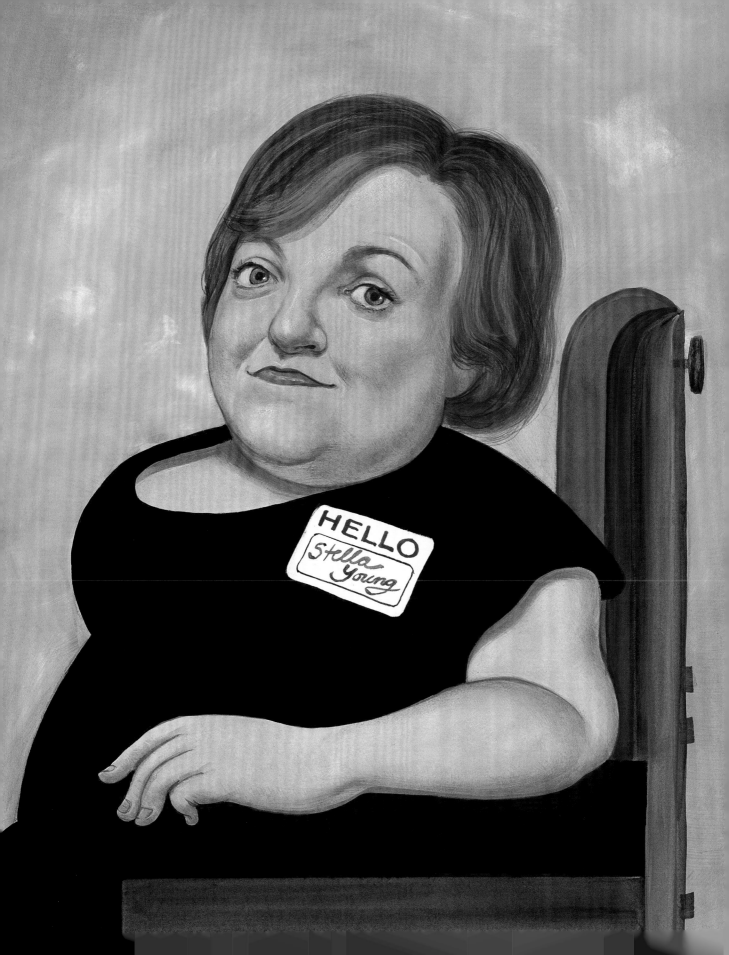

MALALA
YOUSAFZAI

(1 9 9 7 –)

is a Pakistani education advocate who was fifteen years old when she was shot in the head by the Taliban while riding a bus home from school. She'd been speaking out for years against the Taliban, who had taken over her home region and banned girls from going to school, shutting down and blowing up many schools in the process. After a long and difficult recovery, Malala resumed speaking out against injustice, earning international respect and acclaim. At seventeen, she became the youngest person ever to win the Nobel Peace Prize. Malala continues to advocate for the right of girls everywhere to receive twelve years of free, safe, quality education.

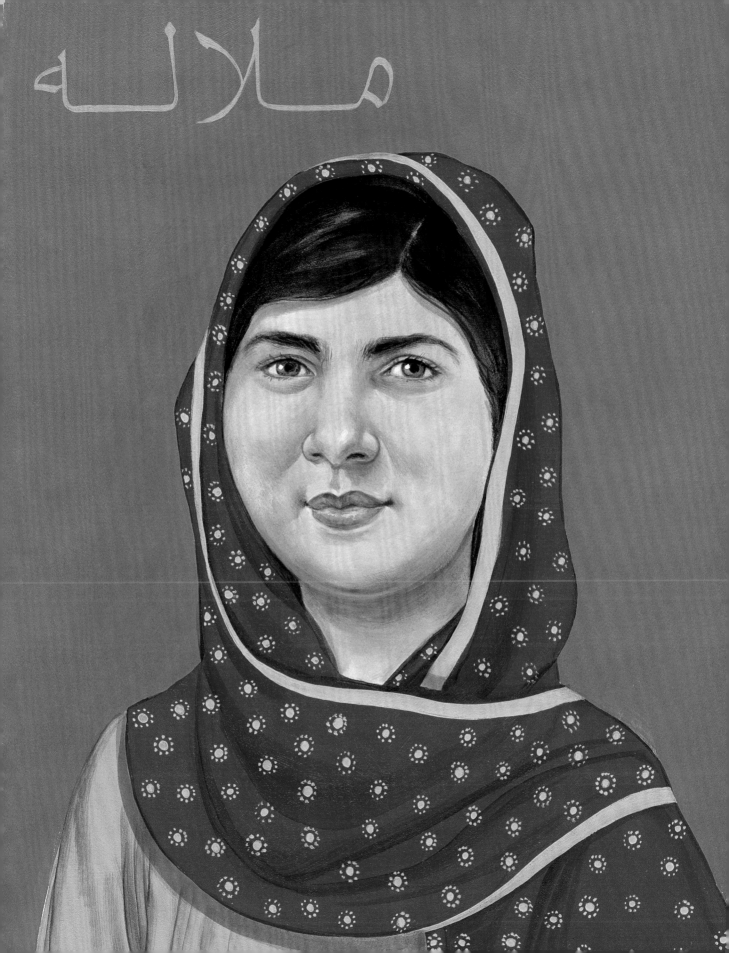

A NOTE ABOUT THE AUTHOR

Anita Kunz is a Canadian-born artist and illustrator whose work has been published and exhibited internationally for four decades. Her art has been featured regularly in and on the covers of many magazines, including *Time, Rolling Stone,* and *The New York Times Magazine.* She has illustrated covers for *The New Yorker* and more than fifty book jackets. Kunz has been inducted into the Society of Illustrators Hall of Fame, and Canada Post has honored her work with a postage stamp. She has been appointed Officer of the Order of Canada (OC), and has received the Queen Elizabeth II Diamond Jubilee Medal. Kunz lives and works in Toronto.

A NOTE ON THE TYPE

The text of this book was set in Filosofia, a typeface designed by Zuzana Licko in 1996 as a revival of the typefaces of Giambattista Bodoni (1740–1813). Basing her design on the letterpress practice of altering the cut of the letters to match the size for which they were to be used, Licko designed Filosofia Regular as a rugged face with reduced contrast to withstand the reduction to text sizes, and Filosofia Grand as a more delicate and refined version for use in larger display sizes.

Licko, born in Bratislava, Czechoslovakia, in 1961, is the co-founder of Emigre, a digital type foundry and publisher of *Emigre* magazine, based in Northern California. Founded in 1984, coinciding with the birth of the Macintosh, Emigre was one of the first independent type foundries to establish itself centered around personal computer technology.

Book design by Chip Kidd and John Kuramoto